D1387703

BREAKING THE RULES

BREAKING THE RULES

The Printed Face of the European Avant Garde
1900–1937

Edited by Stephen Bury

The British Library

First published in 2007 by
The British Library
96 Euston Road
London NW1 2DB

on the occasion of the exhibition at the British Library:

Breaking the Rules
The Printed Face of the European Avant Garde 1900–1937
9 November 2007–30 March 2008

Text © The British Library 2007
Images © The British Library and other named copyright holders 2007

The publishers have made every effort to contact all copyright holders.
If proper acknowledgement has not been made, we ask all copyright
holders to contact the publishers

British Library Cataloguing in Publication Data
A catalogue record for this book is available from The British Library

ISBN 978 0 7123 0975 2 (HB)
ISBN 978 0 7123 0980 6 (PB)

Designed and typeset by Andrew Shoolbred and Gregory Taylor
Printed in Italy by Printer Trento S.r.l.

Contents

INTRODUCTION

Between 1900 and 1937 Europe experienced an extraordinary cultural rebirth and interchange of ideas, comparable to the Renaissance and Enlightenment. If the precise causes of this phenomenon are unclear, what is clear is that it coincided with an economic surge or Kondratiev wave (a term invented in 1925), resulting from developments in communications, increased industrialization, the rise of the automobile, the importance of oil and conventional paper money which is inconvertible (as opposed, for example, to the gold standard). These obviously had an impact on political and cultural institutions, and the concomitant challenge to these institutions is associated with the avant garde.

Avant garde (literally 'vanguard') denotes a band of soldiers preparing the way for a general advance. In the early nineteenth century, the term came to be used in utopian politics, appearing in Henri de Saint-Simon's *Literary, Philosophical and Industrial Opinions* (1825). His view was that, working together, artists, scientists and manufacturers could lead mankind out of the alienation created by modern industrial society:

> 'Let us unite. To achieve our one single goal, a separate task will fall to each of us. We, the artists, will serve as the avant-garde: for amongst all the arms at our disposal, the power of the Arts is the swiftest and most expeditious. When we wish to spread new ideas amongst men, we use in turn the lyre, ode or song, story or novel...we aim for the heart and imagination, and hence our effect is the most vivid and the most decisive.'[1]

This was perhaps the first manifesto, and the beginning of the association of the avant garde with the printed format. Later in the nineteenth century, the term came to be applied to art. It was more complex than this simple trajectory would suggest, and the art avant garde could move seamlessly into radical politics, as Dada did in Berlin and the Constructivists did in the USSR in order to achieve a new socialist utopia. Between 1900 and 1937 the avant garde consisted of a series of overlapping movements,

OPPOSITE:
Kazimir Malevich,
Woman at Poster Column,
1914, oil and collage.

Malevich was one of the few Russians who welcomed Marinetti and Italian Futurism. This painting reflects the literal and dynamic approach to collage, characteristic of Futurism. The column is denoted by the letters Y and B, and the woman by the S shapes and white breast-like object behind lace.

Stedelijk Museum, Amsterdam

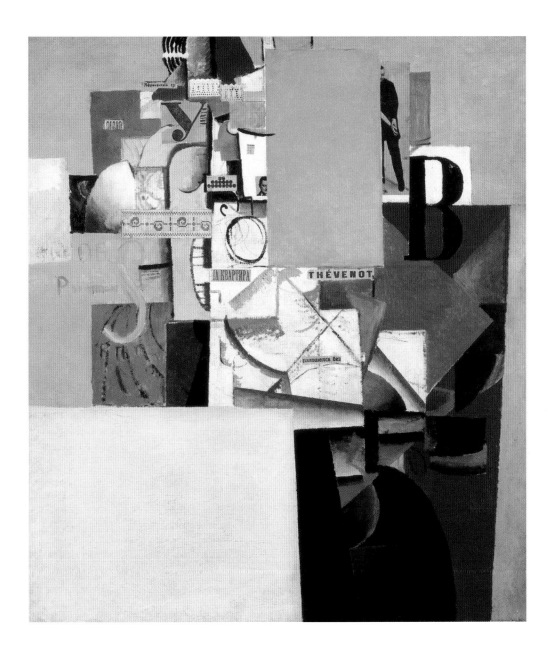

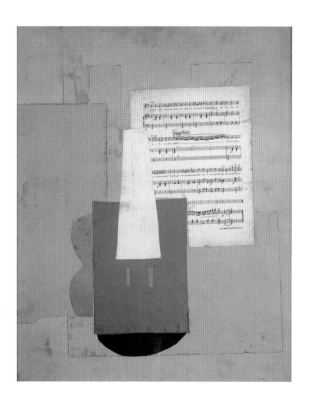

Pablo Picasso,
Violin and Sheet Music,
late 1912, pasted papers
on cardboard.

Musée Picasso, Paris /
Bridgeman Art Library

© Succession Picasso /
DACS 2007

'isms' or groups, and participants took part in more than one, often simultaneously. These were Cubism, Expressionism, Futurism, Dadaism, Constructivism and Surrealism. Because of its very nature, traditional modes of communication and exhibition were often denied to the avant garde, it was adept at finding its own outlets, publishing its own manifestos, magazines and books, and creating new ones – the artist's book and the photo-book. Some groups were synonymous with magazines – *De Stijl* in Leiden and *Ma* in Budapest, then Vienna; the Bauhaus had its own series of books or *Bauhausbücher*. Dada with its anti-art stance existed primarily through the printed format. This period was the last one in which the printed format was the primary mode for communicating information; film and broadcasting were ready to take over. An avant garde today would not use printed media in a significant way.

From 1910 Georges Braque and Pablo Picasso painted and stencilled words, and from 1912 they collaged fragments of newspapers. If this served the Cubist project's emphasis on the flatness of the picture plane, it also highlighted the artists' surroundings and made them painters of modern

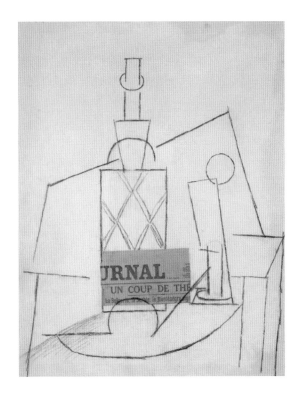

Pablo Picasso,
Table with Bottle, Wineglass and Newspaper, late 1912,
pasted paper and charcoal on paper.

Musée National d'Art Moderne / RMN, Paris

© Succession Picasso / DACS 2007

life. Whilst some have read anti-militaristic views in some of these collages, others have seen Picasso punning verbally and visually, enjoying the verbal environment surrounding him in newspapers, signs and advertisements. His *Guitar, Sheet Music and Glass* (*La Bataille s'est engagée...*) of 1912, referring to the Tchataldja battle in the First Balkan War also, literally plays with the title of the mass-circulation republican newspaper *Le Journal*, truncating it to *jou*, game. But the collage also contains other printed materials – wallpaper and music. *Table with Bottle, Wineglass and Newspaper*, of late 1912, has only one extract of newsprint, again referring to the Balkan War, functioning as a pseudo-label. *Un Coup de théâtre* becomes *Un Coup de thé*, a cup of tea, but also perhaps makes a reference to Stéphane Mallarmé's 'Un Coup de dès n'abolira jamais le hasard', which had first appeared in 1897. *Journal* has been cut back to *urnal*, with its schoolboy echo of urinal. These multiple titles suggest not only a playfulness but also a desire to re-form existing materials into new forms, into new art. *Glass and Bottle of Bass* of 1914 has a poorly cut picture frame with a mock label, 'Picasso', within which is more wallpaper on which is an oval still life with a newspaper cutting

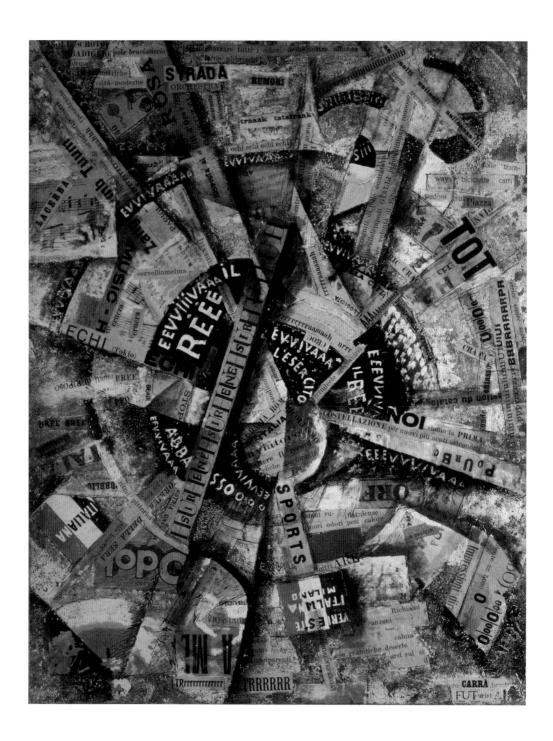

RIGHT:
Gino Severini,
'Danza Serpentina',
Lacerba, 1 July 1914
© ADAGP, Paris and DACS,
London 2007

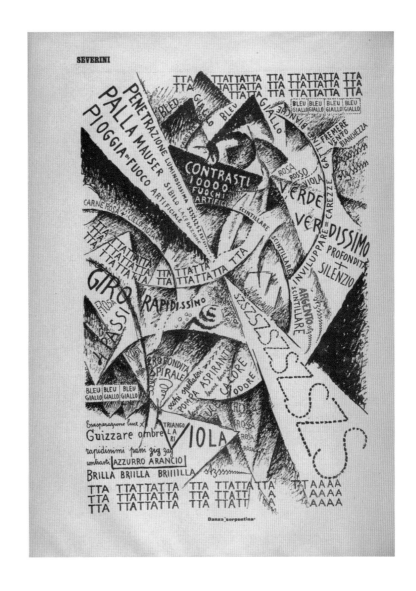

OPPOSITE:
Carlo Carrà,
*Free-word Painting – Patriotic
Festival*, July 1914, pasted
papers, charcoal, gouache
and ink on board.
Mattioli Collection
© DACS 2007

in the crude shape of a glass, abutting the painted cut-out shape of a bottle
with the stencilled letters of 'Bass' on it; the internal wallpaper surround
of the 'still life' echoes the wallpaper backgrounds on which Picasso's
patrons at that time hung their pictures. Picasso again used the false border
and label when he came to design the first front cover for *Minotaure* in
1933. That cover is a work of art in itself.

But Picasso was just one artist exploiting and interrogating his visual,
textual environment. Carlo Carrà's painting *Free-word Painting – Patriotic*

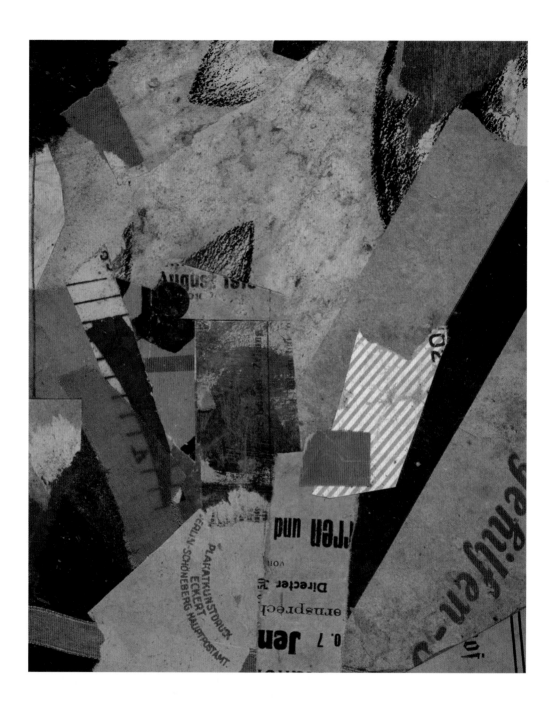

Festival, renamed *Demonstration for Intervention in the War – Interventionist Manifesto*, of July 1914, collages text from the Futurist Florentine magazine *Lacerba* as well as from the *Corriere della Sera*. It also appropriates the circular structural arrangement from Guillaume Apollinaire's 'Lettre-Océan', first published in *Les Soirées de Paris* (15 June 1914). It too alludes to Apollinaire's 'La Rosa' as well as to Filippo Tommaso Marinetti's *Zang Tumb Tuuum*. Finally, the collage itself is reproduced in a later issue of *Lacerba*; in fact *Lacerba* is collaged in Picasso's *Still Life: 'Almanacco Purgativo'* and Braque's *Violin*, both of spring 1914 – perhaps responses to Ardengo Soffici's own *Still Life with Lacerba* of late 1913, which has the phrase 'cubismo e oltre' at its centre.

Collaged text, real or illusionary, figures in the works of many other painters – Louis Marcoussis, Juan Gris, Fernand Léger and Gino Severini, for example. In 1919 Varvara Stepanova made an artist's book, *Gaust chaba*, the pages of which were newsprint on which were roughly handwritten *zaum*, or experimental poetic words and other collaged newspaper text. But journals, posters, printed music and wallpaper were not the only printed formats that artists used. Kurt Schwitters, who worked as a graphic designer in his native Hanover as well as editing and publishing *Merz*, inserted tram tickets and other printed ephemera in his *merz* (a fragment of *Commerz*) paintings. Max Ernst collaged nineteenth-century illustrated journals for *Une Semaine de bonté* (1934); Francis Picabia and Marcel Duchamp were influenced by patents and technical drawing manuals.

Interest in and use of the collaged text fragment was not confined to artists. Marinetti, Blaise Cendrars and Apollinaire were doing similar things in poetry: the 'HURRY UP PLEASE IT'S TIME' of T.S. Eliot's 'Game of chess' sequence in *The Waste Land* (1922) has its origins in this French tradition. So too do the advertisements appearing in John Dos Passos's *USA Trilogy* (1938); Dos Passos had known Cendrars and translated his *Panama*. Both poets and artists were interested in the total work of art (*Gesamtkunstwerk*); two of the locations for this were the artist's book and the calligramme (when they were not the same thing). Whether it was Vasily Kamensky's ferro-concrete poem 'Constantinople' in *Tango with Cows* (1914) or Apollinaire's 'Lettre-Océan' in *Les Soirées de Paris* (June 1914), the poem could be both read and visualized, and the one could modulate the other; a poem becomes a poster, image is read as text, text is seen as art, and the horizontal becomes vertical. Although shaped poetry was known in the sixteenth century, it thrived in the second decade of the twentieth century and, as concrete poetry, flourishes today. The Futurist project

OPPOSITE:
Kurt Schwitters,
Mz 299,
1921, pasted papers
on paper.
National Galleries of
Scotland, Edinburgh
© DACS 2007

aimed at the total work of art, combining all the senses, so that, for example, Futurist cooking would involve sound and sight as well as taste and smell. Significantly, with Futurism the manifesto came first, and sometimes practice remained at the level of illustration.

But Dada contained within itself a contradictory imperative. Walter Benjamin, who had contributed a translation of a Philippe Soupault poem to Hans Richter's Dadaist-Constructivist review G, published his famous essay 'The work of art in the age of mechanical reproduction' in 1936. He had argued that the era of unique, authentic art objects – ones that possessed 'aura' – had been brought to an end by industrialization and the rise of the mass audience, exemplified by photography and film. What is less well remarked is his analysis of Dada as anti-art: 'What they intended and achieved was a relentless destruction of the aura of their creations, which they branded as reproductions with the very means of production.'[2] For Hans Richter, Dada was anti-art, whilst Richard Huelsenbeck, writing in 1936, criticized Tristan Tzara because he 'transformed Dadaism into an artistic movement'.[3] Like the conceptual art movement of the late 1960s and early 1970s the attempt to avoid the creation and commercialization of art objects was perhaps always doomed to failure; the dematerialization of the art object reifies that object in its secondary productions – magazines, exhibition catalogues, manifestos, flyers; the catalogue of Dadaism is in fact a bibliography.[4]

One of the significant roles of the avant-garde magazine and almanac was to make reproductions of works of art accessible to an international audience. There were no museums or galleries of 'living art' or modern art; the Museum of Modern Art, New York, did not open until 1929. In this vacuum the magazine or such a publication as Wassily Kandinsky's and Franz Marc's *The Blaue Reiter Almanac* (1912) could provide reproductions of works by Henri Rousseau (the plates borrowed from Wilhelm Uhde's monograph published in Paris), Henri Matisse, Henri Le Fauconnier, Max Pechstein, Robert Delaunay, David Burliuk, Vladimir Burliuk, Kandinsky, Marc, Gabriele Münter, Paul Klee, Natalia Goncharova, Oskar Kokoschka, Alfred Kubin, Arnold Schoenberg, Emil Nolde and Paul Gauguin – alongside child art, Bavarian glass painting and Russian folk art. *The Blind Man* no. 2 (May 1917) had on its front cover Duchamp's *Chocolate Grinder no. 1* (1914), bought by Walter Arensburg and not on view to the public until 1954 after the gift of the collection to the Philadelphia Museum of Art in 1950. It also contained Alfred Stieglitz's photograph of Duchamp's *The Fountain*, the porcelain 'Bedfordshire' urinal, withdrawn from the 1917

Independents exhibition in New York. Likewise Duchamp's photographs of the dust-encrusted *The Large Glass* in *Littérature* (1 October 1922) and half-concealed on the cover of *Minotaure* no. 6 (1934) were rare public appearances; until it was reconstituted, *The Large Glass* lived primarily in the published notes about it, 'The green box'. Something of the impact of these magazines can be gauged: in 1922 Charles Pollock, studying at the Otis Art Institute, sent copies of *The Dial* to his teenage brother Jackson Pollock. These contained reproductions of works by Picasso, Constantin Brancusi and Marc, as well as providing the first American appearance of T.S. Eliot's *The Waste Land*.

These international connections came in useful with the avant-garde diaspora, as the Nazis condemned the avant garde as degenerate and the Stalinists proscribed formalism and avant gardism. But photography and film had also undermined the printed format as a conveyor of information; and the lifeblood of the avant garde, its use of print, was attenuated.

1 *Art in Theory 1815–1900: an Anthology of Changing Ideas*, edited by Charles Harrison and Paul Wood, Oxford: Blackwell, 1998, p. 40.
2 Walter Benjamin, *Illuminations*, London: Fontana, 1973, p. 231.
3 Richard Huelsenbeck, 'Dada lives!', *The Dada Painters and Poets: an Anthology*, edited by Robert Motherwell, Cambridge, Mass., and London: The Belknap Press for Harvard University Press, 1981, p. 281.
4 Lucy Lippard, *Six Years: the Dematerialization of the Art Object from 1966 to 1972*, London: Studio Vista, 1973.

THE MANIFESTO

'Make room for youth, for violence, for daring!'[1]

The European avant garde in the first three decades of the twentieth century was characterized by its use of the manifesto. Filippo Tommaso Marinetti's 'The founding and manifesto of Futurism' of 1909 unleashed a torrent of manifesto publications – there were Futurist manifestos on painting, sculpture, literature, noise, women, photography, syntax, architecture, cinema, tactilism, theatre, flowers and even lust (by Alphonse de Lamartine's granddaughter, Valentine de Saint-Point). It is conventionally assumed that Futurist manifestos petered out in 1918 with Giacomo Balla's *The Futurist Universe*, but they were still being published in the 1920s, and they were engaging with Dada in print. Manifestos crossed the divide of the 'isms' – Futurism, Cubo-Futurism, Dada, Constructivism and Surrealism; Tristan Tzara maintained that he was against manifestos in principle and that he was also against principles, the statement itself appearing in his *Dada Manifesto* of 1918.

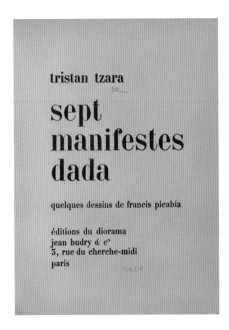

Tristan Tzara, *Sept Manifestes dada*, Paris, 1924

(BL 11881.tt.21)

OPPOSITE:
El Lissitzky and Hans Arp, *The Isms of Art* (*Die Kunstism*), Zurich, 1925

El Lissitzky, responsible for the typography and layout, argued that this book, which described and illustrated the main art trends of 1914 to 1925, could reach 'hundreds and thousands of poor people' and transform their consciousness.

(BL C.107.k.23)

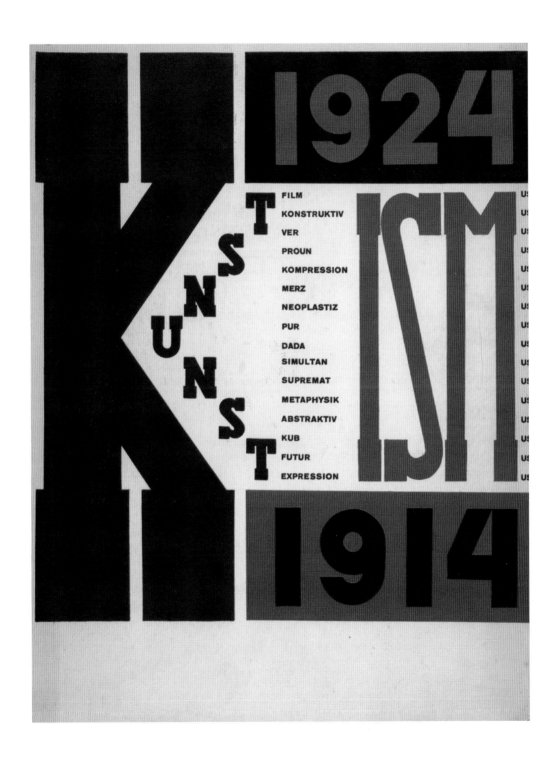

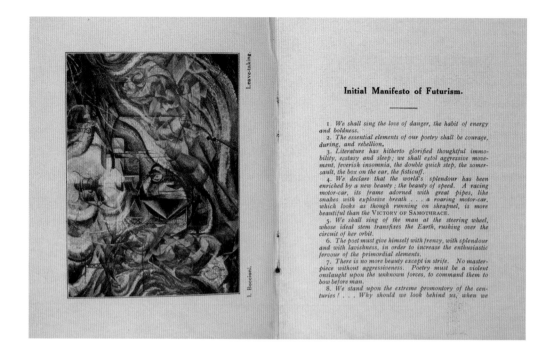

Filippo Tommaso
Marinetti, 'Initial
Manifesto of Futurism',
*Exhibition of Works by the
Italian Futurist Painters*,
Sackville Gallery, London,
March 1912

(BL D-7854.cc.39)

Manifestos had appeared before 1900. Perhaps the most relevant precursor is the so-called *Communist Manifesto* of Friedrich Engels and Karl Marx, commissioned by the Communist League and published on 14 April 1848, during the revolutions then convulsing Europe; it promoted the proletarian revolution, overthrowing the bourgeoisie – the new kicking out the old. The international pattern of publication and translation can be seen as a precedent for the avant garde. Another influence was the poetical manifesto, such as Arthur Rimbaud's *Season in Hell* (1873) – Marinetti was, after all, primarily a poet, writing in French as well as in Italian.

But the avant-garde manifesto was a more widespread and continuous affair. It could take many forms. Marinetti's 'The founding and manifesto of Futurism' first appeared in print not as a self-proclaimed manifesto, but as 'le futurisme' on the front page of *Le Figaro* (Paris) on 20 February 1909 and was translated into many languages, again appearing in newspapers. It appeared in the Marinetti-edited *Poesia* (April–June 1909), which formed the basis of the English translation, published in the catalogue of the exhibition at the Sackville Gallery, March 1912. And it was published separately by the Futurists' own imprint.

PROCLAMATION

TIRED OF THE SPECTACLE OF SHORT STORIES, NOVELS, POEMS AND PLAYS STILL UNDER THE HEGEMONY OF THE BANAL WORD, MONOTONOUS SYNTAX, STATIC PSYCHOLOGY, DESCRIPTIVE NATURALISM, AND DESIROUS OF CRYSTALLIZING A VIEWPOINT...

WE HEREBY DECLARE THAT :

1. THE REVOLUTION IN THE ENGLISH LANGUAGE IS AN ACCOMPLISHED FACT.

2. THE IMAGINATION IN SEARCH OF A FABULOUS WORLD IS AUTONOMOUS AND UNCONFINED.
(*Prudence is a rich, ugly old maid courted by Incapacity...* Blake)

3. PURE POETRY IS A LYRICAL ABSOLUTE THAT SEEKS AN A PRIORI REALITY WITHIN OURSELVES ALONE.
(*Bring out number, weight and measure in a year of dearth...* Blake)

4. NARRATIVE IS NOT MERE ANECDOTE, BUT THE PROJECTION OF A METAMORPHOSIS OF REALITY.
(*Enough ! Or Too Much !...* Blake)

5. THE EXPRESSION OF THESE CONCEPTS CAN BE ACHIEVED ONLY THROUGH THE RHYTHMIC " HALLUCINATION OF THE WORD ". (Rimbaud).

6. THE LITERARY CREATOR HAS THE RIGHT TO DISINTEGRATE THE PRIMAL MATTER OF WORDS IMPOSED ON HIM BY TEXT-BOOKS AND DICTIONARIES.
(*The road of excess leads to the palace of Wisdom...* Blake)

7. HE HAS THE RIGHT TO USE WORDS OF HIS OWN FASHIONING AND TO DISREGARD EXISTING GRAMMATICAL AND SYNTACTICAL LAWS.
(*The tigers of wrath are wiser than the horses of instruction...* Blake)

8. THE " LITANY OF WORDS " IS ADMITTED AS AN INDEPENDENT UNIT.

9. WE ARE NOT CONCERNED WITH THE PROPAGATION OF SOCIOLOGICAL IDEAS, EXCEPT TO EMANCIPATE THE CREATIVE ELEMENTS FROM THE PRESENT IDEOLOGY.

10. TIME IS A TYRANNY TO BE ABOLISHED.

11. THE WRITER EXPRESSES, HE DOES NOT COMMUNICATE.

12. THE PLAIN READER BE DAMNED.
(*Damn braces ! Bless relaxes !...* Blake)

— *Signed* : KAY BOYLE, WHIT BURNETT, HART CRANE, CARESSE CROSBY, HARRY CROSBY, MARTHA FOLEY, STUART GILBERT, A. L. GILLESPIE, LEIGH HOFFMAN, EUGENE JOLAS, ELLIOT PAUL, DOUGLAS RIGBY, THEO RUTRA, ROBERT SAGE, HAROLD J. SALEMSON, LAURENCE VAIL.

Transition, 16/17 June 1929

This Paris-based magazine, edited by Eugène Jolas, republished this literary manifesto, 'The Revolution of the Word' (1928), which shows indebtedness to Arthur Rimbaud and, in particular, William Blake whose 'Damn braces! Bless relaxes!' had been one of the influences on the Vorticist *Blast*.

(BL Cup.400.a.30)

Other manifestos appeared as pamphlets and posters – a synonym for 'poster' in Italian is manifesto. Naum Gabo's and Antoine Pevsner's 'The Realistic manifesto' (1920) took the form of a three-column poster, accompanying an open-air show on the Tverskoy Boulevard in Moscow; five thousand copies were printed and fly-posted. The little magazine – *Blast*, *Dada*, *Der Zeltweg*, *391*, *Mécano* or *Merz* – was another home for the manifesto. *Littérature* no. 13 (May 1920) had the sub-title 'Vingt-trois manifestes du mouvement dada', and included manifestos by Tzara, Francis Picabia, Louis Aragon, André Breton, Hans Arp, Paul Éluard, Philippe Soupault, Walter Serner, Paul Dermée, Georges Ribemont-Dessaignes and Céline Arnauld and the made-up one of Walter Arensberg, 'Dada est americaine' – Arensberg had sent a blank sheet of paper with that heading, only for the editors (or Picabia) to fill it out with a formulaic Dada manifesto.

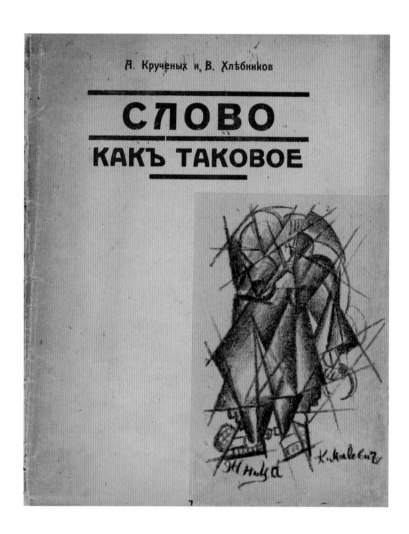

Aleksei Kruchenykh and
Velimir Khlebnikov,
The Word as Such
(*Slovo kak takovoe*), 1913

Cover lithograph, 'The
Reaper' by Malevich. This
fifteen-page pamphlet
mixes manifesto, verse
and illustrations by Olga
Rozanova. It reprints
Kruchenykh's *zaum* poem,
'dyr bul shchyl', which
is declared to be more
Russian than Pushkin.

(BL C.114.mm.23)

The manifesto could be one paragraph or a whole book: Ivan
Ignatyev's *Ego-Futurism* was a sixteen-page booklet, published by the St
Petersburg *Herald* in 1913, while Breton's first *Manifesto of Surrealism* (1924)
was over a hundred pages in length. Such texts as *Der Blaue Reiter* (1912),
edited by Wassily Kandinsky and Franz Marc – basically an Expressionist,
avant-garde anthology of art and music – could be seen as more of a
programmatic manifesto. Marinetti's *La cucina futurista* (1932), in all intents
and purposes a cook book, could also be seen as a Futurist manifesto of
cookery, promoting rice over pasta and adding touch, smell and sound to
the table.

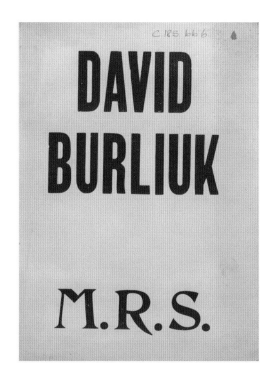

David Burliuk,
Manifesto Radio-style, 1926

Burliuk emigrated to the
USA in 1922. In 1926 he
published this Futurist
manifesto of the word
broadcasted worldwide
by radio.

(BL C.185.bb.6)

Although there was a wide range of formats, a core definition is discernible. Some manifestos were typographically experimental, but the manifesto was meant to be read aloud. Precedents could be found for this, as in James McNeill Whistler's *The Ten O'clock Lecture* (1885), but nothing could anticipate the noise and disturbance of the Futurist recital. Umberto Boccioni, Carlo Carrà, Luigi Russolo, Giacomo Balla and Gino Severini described the launch of 'Futurist painting' to an audience of three thousand at the Chiarella Theatre, Turin, on 18 March 1910: 'It was a violent and cynical cry which displayed our sense of rebellion, our deep-rooted disgust, our haughty contempt for vulgarity, for academic and pedantic mediocrity, for the fanatical worship of all that is old and worm-eaten.' The performative, aggressive tone is common to Francesco Cangiullo, taking a stick to the 'bourgeois passéistes' in the theatre, and to Richard Huelsenbeck at the Cabaret Voltaire. The Russian Futurists appeared at the Society of Art Lovers on 13 October 1913, the event advertised by posters printed on toilet paper and by 'walk-abouts' and public recitals on Kuznetsky Prospekt, with Vladimir Mayakovsky sporting his yellow blouse (and a wooden spoon in his button-hole).

Oral performance meant that the manifesto deployed rhetorical devices – repetitions, anaphora, epizeuxis and epistrophe. It also explained the voice of the text: many manifestos began with the programmatic 'we', moving to the exhorting 'you'. This approach demanded simplification of language: Guillaume Apollinaire and Marinetti wanted to purge language of all adjectives and other useless words: 'It's stupid to write one hundred pages where one will do.'[2] And it also meant simplification of ideas. Marinetti's first manifesto enumerated eleven propositions, some promoting positive ideals – love of danger, courage, audacity, revolt, the beauty of speed, violence, war and the industrial city – and others attacking established institutions and mores – 'we will destroy the museums, libraries, academies of every kind'. The dichotomy – this is good, this is bad – is a characteristic of the typical manifesto. Apollinaire's 'L'antitradition futuriste' (1913), first published in *Lacerba* dated 29 January 1913, embodies this contrast in its very title. Typographically it is comparatively restrained; there are occasional mixtures of upper and lower case within words, vertical lines and aligned text, single and double underlinings, a line of music, and very little punctuation. The manifesto version is

Guillaume Apollinaire,
L'antitradition futuriste, 1913

(BL, new acquisition)

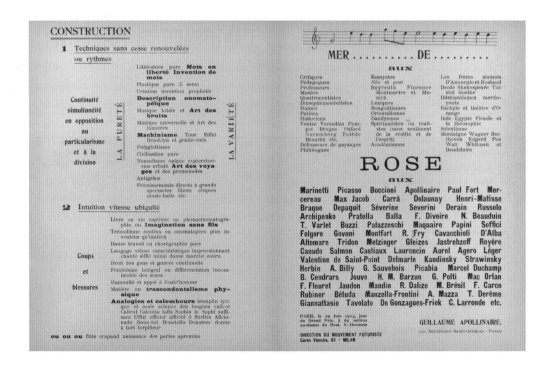

both longer (three pages as opposed to two) and more typographically daring with its bolder type. The content is structured on the opposition of destruction to construction. Apollinaire proposes the abolition of syntax, the adjective, punctuation, typographic harmony, the tenses and persons of verbs, verse and stanza in a poem. Instead he would have a literature made from free words ('parole in libertà'), neologisms, onomatopoeic description and polyglottism. The machine and the city would inspire it. The rest of the manifesto, after a stave of music, parallels this negative/positive or constructive/destructive dichotomy in a listing of common and proper nouns that Apollinaire dislikes: 'mer...de...aux', (shit to): historians, Venice, Bayreuth, theosophists etc and 'rose aux' Marinetti, Georges Braque, Marcel Duchamp and so on and, of course, Apollinaire himself. The choice of *merde* and *rose* has been explained by an incident Apollinaire witnessed at La Turbie, where he saw a dishevelled woman abusing her tormentors – children – who then replied 'Merda-rosa, merd'a ti ros'a mi'. Equally, it may owe much to the infamous one-word opening of Alfred Jarry's *Ubu Roi*, first performed on 11 December 1896 for a run of two performances, but revived in 1908.

This simple dichotomous approach is taken up in the *Futurist Synthesis of the War* (1914), which has a wedge of Futurism and the anti-German allies penetrating the passéism of Austria, Germany and Turkey. It is creative genius, 'elasticity, intuitive synthesis, invention, multiplication of forces, invisible order' against German culture, 'rigidity, analysis, methodical imitation, addition of idiocies, numismatic order'. The English Vorticist Wyndham Lewis in *Blast* (1914–15) had Bless and Blast sections: bless England, the ocean, all ports and 'bless cold, magnanimous, delicate, gauche, fanciful, stupid Englishmen', whilst blasting France, 'aperitifs...bad change etc.' When it came to listing individuals, the Russian Futurists of *A Slap in the Face of Public Taste* (1912) could disparage those they did not like by pluralizing their names: 'those Maxim Gorkys, Kuprins, Bloks etc...need only a dacha by the river. Such is the fate of tailors.' And it was possible to do this in pictures too: Jan Tschichold's *Die neue Typographie* (1928) would contrast a magazine layout as 'decorative, impractical, uneconomic =ugly' as opposed to one that was 'constructive, meaningful, and economical =beautiful'.

Other characteristics were the signatures. Although many manifestos had single or group authorship, many had a list of subscribing individuals appended: *A Slap in the Face of Public Taste* with its bold assertion that 'only we are the face of our time' was in fact signed by only four of its seven

Jan Tschichold,
Die neue Typographie, 1928
(BL 11911.aa.23)
See p. 23

contributors – D. Burliuk, Aleksei Kruchenykh, V. Mayakovsky and Velimir Khlebnikov, although the last-named claimed not to have participated in its composition.'[3] Benedict Livshits, on military service, and Nikolai Burliuk were absent from Moscow and thus unable to sign. The seventh was Kandinsky who objected to having been included at all. Many Italian Futurist manifestos additionally had the imprimatur of the 'Direction du mouvement futuriste' or 'Direzione del movimento futurista' with an office at Corso Venezia 61, Milan, where Marinetti lived. This was the first time that an art movement called itself a 'movement', a word adopted by Dada.

Futurism was intended by its founders to be international, not least in the almost simultaneous publication of translations in French and Italian of most manifestos. One manifesto, *Le Futurisme et la philosophie* (July 1912) by Auguste Joly was bilingual. Like *Fluxus* in the 1960s, one manifesto advertised earlier ones, on sale for 1 franc. Some of the editions had runs of 50,000.

Adolf Dresler,
*Deutsche Kunst und entartete
Kunst*, 1938
(BL 7811.ppp.21)

The end of the avant garde coincided with the hijack of the manifesto by the forces of reaction. The *Entartete Kunst* and *Entartete Musik* catalogues of the Nazis would contrast 'good' Aryan Neo-classical art with degenerative Expressionist and Cubist art, or classical music with decadent and primitive jazz. And, earlier, in Yevgeny Zamyatin's dystopic *We* (1924) – the inspiration for George Orwell's *1984* – D-503, the hero and narrator, sees that a manifesto on the front page of the *State Gazette* proclaims the necessity for the operation to remove imagination from the brain.

1 Umberto Boccioni...et al, 'Manifesto of the Futurist painters' (1910) in Umbro Apollonio, *Futurist Manifestos*, Boston, Mass.: MFA Publications, 2001, p. 27

2 F.T. Marinetti...[et al.], 'The Futurist synthetic theatre' (1915), translated by R.W. Flint in Umbro Apollonio, *Futurist Manifestos*, Boston, Mass.: MFA Publications, 2001, pp. 183–96.

3 Vladimir Markov, *Russian Futurism: a History*, Washington, D.C.: New Academia Publishing, 2006, p. 45.

THE LIVRE D'ARTISTE AND THE ARTIST'S BOOK

When Daniel-Henry Kahnweiler rejected the prospective broking career of his Mannheim family and set up his gallery in a Polish tailor's shop at 28 rue Vignon, near the Madeleine in Paris, he began a revolution in the financial support of contemporary artists. Traditionally, artists had sold their work through the Salon, and their production was based on the creation and preparation of one large-scale work for this exhibition, although there was no guarantee that paintings and sculpture would be selected for the Salons. Picasso's agreement with Kahnweiler committed him for a period of three years from 2 December 1912 to 'sell nothing to anyone except you' at fixed prices on a sliding scale based on size. By creating an exclusive contract with himself (and through successful promotion of his artists by supplying photographs of their work to most early twentieth-century books and periodicals, and to a smaller circle of clients such as Hermann Rupf, Roger Dutilleul and Serge Stchoukine), Kahnweiler freed up the artist to work on his own paintings and other work, to travel and exhibit abroad, and to work with other artists and writers.

Kahnweiler's publishing of livres d'artiste under his own imprint, and then between 1920 and 1941 under that of the Éditions de la Galerie Simon, could be seen as another strategy to promote the artist. In his autobiographical interview with Francis Crémieux, *My Galleries and Painters*, Kahnweiler recalled that the works of the poets and friends of the Cubist painters, such as Guillaume Apollinaire and Max Jacob, lacked a publisher, 'so it occurred to me to publish editions illustrated by their painter friends. The admirable editions of Ambroise Vollard were all new editions of old texts, whereas I always published first editions, generally of writers who had never been published before...it gave a little exposure, and above all it encouraged other publishers to put out larger editions later.'[1]

André Derain had illustrated Apollinaire's 'L'Enchanteur pourrissant' for Kahnweiler in 1909 and was the first choice to work on a series of prints for Jacob's *Saint Matorel*, the first part of Jacob's trilogy. Kahnweiler then asked Picasso, who responded with four etchings that engage with the broken scenes and almost picaresque narrative of Jacob's prose poem, in

OPPOSITE LEFT:
Pablo Picasso, *Mademoiselle Léonie*, etching, 1910. Plate I from *Saint Matorel* by Max Jacob, Paris, 1911
V&A, London © Succession Picasso / DACS 2007

OPPOSITE RIGHT:
Pablo Picasso, *Mademoiselle Léonie dans une chaise longue*, etching, 1910. Plate III from *Saint Matorel* by Max Jacob, Paris, 1911
V&A, London © Succession Picasso / DACS 2007

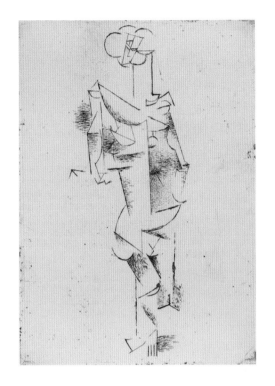 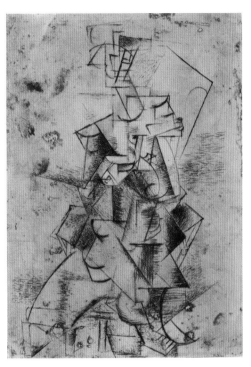

a sympathetic but non-literal way. The plates were etched in July–August 1910, when he and Fernande Olivier were on holiday in the Catalan village of Cadaqués with Derain and his wife; *Mademoiselle Léonie*, representing Victor Matorel's young mistress (in which Picasso experiments with a new form of shading with clusters of short parallel notations); *La Table*, a table still life in a village inn, where Matorel and Cordier meet the traveller Millancourt; *Mademoiselle Léonie dans une chaise longue*, a revolutionary treatment that dissolves the figure, contour and light sources as well as leaving untreated significant areas of the etching plate; and *Le Couvent*, the site of the debate about conversion. The book was printed by Delâtre and published in an edition of 106 on 11 February 1911. Picasso's etchings for this book are one of the landmarks of analytical Cubism.

The deluxe publications of Vollard and Kahnweiler aimed at an exclusive audience of collectors and bibliophiles. They emphasized high book production values – Arches, Holland Van Gelder, Masure et Perrigot, Montval, Rives, Shidzuoka Japan and Vidalon paper, and specially designed typographic ornaments. They often required multiple runs through presses to accommodate lithographic, etching and letterpress processes. It has been argued that the Russian Futurists found them anathema, although it is unclear how they would have seen them. Without doubt the Russian Futurist books were at the other end of the spectrum. The Futurists published myriad cheaply produced but ground-breaking artist's books; they used wallpaper (which led to problematic accumulations of chalk on the plates), newsprint, gingerbread (Aleksei Chicerin's *Aveki vekov* of 1924), different weights and types of paper within the same book, sackcloth, stencil, offset lithography, hectography and collage. It was likely that they were reacting just as much against the Russian art nouveau and Symbolist publications, such as the fine printing and elaborate covers of *Mir iskusstva* (World of Art) 1898–1904, *Vesy* (The Scales) 1904–09, *Zolotoe runo* (The Golden Fleece) 1906–09, *Apollon* 1909–17, or Nikolai Kulbin's *Studiya impressionistov* (Impressionists' Studio), first published in February 1910. Russian Futurist books were intended to be cheap, often 30–70 kopecks – *Pomada* cost 30 kopecks and *Worldbackwards* 70 – compared to a 1913 copy of *Apollon*, which cost 1 rouble 75 kopecks, and up to fifty times less expensive than collectors' editions.[2] They were obviously intended for a different audience – other artists, writers and students. In 1913 Olga Rozanova reported to her sister that the books she had illustrated for Aleksei Kruchenykh were selling very well, but this was not always the case. *Sadok sudei* (A Trap for Judges), printed on wallpaper, was published in St Petersburg. It included

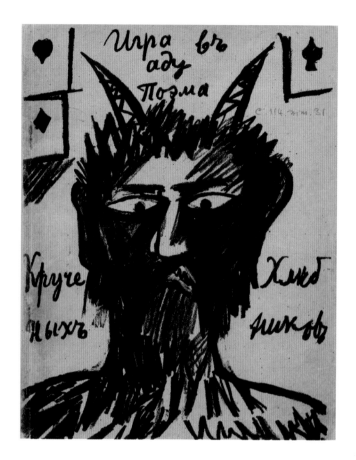

Aleksei Kruchenykh and
Velimir Khlebnikov,
A Game in Hell (Igda v adu),
1912

(BL Cup.406.g.2)

poetry by David and Nikolai Burliuk, Elena Guro, Vasily Kamensky and
Velimir Khlebnikov, and was illustrated with portraits of most of the poets
by Vladimir Burliuk. It was registered in the Russian weekly bibliography
Knizhnaya letopis, for 11–18 May 1910 in an edition of 300 copies, although
other sources suggested 480. According to Vladimir Markov, however, the
printer's bill was unpaid, and only the twenty copies removed by Kamen-
sky survived.[3]

Between 1912 and 1913 Kruchenykh produced six Futurist books,
which can be said to be revolutionary in the development of the artist's
book and are in strong contrast to the livres d'artiste of Kahnweiler and
Vollard. They were sponsored by Sergei Dolinsky and Georgy Kuzmin, a
poet and aviator respectively. It was not as if these were expensive produc-
tions: Kruchenykh copied *A Game in Hell* and *Old-fashioned Love* in litho-
graphic pencil: 'Natalia Goncharova and Mikhail Larionov's drawings

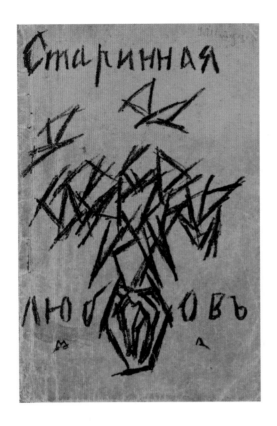

were a friendly gratis favor. We were forced to scour Moscow for the three-rouble down payment to the printer.'[4] These poems (reinforced by the illustrations by Larionov and Goncharova, although occasionally they supplied abstract compositions) aimed at a kind of Primitivism. This was reinforced by the appearance of the books, which were handwritten and then lithographed or mimeographed – sometimes with hand-stamped letters, deliberately inconsistent letter sizes and omission of normal punctuation. The artists were completely unabashed about errors.

Old-fashioned Love and A Game in Hell, both in an edition of 300 copies, appeared in Knizhnaya letopis 15–22 October 1912. Starinnaya lyubov (Old-fashioned Love) is illustrated by Larionov, with a vase of flowers drawn in an abstract way. There are seven poems, subverting romantic lyrics with dissonance or such words as 'vomit'. Igda v adu (A Game in Hell) was Larionov's first collaboration with the poet Khlebnikov. Goncharova provided sixteen illustrations that add to its lubok (folk lithograph) allusions. Mirskontsa (Worldbackwards) was illustrated by Goncharova, Larionov, I. Rogovin and

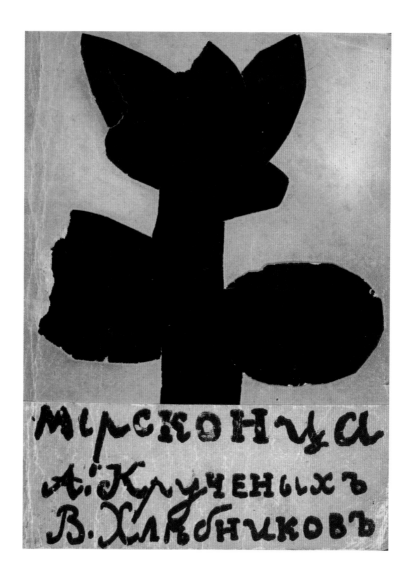

Aleksei Kruchenykh and
Velimir Khlebnikov,
Worldbackwards
(*Mirskontsa*), 1912
(BL C.114.mm.42)

Vladimir Tatlin, and in its very title Kruchenykh signalled his intention to experiment. The paper is mixed in colour and weight. The cover consists of a variant foil collage by Goncharova. Rubber-stamps are used as well as lithography. There are blank pages. Some text can be read only by manipulating the direction of the book. Words and images interact, and there are the usual mistakes and misalignments. In February 1913 three more books followed in a larger edition of 480 copies. *Poluzhivoi* (*Half-alive*) is a Primitivist treatment of war. The erotic and anti-clerical *Pustynniki* (*Hermits*) has

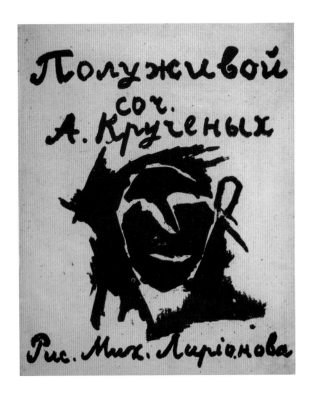

Aleksei Kruchenykh,
Half-alive (Poluzhivoi), 1913
(BL, C.114.mm.44)

Goncharova illustrations so separate from the text that the book requires physical manipulation to see some of the images, which are 90 degrees to the text. *Pomada* was illustrated by Larionov in both his Primitivist and Rayonist manners; unusually, twenty-five of the edition were hand-coloured by the artist. The first three poems introduced *zaum* poetry or, as Kruchenykh described it, 'in my own language differing from others: its words do not have a definite meaning'. The first one, beginning 'dyr bul shchyl', gained typical Futurist notoriety when Kruchenykh claimed it was more Russian than Pushkin.

In between the livre d'artiste of a Vollard or Kahnweiler and the inexpensive Russian Futurist book of Kruchenykh, there was an interesting middle ground. Again Russian artists were key influences. In *Mirskontsa* (*Worldbackwards*), Kruchenykh had written a 'voyage across the whole world' without punctuation or capital letters, in anticipation almost of automatic writing and contemporaneous with Apollinaire's *Zone*. Blaise Cendrars' free-verse poem, entitled with a significant first noun, *La Prose du Transsibérien et de la Petite Jehanne de France*, begun in January 1913, was

OPPOSITE:

Aleksei Kruchenykh,
Pomada, 1913
(BL C.114.mm.40)

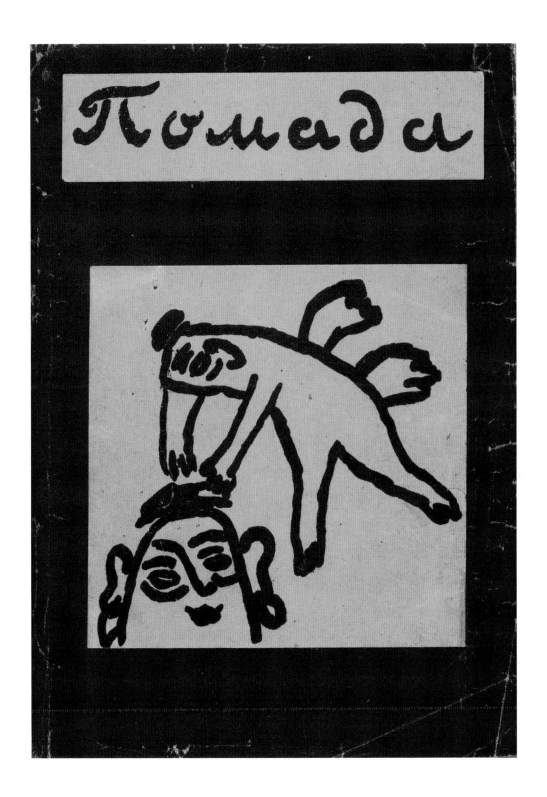

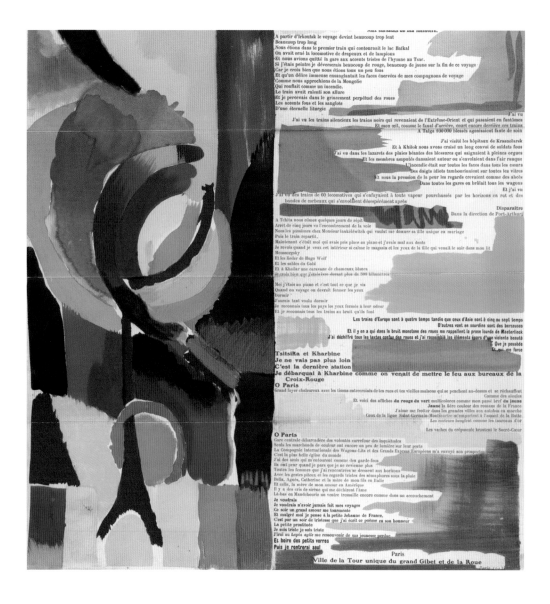

Les traces de la mémoire.

A partir d'Irkoutsk le voyage devint beaucoup trop lent
Beaucoup trop long
Nous étions dans le premier train qui contournait le lac Baïkal
On avait orné la locomotive de drapeaux et de lampions
Et nous avions quitté la gare aux accents tristes de l'hymne au Tsar.
Si j'étais peintre je déverserais beaucoup de rouge, beaucoup de jaune sur la fin de ce voyage
Car je crois bien que nous étions tous un peu fous
Et qu'un délire immense ensanglantait les faces énervées de mes compagnons de voyage
Comme nous approchions de la Mongolie
Qui ronflait comme un incendie.
Le train avait ralenti son allure
Et je percevais dans le grincement perpétuel des roues
Les accents fous et les sanglots
D'une éternelle liturgie

J'ai vu
J'ai vu les trains silencieux les trains noirs qui revenaient de l'Extrême-Orient et qui passaient en fantômes
Et mon œil, comme le fanal d'arrière, court encore derrière ces trains
A Talga 100 000 blessés agonisaient faute de soin
J'ai visité les hôpitaux de Krasnoïarsk
Et à Khilok nous avons croisé un long convoi de soldats fous
J'ai vu dans les lazarets des plaies béantes des blessures qui saignaient à pleines orgues
Et les membres amputés dansaient autour ou s'envolaient dans l'air rauque
L'incendie était sur toutes les faces dans tous les cœurs
Des doigts idiots tambourinaient sur toutes les vitres
Et sous la pression de la peur les regards crevaient comme des abcès
Dans toutes les gares on brûlait tous les wagons
Et j'ai vu
J'ai vu des trains de 60 locomotives qui s'enfuyaient à toute vapeur pourchassés par les horizons en rut et des
bandes de corbeaux qui s'envolaient désespérément après

Disparaître
Dans la direction de Port-Arthur

A Tchita nous eûmes quelques jours de répit
Arrêt de cinq jours vu l'encombrement de la voie
Nous le passâmes chez Monsieur Iankéléwitch qui voulait me donner sa fille unique en mariage
Puis le train repartit.
Maintenant c'était moi qui avais pris place au piano et j'avais mal aux dents
Je revois quand je veux cet intérieur si calme ce magasin et les yeux de la fille qui venait le soir dans mon lit
Moussorgsky
Et les lieder de Hugo Wolf
Et les sables du Gobi
Et à Khaïlar une caravane de chameaux blancs
Je crois bien que j'étais ivre durant plus de 500 kilomètres

Mais j'étais au piano et c'est tout ce que je vis
Quand on voyage on devrait fermer les yeux
Dormir
J'aurais tant voulu dormir
Je reconnais tous les pays les yeux fermés à leur odeur
Et je reconnais tous les trains au bruit qu'ils font

Les trains d'Europe sont à quatre temps tandis que ceux d'Asie sont à cinq ou sept temps
D'autres vont en sourdine sont des berceuses
Et il y en a qui dans le bruit monotone des roues me rappellent la prose lourde de Maeterlinck
J'ai déchiffré tous les textes confus des roues et j'ai rassemblé les éléments épars d'une violente beauté
Que je possède
Et qui me force

Tsitsika et Kharbine
Je ne vais pas plus loin
C'est la dernière station
Je débarquai à Kharbine comme on venait de mettre le feu aux bureaux de la
Croix-Rouge
O Paris
Grand foyer chaleureux avec les tisons entrecroisés de tes rues et tes vieilles maisons qui se penchent au-dessus et se réchauffent
Comme des aïeules
Et voici des affiches du rouge du vert multicolores comme mon passé bref du jaune
Jaune la fière couleur des romans de la France
J'aime me frotter dans les grandes villes aux autobus en marche
Ceux de la ligne Saint-Germain-Montmartre m'emportent à l'assaut de la Butte
Les moteurs beuglent comme les taureaux d'or
Les vaches du crépuscule broutent le Sacré-Cœur

O Paris
Gare centrale débarcadère des volontés carrefour des inquiétudes
Seuls les marchands de couleur ont encore un peu de lumière sur leur porte
La Compagnie internationale des Wagons-Lits et des Grands Express Européens m'a envoyé son prospectus
C'est la plus belle église du monde
J'ai des amis qui m'entourent comme des garde-fous
Ils ont peur quand je pars que je ne revienne plus
Toutes les femmes que j'ai rencontrées se dressent aux horizons
Avec les gestes piteux et les regards tristes des sémaphores sous la pluie
Bella, Agnès, Catherine et la mère de mon fils en Italie
Et celle, la mère de mon amour en Amérique
Il y a des cris de sirène qui me déchirent l'âme
Là-bas en Mandchourie un ventre tressaille encore comme dans un accouchement
Je voudrais
Je voudrais n'avoir jamais fait mes voyages
Ce soir un grand amour me tourmente
Et malgré moi je pense à la petite Jehanne de France.
C'est par un soir de tristesse que j'ai écrit ce poème en son honneur
La petite prostituée
Je suis triste je suis triste
J'irai au Lapin agile me ressouvenir de ma jeunesse perdue
Et boire des petits verres
Puis je rentrerai seul

Paris
Ville de la Tour unique du grand Gibet et de la Roue

published in October by Éditions des Hommes Nouveaux, 4 Rue de Savoie, 4 Paris, a press that Cendrars had set up with a friend with a 3,000-franc legacy. The book has some characteristics of the livre d'artiste – it was in a limited and numbered edition of 150, with copies 1–8 on vellum, 9–36 on Japanese Imperial and 37–150 on Simili-Japon. The first two sub-sets of the edition were bound in kid with the remainder in vellum. The cost was 500, 100 and 50 francs respectively. Cendrars claimed fancifully

Blaise Cendrars and
Sonia Delaunay,
La Prose du Transsibérien,
1913
(BL, new acquisition)
L&M Services BV,
The Hague, 20070812
Copyright © Miriam
Cendrars

that 'the edition should reach the height of the Eiffel Tower' if fully extended.

However, this was also an artist's book, with Sonia Delaunay – who had been brought up in St Petersburg – providing 'couleurs simultanées', the visual treatment and the text reinforcing each other, so that one would be seriously impoverished without the other. For Robert Delaunay in a 1913 note on simultaneism in contemporary modern art, painting and poetry, literary simultaneism was achieved through contrasts of words, whilst visuality is achieved through colours in simultaneous contrast. Cendrars' poem recounts his journey on the 'Transsibérien', the railway that ran from St Petersburg/Moscow to Nikolskoye on the Sea of Japan, completed in 1905. The journey was abandoned at Harbin. The Futurist obsessions with speed, travel and war are present with the poet's juxtaposition of immediacy and memories, a collage of proper names. His companion, the Montmartre prostitute Jehanne, repeatedly asks: 'Blaise, dis, sommes-nous bien loin de Montmartre?' (Are we at Montmartre yet, Blaise?) The poem is also a paean to Paris in both its presence and absence; the city is apostrophized as the 'grand foyer chaleureux avec les tisons entrecroisés de tes rues' (big glowing fire intersected by your incandescent streets), with its posters, speeding buses and hardware stores.

Sonia Delaunay's visual contribution to her friend's poem has the immediacy and simultaneous impact of a poster. Like a poster it is a vertical 'leperello' (usually a horizontal format), with one vertical fold and then an accordion fold of twenty sections. Open, it extends to about 2 metres, closed it is 36cm.

There is a Michelin map of the railway route at the top left, balancing the title information. Delaunay's 'pochoir' painting scrolls down the left-hand side, culminating in a simple Eiffel Tower and Ferris wheel. The text occupies the right-hand side of the sheet; it is in twelve different typefaces and colours; there are additional coloured shapes filling in the space generated by the unevenness of the free-verse lines. The only precedent is Giovanni Battista Piranesi's *Veduta del prospetto principale della Colonna Trajana*, published in *Trofeo o sia magnifica* (Rome, 1774–79); this is 297 x 53cm in six joined sheets of paper, but has text on both sides of the column. It is uncertain whether Delaunay or Cendrars was aware of this earlier innovative use of the book.

Although only sixty-two were ever 'finished' (i.e. assembled and bound), *La Prose du Transsibérien* was a book that greatly influenced other artists. It was exhibited in November 1913 in Berlin, which was reported

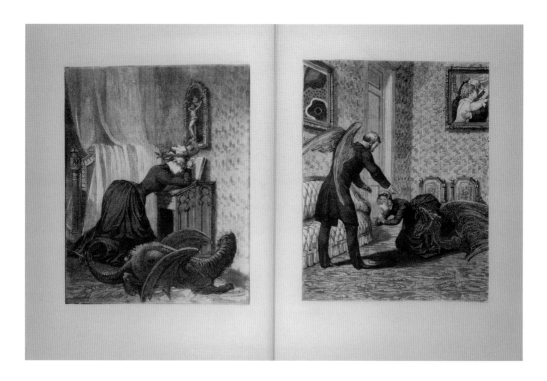

in *Der Sturm*, and in December at the Stray Dog Cabaret, St Petersburg, as part of Alexandr A. Smirnov's lecture on the theories of simultaneism of Sonia Delaunay's husband, Robert, reported in *Apollon* for January–February 1914.

Twenty-one years later, the Surrealist Max Ernst published *Une Semaine de bonté, ou les sept éléments capitaux, roman* (1934). This again occupies the territory between livre d'artiste and artist's book. Published by the Galerie Jeanne Bucher, Paris, in a limited edition of 812 copies, it was presented unusually in chapters: 'Dimanche' (dated 15 April), 'Lundi' (dated 16 April), 'Mardi' and 'Mercredi' (dated 2 July) and the last three together 'Vendredi', 'Jeudi' and 'Samedi' (dated 1 December). It was produced through a photo-mechanical process known as *clichés traits*, an etching procedure with the effects of wood engraving. This helps to give a seamless continuity to the chapters and book, reinforced by the absence of text except for the title page. André Breton recalled his first encounter in 1920 with Ernst's collages in Francis Picabia's house, when they arrived for Ernst's first Paris exhibition at Au Sans Pareil, and their Surrealist potential: 'The external object had broken with its normal environment, and its component parts had,

Max Ernst,
Une Semaine de bonté, Vol. 3
(1934)
(BL X.415/2117)

Max Ernst,
Une Semaine de bonté, 1934

(BL X.415/2117)

so to speak, emancipated themselves from it in such a way that they were now able to maintain entirely new relationships with other elements, escaping from the principle of reality but retaining all their importance on that plane.'[5]

Many of the images in *Une Semaine de bonté* derive from illustrated magazines, catalogues (e.g. *Catalogue de grand magasin du Louvre* and the *Magasin des nouveautés*) and Jean-Martin Charcot's study of hysterics, *Iconographie de la Salpêtrière*. In one move, Ernst had reinscribed his book onto previous books, and disturbed the equilibrium of the bourgeois interior domain, supposedly a refuge from capitalism and industrial mechanization; the book itself with its covers, analogous with doors, and its tactic of immersing the reader in another world of narrative, is another device of interior escape – this too Ernst subverts. In a sense this is a book to end all books. It is ironic that this is one of the predecessors of today's graphic novel.

1 Daniel-Henry Kahnweiler and Francis Crémieux, *My Galleries and Painters*, London: Thames & Hudson, 1971, pp. 48–49.
2 Nina Gurianova, 'A game in hell, hard work in heaven: deconstructing the canon in Russian Futurist books', in Margit Rowell and Deborah Wye, *The Russian Avant-Garde Book 1910–1934*, New York: Museum of Modern Art, 2002, pp. 24–32.
3 Vladimir Markov, *Russian Futurism: a History*, Washington, D.C.: New Academia Publishing, 2006, p. 22 and n. 55, 390, quoting 'Doxlaja luna' describing *Sadok sudei* as 'sold out'.
4 Gurianova (2002), p. 32, n. 7.
5 André Breton, 'Artistic genius and perspective of Surrealism' (1941), reprinted in *Surrealism and Painting*, New York: Harper and Row, 1972, p. 64.

THE AVANT GARDE AND THE LITTLE MAGAZINE

The little magazine – a magazine not intending or achieving mass circulation – was not a unique phenomenon of the avant garde from 1900 to 1937. Magazines like *The Yellow Book* in London and *La Plume* in Paris had promoted advanced art and literature practice at the end of the nineteenth century. What characterized European avant-garde magazines was their status as a preferred forum for avant-garde debate, their number (however short lived) and their internationalism in terms of the interchange of texts, translated (or not), approved by their authors (or not), and their promotion of other 'like-minded' magazines. The March 1920 issue of *Dada* or *Dadaphone*, edited by Tristan Tzara, advertised Francis Picabia's *Cannibale*,

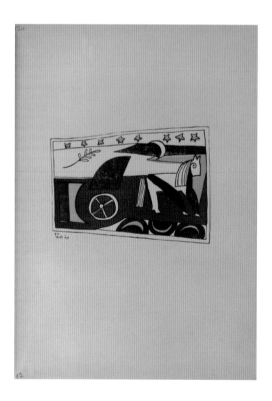

LEFT:
First Journal of Russian Futurists (Pervyi zhurnal russkikh futuristov), No.1-2 (1914)

Lithograph by Vladimir Burliuk

(BL C.102.k.28)

OPPOSITE:
My journal – Vasily Kamensky (Moi zhurnal – Vasilliia Kamenskogo), No.1 (February 1922)

Kamensky's journal was published in Moscow in an edition of 3000 copies. Only one issue was produced.

(BL R.F.2004.b.35)

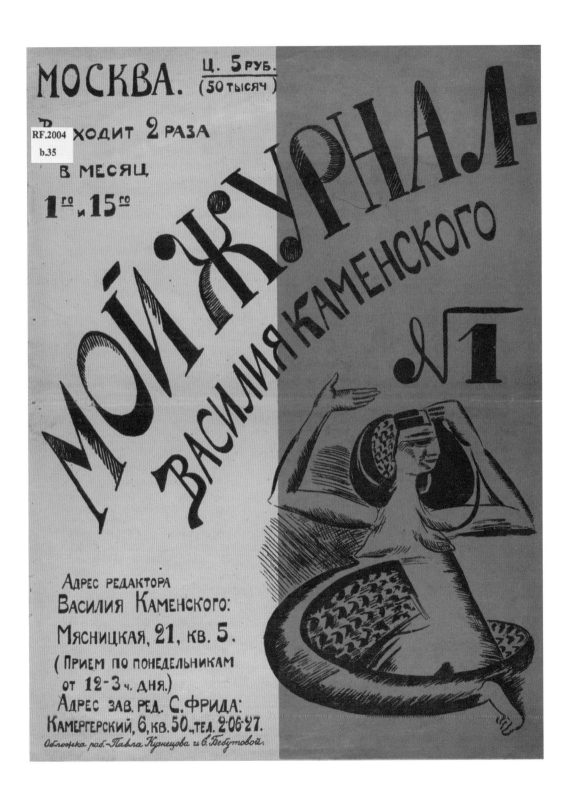

МОСКВА. Ц. 5 РУБ.
(50 ТЫСЯЧ)

RF.2004
b.35

ХОДИТ 2 РАЗА
В МЕСЯЦ
1ГО и 15ГО

МОЙ ЖУРНАЛ-
ВАСИЛИЯ КАМЕНСКОГО
№ 1

АДРЕС РЕДАКТОРА
ВАСИЛИЯ КАМЕНСКОГО:
МЯСНИЦКАЯ, 21, КВ. 5.
(ПРИЕМ ПО ПОНЕДЕЛЬНИКАМ
ОТ 12-3 Ч. ДНЯ.)
АДРЕС ЗАВ. РЕД. С. ФРИДА:
КАМЕРГЕРСКИЙ, 6, КВ. 50., ТЕЛ. 2-06-27.
Обложка раб.-Павла Кузнецова и В. Бебутовой.

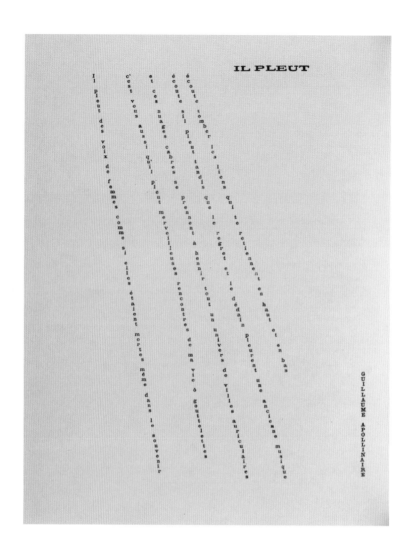

IL PLEUT

GUILLAUME APOLLINAIRE

Sic, No.12
(December 1916),
'Il Pleut' by Guillaume
Apollinaire

Apollinaire's choice of
rain as the subject of this
calligramme may refer to
the poet Gustave Kahn's
volume of free verse *La
Pluie et le beau temps* (1896):
Kahn had argued that
poetry should not be picto-
rial, and that paintings
should not include words.

(BL P.903/188, 1973)

Paul Éluard's *Proverbe*, Pierre Albert-Birot's *Sic* and Pierre Reverdy's *Nord-
Sud*. The back cover for volume 8 no. 1 (1922) of *Ma: internacionális aktivista
müvészeti folyóirat*, the Hungarian-language magazine then published in
Vienna by Lajos Kassák has a grid of thirteen other magazines – *De Styl*
(Weimar), *2 x 2* (Vienna), *Ça Ira* (Brussels), *Ut* (Novisad), *Der Sturm* (Berlin),
L'Ésprit nouveau (Paris), *Broom* (Berlin), *Mécano* (Weimar), *La Vie des lettres et
des arts* (Paris), *Der Gegner* (Berlin), *Die Aktion* (Berlin), *Clarté* (Paris) and *Zenit*
(Zagreb). The first issue of the Dada-Constructivist *G (Gestaltung)*,
(1923–26), edited by Hans Richter, advertised *De Stijl*, *Ma*, *Mécano* and *Merz*,
and by the third number had added *Contimporanul* (Bucharest), *Devĕtsil* and

OPPOSITE:
Merz 1: Holland Dada,
January 1923
(BL R.F.2006.b.103)

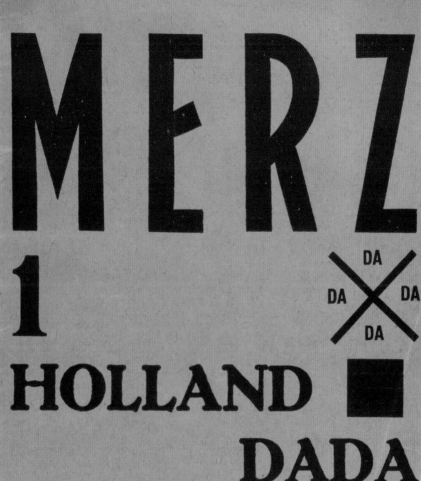

Inhalt: DADA IN HOLLAND. KOK: GEDICHT. BONSET: GEDICHT; AAN ANNA BLOEME.
PICABIA: ZEICHNUNG. HANNAH HÖCH: ZEICHNUNG; WEISSLACKIERTE TÜTE

MERZ

1

DA
DA DA
DA

HOLLAND

DADA

JANUAR 1923
HERAUSGEBER: KURT SCHWITTERS
HANNOVER · WALDHAUSENSTRASSE 5"

Disk (Prague) and *Zwrotnika* (Cracow). Richter's G magazine film issue of April 1926 spread its publicity worldwide: *De Stijl*, *Der Sturm*, *Martin Fiero* (Buenos Aires; listed twice), *Mavo* (Tokyo), *Little Review* (New York), *Neues Russland* (Berlin), *La Vie des lettres et des arts*, *Zenit/h* (Belgrade), *Pasmo* (Brno), *Manometre* (Lyons), *Contimporanul* (Bucharest), *Les Arts plastiques* and *A.B.C.* (Basle), *L'Effort moderne*, *Zwrotnika* (Cracow), *Stavba* (Prague), *Ma* (Vienna), *Het Overzicht* (Antwerp) and *Artwork* (London).

Most little magazines after the first or second issues began to give foreign subscription rates. In its fourth issue *abstraction creation art non-figuratif*, printed in lower case and published in Paris 1932–36 by Éditions les tendances nouvelles at 3 bis, Rue Émile-Allez, Paris 17, gave a breakdown of its international distribution or rather membership; there were 209 subscribers in Paris (concentrated in the 14th and 15th arrondissements – the 11th had none), 43 in the rest of France, 68 in Switzerland, 12 in Holland, 11 each in Germany and Great Britain, 7 each in Poland and Italy, 3 in Belgium, 2 each in Spain, Czechoslovakia and Sweden, and 1 in Hungary.

This breakdown allows us to determine the circulation figure for this journal as 416, raising 7,060 francs. Figures for other little magazines are less clear. Walther Mehring claimed to be responsible for the unusual distribution method used for *Jedermann sein eigner Fussball* (*Everyman his own Football*), dated 15 February 1919, costing 30 pfennigs, and with its pioneering Heartfield cover photomontage of the Weimar government led by Friedrich Ebert (*Wer ist der Schönste? Who is the prettiest?*):

> 'We hired a char-a-banc...and also a little band, complete with frock coats and top hats, who used to play at ex-servicemen's funerals. We, the editorial staff, paced behind, six strong, bearing bundles of *Jedermann sein eigner Fussball* instead of wreaths. In the sophisticated west end of the city we earned more taunts than pennies, but our sales mounted sharply as we entered the lower-middle class and working-class districts of north and east Berlin....'[1]

Jedermann was published by Malik Verlag, which had been founded by Wieland Herzfelde and his brother John (Heartfield) in an edition of 7,600 copies, with 100 in a limited edition and the first 20 signed and numbered. This combined the ambition of a newspaper with the niche marketing of a livre d'artiste. However, it was suppressed immediately and remaining copies destroyed. Alfred Stieglitz's *291*, March 1915–February 1916, was

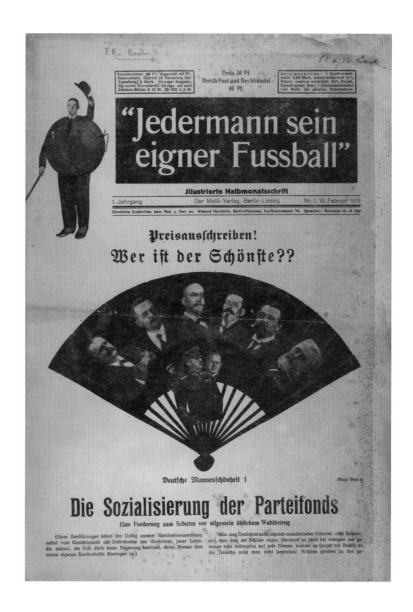

Jedermann sein eigner Fussball,
No.1 (15 February 1919)

(BL P.P.4736.hmd)

issued in New York as a regular edition of a thousand, with a hundred deluxe copies – on vellum. It sold just eight deluxe and a hundred of the regular edition. The remainder were sold off as a job lot for $5.80.[2]

Stieglitz's *291* had been inspired by Guillaume Apollinaire's *Les Soirées de Paris*. This was an unfortunate financial precedent. *Soirées* had been set up in 1912 by Apollinaire's friends André Billy, André Salmon, Réné Dalize and André Tudesq in order to raise the spirits and financial fortunes of

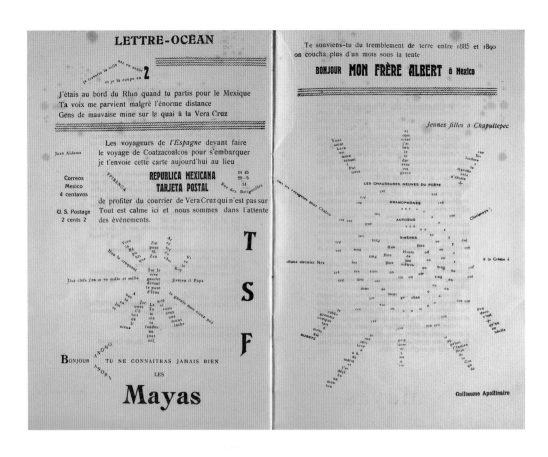

Guillaume Apollinaire,
'Lettre-océan', *Les soirées de
Paris*, No.25 (15 June 1914)

Apollinaire after his arrest in the aftermath of the theft of the *Mona Lisa* from
the Louvre on 21 August 1911. Using the same format as the *Mercure de
France*, with a chocolate-brown cover and mustard-coloured paper, produc-
tion costs were kept low; the five editors contributed 20 francs a month
towards these. By no. 12/13 Billy had become the sole editor and was
bearing the whole burden of costs. He was thus very willing to sell the
enterprise for 200 francs, although its debts were around 1,200 francs,
suggesting production costs were around 200 francs per issue. The new
buyers were friends of Apollinaire: Serge Férat and his associate, the
Baronne d'Oettingen, the widow of a Baltic nobleman, who wrote for the
magazine too under the pseudonym Roch Grey. They used the joint name
of Jean Cérusse for their associate editorship – the name no doubt playing
on 'C'est russe' – it's Russian. It could now afford illustrations, and the
first of the new series, no. 18 (15 November), included a series of five
photographs of still lifes by Picasso.

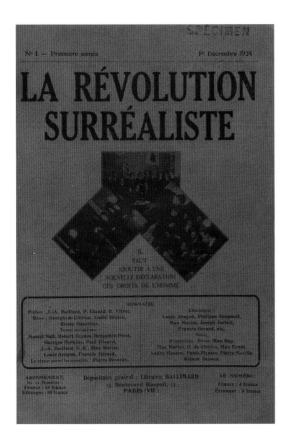

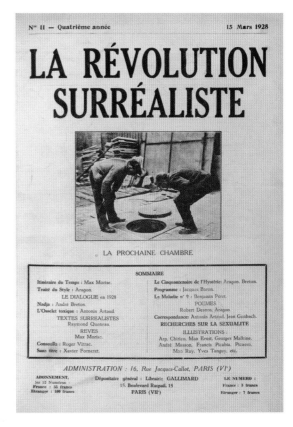

La Révolution surréaliste,
No.1 (1 December 1924),
No.11 (15 March 1928)

(BL, new acquisition)

A similar trajectory awaited *La Révolution surréaliste, Le Surréalisme au service de la révolution* and *Minotaure*. The founding of *La Révolution surréaliste* and its first appearance in December 1924 built on the momentum of André Breton's first manifesto of Surrealism (and 'Poisson soluble') which had appeared earlier that year. To follow through the scientific ambitions of Surrealism, not least its Bureau of Surrealist Research, Pierre Naville – the director with Benjamin Péret of its first three numbers – suggested that they adopt the two-columned austerity of *La Nature*, the main popular scientific journal of its day in France. It was priced at 4 francs per issue, with foreign subscriptions at 55 francs. After the Antonin Artaud-influenced assault on religion, madhouses and universities in the third issue, Breton assumed direction and the magazine began to promote a communist line (Breton had joined the party in 1927). By the publication of his second manifesto in no. 12 (15 December 1929) and the anathema he pronounced against his rivals, including Georges Bataille, *La Révolution surréaliste* had

THE AVANT GARDE AND THE LITTLE MAGAZINE

LA VIE

(ŽIVOT)

L'ART NOUVEAU – CONSTRUCTION
ACTIVITÉ INTELLECTUELLE
CONTEMPORAINE

DIRECTEUR
J. KREJCAR

PUBLIÉ PAR UMĚLECKÁ BESEDA (UNION D'ARTISTES)
[SECTION DES ARTS PLASTIQUES]
PRAGUE, TCHÉCO-SLOVAQUIE, 1922

ŽIVOT

NOVÉ UMĚNÍ – KONSTRUKCE
SOUDOBÁ INTELEKTUELNÍ
AKTIVITA

REDAKTOR
J. KREJCAR

VYDAL VÝTVARNÝ ODBOR UMĚLECKÉ BESEDY
PRAHA 1922.

REKLAMA

ŠÍMA

První, co vybaví se v mysli při slově „reklama" jest plakát, oznámení, afiš, a hned otázka: Má býti plakát uměním, má býti obrazem? Reklama nemůže jen plakát, nemůže se tedy obejíti bez malířství. Reklama zmocňuje se stejně prvků malířských jako sochařských, stejně fotografie, grafu a světla jako zvuku. Ale jakým způsobem? Proč? Reklama má jediný účel, jehož si je vždy vědoma a tento účel jedině a jediné, neustále reklamovati určitý způsobem měnícím se danými okolnostmi. Nápadnosti, upoutání — jest disproporcela, v nejkrásim smyslu tohoto slova, opakující se — jest zveličení.

Mnohdy jest to vyhledati jediného slova, které vyzvětluje anebo naopak, které nezliká. Na příklad. V pařížských předměstích celé štíty několikapatrových domů jsou popsány obrovskými písmenami slova „Dunlop". Jediné ohromné slovo „Dunlop" na štítu třípatrového domu. Dunlop se opakuje stokrát, tisíckrát, v ulicích vnitřního města rovněž, aniž by řeklo více než záhadu svého významu. Konečně v některé ulici spatříte krám s nápisem Dunlop a ve výkladních skříních pyramidy pneumatik od největší k nejmenší. Dunlop jsou pneumatiky. Drobně tištěné prospekty a ceníky vám dodatečně málo co vyvětlí. Dunlop však svojí záhadou a opakováním se stalo nezapomenutelným.

REKLAMU není možno pojímati malířsky ani jakkoli jinak: Reklamní předmět krásný ve smyslu uměleckém jest špatným ve smyslu reklamy. Účelem reklamy není ukázati kvality moderního malířství a sochařství nebo fotografie. Veškeré dosavadní umělecké plakáty, stravilvé produkty umělecko-průmyslových škol (co jest to umělecký průmysl?) jsou špatné se stanoviska reklamy. Plakát musí býti vždy reklamou a nikoli obrazem, ani dekorací. Styčným bodem jest jediné ona okolnost, že plakát jest právě tak barevnou skvrnou jako obraz. Krása reklamy záleží jediné v dokonalém dosažení jejího účelu.

REKLAMA právě tak jako kinematograf dotýká se hluboce života dnešní doby. Doba v nich snad nachází lépe svého výrazu nežli v umění, nalézajícím se v bolestném obrození. Reklama, nezatížena tradicí, jest fenoménem doby a tak jako kinematograf tvoří žádostí davu; prostá a srozumitelná jest. Resonuje veškeré chtění, jest měřitelnou dle okolnosti a prostředí a přece tak přesně vymezena, že zůstává vždy tak reálná a s největší možností. Reklama i kinematograf všechnu šíři umění starých; srozumitelná a s největší možnosti delikátnosti.

REKLAMA připustí nejbanalnější tvary předmětů. Pro víno jest nejprostší lahvi, jakou si lze představiti a tato láhev s ohromným nápisem, jména vína, nebo likéru stává se typem lahví všech „pathetická mluva reklamy jest přesně vyjádřená, má svá pravidla, proporce jiné nežli výtvarné umění. Má rámec, za kterým umí nikdy vyboočiti pod optickou prostředí. Disponuje bohatší, uchvacuje umělým pathosem. Reklama, toť dav. Cirkus Medrano, boulevard de Clichy, place Pigalle, plné cirkusovými plakáty fvou Chochem našeho věku. Kolik již dalo touto impresionistům, velikému Seuratu? Plakáty de Toulouse Lautreca moderního vznikounul. Sarah Bernhard byla masse šťastnou s Alfonsem Muchou.

V REKLAMĚ a kinematografu nalézá se odevzdaný dává charakter novému věku, jeho trvání v dosavadní formě, nemůže býti ostatní nazváno než paumění. Avšak uvažme, jestliže toto paumění dosáhlo intimně života, zdaž nestojí alespoň dočasně výše než ono opravdové umění, tyjící z tradice, nemohoucí se osvoboditi od klasického materiálu: kamene, dřeva, plátna, ideálně vodové barvy, dnes, kdy stal se honí materiálem beton a železo, skvostné zpracované kovů skvělých vlastností, barviva chemických tónů a seobyčejné resistence pro nátěry obrovských ploch?

REKLAMA, jak jsem již na počátku zdelidal, nemá nic společného s uměním trvajícím. Poměr jest asi týž jako mezi socharstvím a architekturou. Nikdo nemůže upříti obrovská přístavní oblini síla nevýznoská, nebo obrovité údolní přehrady severoamerických řek architekturou ve smyslu architektury jako umění. Jest však jisto, že moderní architektura nesmí býti po technické stránce méně nežli kterékoli dílo moderního inženýra. Kopule petrského chrámu v Římě byla ve svě době konstruktivním unikem. Ač ne stanovena matematicky, jest postavena přesné s desateronásobnou jistotou. Mistr za Farmanově továrně konstruuje bez výpočtů a paternonásobnou jistotou trup aeroplánu. Proč by moderní architektura měla opomijet tyto možnosti? Malíř afichi vi zcela přesné, co jest to barva, linie a prostor, třebaže by nebyl s to, aby psal theorie malby na zeď. Často seskupuje předměty a litery na jedné obrazové ploše a bez pomoci perspektivy a optického zobrazení věcí odstupňuje do prostoru. Affiche, malované řemeslníkem na zdi, nabývají barevnou redukcí tři, čtyři tóny a linearní charakteristikou neobyčejné monumentality.

PRO REKLAMU jest významné prostorové řešení. Sáhnuto prosté k tomu, k čemu došlo vždy malířství. Než, v tom jest plus, reklama se zde nezastavila. Aniž bylo valné přemýšleno o vybudování theorií, zcela logicky a instinktivně sáhnuto bylo k prostředkům, před kterými umění rozpačitě zůstalo stát: k pohybu a světlu. Pohyb dochází svého moderního uměleckého výrazu v kinematografu; pravím pohyb úkoli gesto. Ale to je kapitola, která sem nepatři. Světlo však, světlo. Tohoto prvku zmocnila se reklama úplně. Jest něco, co může být nazváno otcem světelné reklamy a to jest odstřený, za bezvýznamný pokládaný a tak krásný ohňostroj. Ohňostroj, používaje světla jako výtvarného prvku, jest velmi blízkým reklamě svoji okázalosti. Má fascinující moc a to jest, co nesmí nikdy scházíeti reklamní zácházka, a jakou bývá zkracován a prostor, může býti tím větší užitou ve na černé ploše domu obrovsky zdůřejnocti, dojdoucí kapesní hodinky, každou dobou jinou barvou svítíci, prodloužiti prospekt ulice. Modrá, karmasinová, oranžová a bílá barva světel, postupné oddalují a přibližují plakou sil. huetu chronometru různé intenzitou své svítivosti. Nízko letící mrak, různobarevně osvětlovaný reflektory ze střechy magazinu, jehož jest reklamou, řídavě zapíná ze zárovek sesazené jméno z spodu nosné budovy. Kolik zde oživeno sugestivních tvarů vhodných pro divadelní scénu?

REKLAMA dotýkajíc se prostředků, k nimž doba dává, jest měnitelna a trvalý v míře kontaktu se životem. Ustrnutí znamenalo by konec a bezúčelnost, kde zúčelno všem. Vývoj její jest nedohledný, jako vývoj lidské společnosti.

PAŘÍŽ, 30. září 1922.

Ať žije život! Neboť co jiného mělo by žíti dnes nade všemi pokáceným modlami minulých věků, po všech bludech, které se stavěly mezi člověka a život?

S. K. NEUMANN.

been replaced by *Le Surréalisme au service de la révolution* (1930–33) – but the sales were only 350 copies, about a third of the final issues of *La Révolution surréaliste*. Priced at 8 francs a number, and with foreign subscriptions at 55 francs, the magazine was always hard pressed financially, perhaps explaining why its illustrations tended to be concentrated at the back of each issue and the scheduling of numbers was intermittent. Other financial devices included the publication and sale of tracts and books, but in the last number, 5–6 (15 May 1933), there appeared a full-page advertisement for Albert Skira's and Tériade's *Minotaure*. Skira and Tériade were determined to avoid the political stridency and blasphemous deviancy of *Le Surréalisme au service de la révolution* and also, if possible, to effect a reconciliation between the Bataille and Breton parties. It was Bataille and André Masson who proposed the title *Minotaure* (Roger Vitrac and Jacques Baron had suggested the Buñuelesque *L'âge d'or*), though this reconciliation was largely ineffective. After the ninth issue (October 1936), when Tériade left to form *Verve* (December 1937–), Skira created an editorial committee which included Breton, along with Marcel Duchamp, Éluard, Maurice Heine and Pierre Mabille. *Minotaure* tried to straddle the visual arts and poetry, art and art history: 'This means that MINOTAURE will single out, bring together and sum up the elements which have constituted the spirit of the modern movement, in order to extend its sway and impact.'[3]

The ambition to publish a glossy and colour-illustrated avant-garde magazine was supported by editorial and distribution skills and expertise that made *Minotaure* an outstanding success. By June 1933 the first two numbers had eight hundred subscribers at 75 francs each. There were overseas agents – Zwemmer, at 76–78 Charing Cross Road, was the sole British distributor. For the first issue Tériade commissioned Picasso, who mislaid the first collage in his living-room in Rue La Boétie. Lacework patterns of silver foil, ribbons, artificial leaves – the remnants of one of his wife Olga's old hats – were precariously pinned around a print of the Minotaur brandishing his knife. The cover was very expensive, but Skira and Tériade gambled that it was necessary for the launch.

The Surrealist *Minotaure* and Herwarth Walden's Expressionist *Der Sturm* (1910–32) were perhaps exceptional in the robustness of their finances and organization. Many avant-garde magazines did not make their second number. This was sometimes because of confiscation and censorship, but more lack of organization and finance. Picabia's independent means allowed him to publish *391* wherever he was between 1917 and 1924.

OPPOSITE:
Život, Prague, 1922
(BL P.423/7)
See p.49

Why did avant-garde writers and artists still think a little magazine was necessary for the cause? The magazine often gave a focus for a particular movement, tendency or programme. Breton's editorship of his magazines allowed him to control his tendency within Surrealism – Bataille had to set up *Documents* (1929–30) to put forward his own position. The magazine's organization and publicity allowed other publications and activities – Céline Arnauld's *Projecteur* (21 May 1920) promoted the Festival Dada of Wednesday May 1920 – to have a focus: *Der Sturm* gave rise to *Sturmbücher* such as August Stramm's *Sancta Susanna* and *Rudimentär*, as well as a wealth of postcards of the work of Franc Marc, Wassily Kandinsky and Oscar Kokoschka; *Veshch Objet Gegenstand* (1922) was closely associated with the Russian Scythian Press, based in Berlin.

Picabia modestly defended 391 in January 1917 to Stieglitz in New York – 'it's better than nothing, because, really, here [Barcelona], there is nothing, nothing, nothing'. If you could not colonize an existing magazine, as the Futurists were able to do with *Lacerba*, there was no alternative, if you wanted to be able to put forward your viewpoint, experimental texts or images, but to found your own magazine. It also allowed you to be

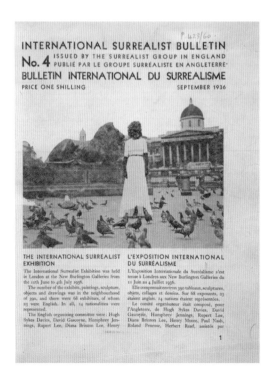

International Surrealist Bulletin, No.4 (September 1936)

(BL P.423/60)

See p.113

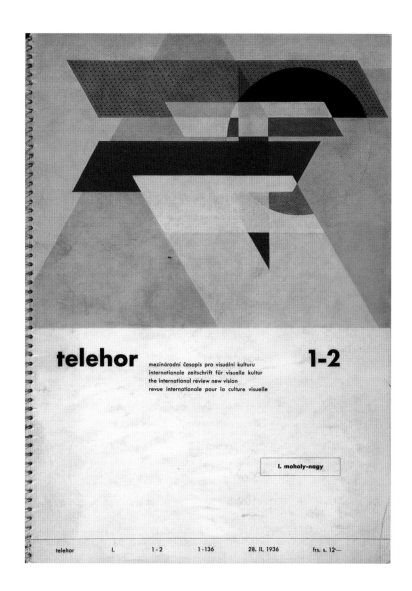

Telehor, No.1-2 (1936)

Telehor or the *International Review [for] New Vision* had only one (double) issue, devoted to the work of Moholy-Nagy. It was edited by Frantisek Kalivoda and introduced by Siegfried Giedion. It was published in Brno, Czechoslovakia. The texts were in English, French, German and Czech.

(BL Cup. 410.c.205)

connected to the international avant-garde scene. The Prague-based *Život* (1922) claimed as *spolupracovnici* (collaborators) Archipenko, Behrens and Ehrenburg in Berlin; Bissière, Blanchard, Delluc, Derain, Faure, Feuerstein, Foujita, Goll, Le Corbusier, Kisling, Krohg, Laurens, Lhote, Lipchitz, Man Ray, Ozenfant, Perret, Sima, Survage, Utrillo and Zadkine in Paris; Prampolini in Rome; and Voskovec in Dijon. The genuineness of this contention is somewhat undermined by the claim that Charlie Chaplin and Mary Pickford were also collaborators – and the inclusion of the dead

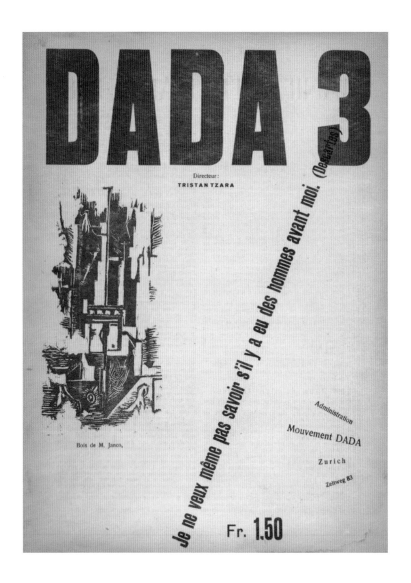

Georges Seurat and Amedeo Modigliani. Francis Picabia, who had put his
name to the third issue of *Dada*, was excited to receive his copy in New
York: 'Dada 3 has just arrived. Bravo! This issue is wonderful. It has done
me a great deal of good to read in Switzerland, at last, something that is
not absolutely stupid.'⁴ Ideas – articles, poems, photographs, reproduc-
tions, book and exhibition reviews – circulated at a higher velocity than
previously, connecting both major centres, but also allowing other cities
to be drawn into the network. In Lyons, Emile Malespine published

Le Mot, No.13
(6 March 1915)

Raoul Dufy's illustration
for the patriotic journal,
Le Mot, which was edited
by Jean Cocteau.

(BL Cup.919/7)

© AGADP Paris and
DACS London, 2007

Manomètre (nine issues between July 1922 and January 1928), initially at 2 francs an issue, and included work by Hans Arp, Tristan Tzara and Philippe Soupault and also by Piet Mondrian, Vicente Huidbro, Lajos Kassák and László Moholy-Nagy; thus Lyons was aligned to the international Dada-Surrealist and Constructivist movements.

The avant-garde magazine was also their contribution to the total work of art or Gesamtkunstwerk.[5] Word and image, word as image and image as word, music and photography could be explored in this portable format, which could be shared with those interested in these ideas, almost simultaneously across the world. The little magazine vied with the manifesto to be seen as the art medium par excellence of the avant garde.

1 Hans Richter, Dada, Art and Anti art, New York: Oxford University Press, 1965, pp. 110–11
2 Alfred Stieglitz, 'The magazine 291 and The Steerage', Twice Year, nos. 8–9 (1942), p. 135.
3 Focus on Minotaure, Musée d'art et d'histoire, Geneva, 1987.
4 Maria Lluïsa Borràs, Picabia, London: Thames & Hudson, 1985, p. 199.
5 Der Hang zum Gesamtkunstwerk: Europäische Utopien seit 1800, Zurich: Kunsthaus, 1983.

THE
AVANT-GARDE
PHOTO-BOOK

Étienne-Jules Marey's *Le Mouvement* (1894) and use of 'chronophotographs' influenced Marcel Duchamp (*Nude Descending a Staircase*) and also the Futurists: Anton Giulio Bragaglia refers to Marey in his manifesto on Futurist photodynamism (1911) and the title of Marey's book may even be the reason why the Futurists described themselves as a 'movement'. If, in retrospect, the main issue was whether photography should be seen as a fetishized art-object or as a mass medium (which ultimately led to cinematic film), photographers and artists at the time used both tactics. In between was László Moholy-Nagy's New Vision, which translated a formalist vision of the medium of photographic film into photo-books and graphic design for use in advertising. Many photographers desperately wanted their work

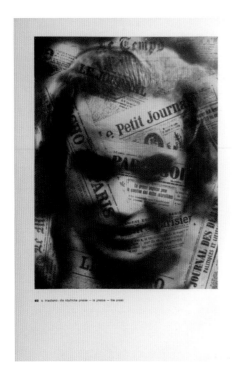

THE AVANT-GARDE PHOTO-BOOK

LEFT AND OPPOSITE:
Franz Roh and
Jan Tschichold,
Photo-eye (Foto-Auge), 1929

This serves as a catalogue to the 1929 'Film und Foto' (FiFo) exhibition in Stuttgart and as a recapitulation of Moholy-Nagy's New Vision in photography, where the camera's vision and the democratic utility of photography are emphasised.

(BL C.186.c.11)

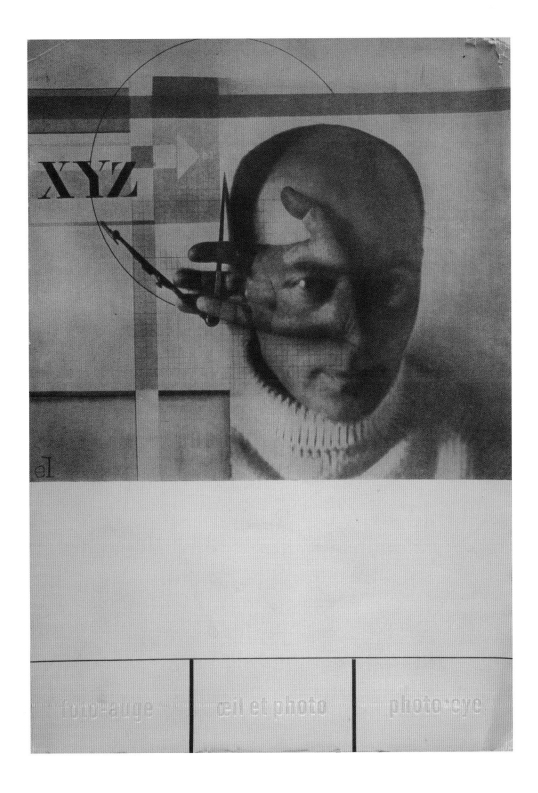

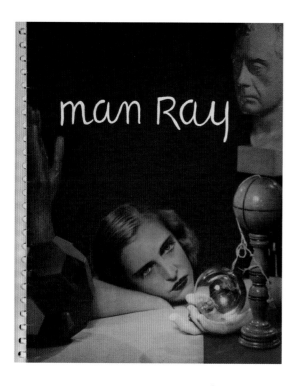

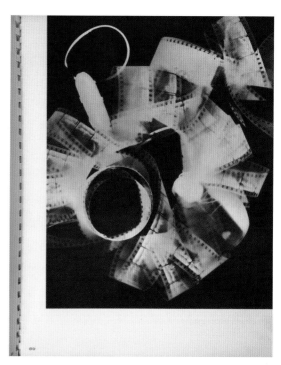

to be seen as art – Alfred Stieglitz would be one such example – whereas artists seized on photography, especially after the 35mm camera appeared in the early 1930s, to document their own work (so it could enter the mass circulation of ideas), explore the world around them, and use the medium as a further way to make art. Both would use the photo-book for their different agendas.

The sumptuously coloured front cover of no. 6 of Albert Skira's and Tériade's *Minotaure*, dated December 1934, was a reproduction of Duchamp's rotorelief 'Corolles' over Man Ray's photograph ('Elevage de poussière', 'Dust breeding'). This photograph of the 'The Large Glass' had been taken in Duchamp's studio at 1947 Broadway, New York, several months after his return from Paris in January 1920. Supposedly (because of the long exposure required) Man Ray and Duchamp went out for dinner during the taking of the photograph. With the caption 'Voici le domaine de Rrose Sélavy: vue prise en aeroplane 1921. Comme il est – aride – comme il est fertile. Comme il est joyeux – comme il est triste!', this had already been published in André Breton's *Littérature*, New Series no. 5, 1 October 1922. This is perhaps the first publication of a photograph as art. The same

Man Ray,
Photographies 1920–1934,
1934

Man Ray was associated with both Dada and Surrealism: he exhibited in the first Surrealist exhibition at the Galerie Pierre, Paris in 1925. This book has a combination of rayograms (based on the photogram), celebrity portraits of Dalí, Picasso and Gertrude Stein, with texts by Éluard, Breton and Duchamp.

(BL, new acquisition)

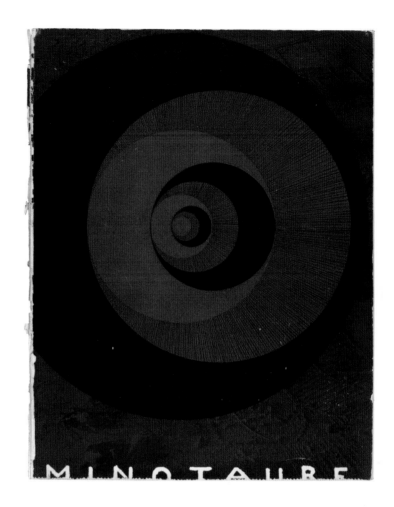

Minotaure, No.6 (1934), cover by Marcel Duchamp

For this cover of Skira and Tériade's Surrealist magazine, Duchamp reproduced the Rotorelief 'Corolles' over Man Ray's photograph 'Dust breeding' (1920), itself of Duchamp's 'Large Glass'.

(BL C.180.d.1)

See pp 47, 54 and 62

issue of *Minotaure* included a photograph by Bill Brandt of abandoned ships' figure-heads in the Scilly Isles, and one by Brassaï for Louise de Vilmorin's *Ce soir*. Both had contributed previously – indeed Brassaï had contributed from the first issue ('Picasso's studio'), but this was the first time they – and Man Ray – had been published together in *Minotaure*.

Brassaï, born Gyula Halász on 9 September 1899, took his name from his birthplace, Brassó in Transylvania, part of Hungary before the First World War. In Paris by 1924, he made a living as a journalist, sometimes accompanying articles with his own photographs. He had made a contract with Vidal, an underwear manufacturer, to publish a book on intimate Paris with a text by Pierre MacOrlan: after some dispute, Brassaï declined to acknowledge authorship of the book Vidal brought out as *Voluptés de*

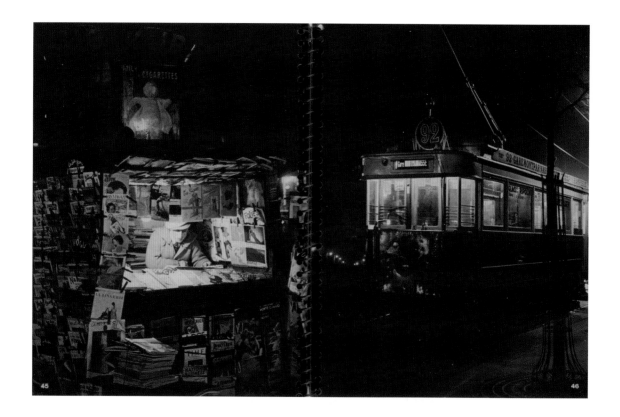

Paris in 1932, and also many of the articles which Brassaï subsequently used for *The Secret Paris of the Thirties* (1976). The companion piece to *Voluptés de Paris* was *Paris de nuit* (1933, issued 2 December 1932).

This book reflected the tendency within Surrealism for the documentary, the ethnographic and the anthropological. Brassaï insisted that he 'never sought to express anything but reality itself, than which there is nothing more surreal'.[1] It also fitted with Surrealist interest in seeing things differently – whether the phallic imagery of the Paris Métro or the unexpected shadows of Parisian statuary – night was a very obvious way of seeing things differently. Whilst Paul Morland's introductory text insists that night was not the negative of day, for Brassaï 'night unnerves us, and surprises us with its strangeness; it frees powers within us, which were controlled by reason during the day'.[2] The mysterious daytime shadows, colonnades and truck of Giorgio de Chirico's 'Melancholy and Mystery of a Street' (1914) were another influence – reproductions had appeared in *Littérature* and other magazines. *Minotaure* reflected this obsession, and

Georges Brassaï,
Paris de nuit, 1933
(BL, new acquisition)

ran a translation of Edward Young's *Night thoughts* (1742), an unlikely Surrealist icon if ever there was one. Nocturnal rambles were the inspiration of others – in the nineteenth century Pierre Zaccone in *Les Rues de Paris* (Paris, 1859), or the accounts of night amusements with crude engravings, *Paris after Dark* (1877), describe the mixture of low and high life that characterizes the work of Charles Baudelaire and Edouard Manet. Another noctambulist was Léon-Paul Fargue, the so-called 'Pedestrian of Paris', a homage to whom appeared in *Les Feuilles* nos. 45/6 (1927), with a portrait of him by Man Ray. In fact Fargue accompanied Brassaï on some of his night walks. Another companion of Rue de la Glacière and the Boulevard Auguste-Blanqui was Henry Miller, perhaps colouring the spectral trees and waterfront descriptions in *Tropic of Cancer* (1934); Miller wrote about Brassaï in 1932, published six years later by the Obelisk Press as *Max and the White*. More often Brassaï walked alone, bearing his Voigtländer Bergheil camera with its 10.5cm Heliar lens, tripod and twenty-four plates. On the fringe of the Cubist and Surrealist circles, he met the art critic Maurice Raynal, who introduced him to Tériade – who, in turn, introduced him to Picasso. For Brassaï the photo-book allowed him to transcend the journalist-photographer/journeyman status, and to put photography at the centre of art practice, where Eugène Atget had not been happy.[3]

Paris de nuit is characterized by rich gravure printing of photographs that bleed over the edge of the page: plate/page numbers lie in white on the photograph. The metallic spiral binding was a relatively recent invention (1924), and this allowed image to abut closely. The cover, inside cover, inside back cover and back cover are photographs downwards in the direction (as if at one's feet) of the dark, wet, shiny cobbles. Because of the spiral binding the book can be opened to expose front and back covers together to reveal the same image reversed to make a converging street. It is possible that the cobbled street is also a homage to his friend, the Hungarian photographer André Kertész's 1929 photograph, 'The sidewalk'. Brassaï's plate 1 'Les ombres des grilles de Luxembourg...tracent... des quadrillages de rêve' extends the pavement into the book as the shadows of the Luxembourg fence mimic the cobbles of a pavement. Elsewhere the pavements are omnipresent, but overlaid by other subject matter.

Brassaï makes very little use of the landscape format. Of the sixty-two plates only seven are in landscape: the Paris skyline, Tuileries trees, Pont Neuf arches, Gare St Lazare, tramway repairs, the last metro at Palais-Royal and the taxi of pleasure seekers – the last-named unusual in the

book as the next photograph to it in that opening, trees in flower, which would have worked in landscape format too, is portrait.

Simply by metonymy – one thing next to another and one thing after another – the book format cannot escape generating narrative. Plate 2 has the Arc de Triomphe as its focal point, but the foreground shows a train, for which the caption is needed to explain that it is en route to the vegetable market of Les Halles; this story is picked up in plates 35 and 36, the former showing a cart with its driver asleep on top, and the latter the vegetable train. Is the taxi conveying the pleasure goers of plate 53 the same as the one outside the Bois de Boulogne pavilion (plate 55)? Alternation of high and low life scenes also gives a rhythm to the book: *pissoir*, prison and back street contrast with the Opéra, Hôtel Crillon and the Palais Bourbon; *vidangeurs* (cesspool cleaners), prostitutes, scavengers and beggars on benches inhabit the book along with pleasure seekers in the Bois de Boulogne, Bal Tabarin and the Folies-Bergère. Plate 43 is of 'La Môme Bijou', the prostitute, taken in the Bar de la Lune, Montmartre; it is one of a series of three, and reflects the fact that Brassaï – with the restrictions of his equipment, such as the slowness of the cameras, and by the very nature of his subject matter – had to stage many of his photographs. Its companion plate 44 is of the road under the railway where the Boulevard Edgar-Quinet meets the Avenue du Maine. The double-spread is initially strange, but La Môme Bijou's table and its legs map onto the pillars supporting the railway in its companion piece, and perhaps hints at the outdoor locale of her activities.

Paris was the subject of two other avant-garde photo-books. Moi Ver (Moshé Raviv-Vorobeichic) published *Paris*, with an introduction by Fernand Léger, in an edition of 1,000 in 1931. It consists of eighty mainly combination photographs. Atget's working-class and small-trader Paris is seen through both Futurism and the New Vision of Moholy-Nagy's *Malerei Fotografie Film* (1927), translated into Russian in 1929, which celebrated the qualities of the photographic medium. Moi Ver's *Paris* (1931) employs the techniques of cinematic montage; images are superimposed and even printed upside down. Ilya Ehrenburg's *Moi Parizh*, published in Moscow in 1933, was designed by El Lissitsky who provided preliminary photographs and photomontages. Ehrenburg concentrates on the underclass of Paris, asleep or passed out drunk on pavements and benches – Paris is horizontal. There is nothing staged about these photographs, and there is no technical necessity for doing this as Ehrenburg has used the highly portable 35mm Leica camera.

OPPOSITE:
Moi Ver, Paris, 1931
(BL, new acquisition)

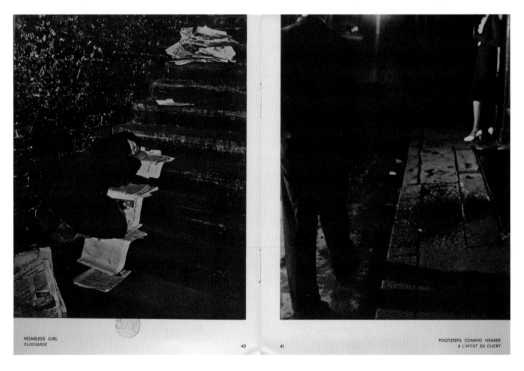

TOP:
Ilya Ehrenburg,
Moi Parizh, 1933
(BL, new acquisition)

BOTTOM:
Bill Brandt,
A Night in London, 1938
(BL P.M.010352.d.21)
Bill Brandt © Bill Brandt
Archive Ltd.

Paris – and Brassaï's Paris in particular – is also present in negation in Hermann Larsen's *København ved nat* (1935) and in Brandt's *A Night in London* (1938). Larsen's Copenhagen book has a metal ring binding and white plate numbering: there is a similar preoccupation with statues and shadows. Plate 15 is a very similar shot to Brassaï's plate 54: trees in bloom, for example. The juxtaposition of welder and tram of Brassaï's plates 37–38 is repeated, if using the pages in portrait mode, in Larsen's plates 36–37. One difference, however, is Larsen's greater use of the horizontal format within the portrait-format book.

Brandt knew Brassaï, and was part of the same Surrealist milieu; he had been introduced by the poet Ezra Pound to Man Ray, and he had worked as his assistant for three months in 1930. Brandt's *A Night in London* (1938) was co-published by Charles Peignot, Brassaï's publisher, with his Éditions Arts et Métiers Graphiques, and the sub-titles are also given in French: 'footsteps coming nearer' is translated as an unbowdlerized 'À l'affût du client'. Its design has moved on from his *The English at Home* (1936) in which photographic images of high and low life sit centrally in the white space of the page. The photographs of *A Night in London* are orientated to the top left of the verso, top right of the recto, bleeding over the page edge. They are entirely portrait, unlike Brassaï's. The text by James Bone is printed in a typeface which has decidedly unmodernist ligatures for 'ct' and 'st'. Bone makes a reference to George Sala's *Twice 'Round the Clock*, and Brandt seeks out some of the high and low scenes of Sala and of Brassaï – Covent Garden replaces Les Halles; the silhouetted couple on the bench in plate 28 ('Magic hours') could be the same as those in Brassaï's plate 24; both end with the morning delivery of milk. Brandt uses the opening to contrast rich and poor, which Brassaï is reluctant to do; darts face a Bloomsbury tea party (plates 26–27), and a late supper is juxtaposed with a scavenger behind a restaurant. The taxi in several photographs again allows the reader to construct a narrative that may or may not be there. Brandt also staged many of his photographs for technical reasons but also – obviously – because his scenes were indoors: bedtime, running a bath, dining and so on.

The photo-book, generating narrative through metonymy and persistence of vision as the page is turned, shares much with film. Indeed, the overlap of photographer and film-maker was frequent – not only did Moholy-Nagy take photographs but he theorized on the relationship between painting, photography and film; his contribution to *Telehor* nos. 1–2 (1936) was a film script based on Kurt Schwitters' *Auguste Bolte* and his

unpublished film script for *Dynamics of a Metropolis* survives.[4] Helmar Lerski, who published his photographic study of the heads of everyday people, *Köpfe des Alltags: unbekannte Menschen*, in 1931, had worked as a cameraman on several German Expressionist films such as Fritz Lang's *Metropolis* (1927) and, having emigrated to Palestine, directed the documentary *Avodah* (1935). Even Brassaï was primarily a photographer who took photographs in series. Moi Ver's *Paris* (1931) with his superimpositions and montage would bear close comparison with Dziga Vertov's *Man with a Movie Camera* (1929), primarily set in Moscow but also including footage of Kyiv and Odessa, which used superimpositions, split screens and so on. What perhaps set Vertov apart was his formalist foregrounding of film.

In the role of a vehicle for conveying information the book was rapidly being replaced by film and then by television: the photo-book was a transitional phase when the danger that film posed to the printed format was not fully identified. Duchamp's front cover of *Minotaure* no. 6 (winter 1934) reflects his interest in moving optical illusions and in film-making. The short film (with Man Ray and Marc Allégret) *Anémic Cinéma* (1925–26) – where 'anemic' is almost a reversal of 'cinema' – presages the move of the avant garde from little magazine and the printed format to film – albeit by means of a pun.

1 Interview with Brassaï by France Bequette in *Culture et communication*, no. 27 (May 1980), Paris: Ministère de la Culture et de la Communication, p. 14.
2 Brassaï, Gilberte Brassaï Archives, undated.
3 In 1868 Paris there were over 365 photographic studios; see Elizabeth Anne McCauley, *Industrial madness:...*, New Haven, Conn.; London: Yale University Press, 1994, *Commercial Photography in Paris, 1848–1871*, p. 1.
4 Mary Ann Caws, *Manifesto*, Lincoln, Neb. and London: University of Nebraska Press, 2001, pp. 413–17.

LEGACY

On 19 July 1937 the Entartete Kunst exhibition curated by Adolf Ziegler, Head of the Reich Chamber of Visual Art, opened in the Haus der Kunst, Munich. It included 650 works from many that had been purged from museums and galleries – 1,052 by the Nazi Party member Emil Nolde and 508 by Max Beckmann. The exhibition also included manifestos, which were juxtaposed with the speeches of Nazi leaders. During the exhibition a second seizure took place and, taking into account Ziegler's previous purge, altogether 16,558 works of art were declared to be degenerate. Beckmann fled to Amsterdam on the opening day of the exhibition. Many others had left before.

Nazi promotion of Aryan Neo-classicism (in their ideology a style uncontaminated by Jewish influence) paralleled Soviet promotion of Socialist Realism and the closure of any art groups not part of official artists' organisations from 1932 onwards. The VKhUTEMAS (Higher Art and Technical Studios/Institute), Moscow, was closed down in 1930, three years before the Bauhaus. Exiles and émigrés helped diffuse avant-garde ideas, building on the nexus of magazines, patrons and emerging institutions. But the pre-war avant garde in all its ebullience had come to an end.

The preliminary course or *Vorkurs* of the Bauhaus did survive through the emigration of artists to the United States and their influence on art and design education. It remains influential there and in Britain (as the Foundation Course). This curriculum kept alive the memory of other avant-garde artists. Surrealism in the USA had a formidable proponent in André Masson who was in residence there 1941–43; he was an important influence in the evolution of American Abstract Expressionism, associated with Jackson Pollock. Futurism because of its connections to fascism was practically ignored. Dadaism fared similarly, perhaps because more of the participants had remained in Europe (with the conspicuous exception of Marcel Duchamp) or because its communist overtones were viewed unfavourably during the Cold War.

In the 1950s and 1960s, perhaps because of the political edge that Dada always potentially had or because it provided an aesthetic (or non-

aesthetic) that challenged the then prevailing hegemony of Abstract Expressionism, there was a revival of interest in the work of Kurt Schwitters (who had died in 1948 at Ambleside), and in Duchamp. The Sidney Janis Gallery in New York showed Schwitters in 1952, 1953 and 1956 and also Duchamp in the same years. The first Schwitters retrospective took place in 1956 at Kestner-Gesellschaft, Hanover. Duchamp's first retrospective, organized by Walter Hopps, was at the Pasadena Art Museum in 1963. But publications (predictably) were the mechanism through which the avant garde reached a wider audience; it could be argued that they created the historical avant garde. The new avant garde was interested in their predecessors. The painter Robert Motherwell compiled *The Dada Painters and Poets: an Anthology* in 1951; it records the views of living Dadaists such as Duchamp, Hans Richter and Richard Huelsenbeck. Robert Lebel's monograph on Duchamp published by the Grove Press in New York (and the Trianon Press, London and Paris) in 1959 was influential for American musicians such as John Cage and artists Jasper Johns, Robert Morris and Robert Rauschenberg, whose 'combine paintings' included newsprint. Allan Kaprow's and Claes Oldenburg's happenings and performances were obviously indebted to Dada performances and the Duchampian insistence that what an artist made was art. Fluxus, with its avant-garde style impresario the Lithuanian George Maciunas, deployed a whole range of neo-Dada activities – mail art (what were internationally exchanged little magazines other than mail art?), publications, artist's books (sold through a mail-order catalogue), and musical/performance scores in the case of La Monte Young, George Brecht, Dick Higgins and Yoko Ono. Higgins contributed to avant-garde literature by writing about visual poetry (George Herbert) and by publishing, at his Duchampianly entitled Something Else Press, Huelsenbeck's *Dada Almanach* and *Manifestos* in 1966. Perhaps the final comment on the avant-garde obsession with the printed format is Daniel Spoerri's multiple, *Les Lunettes noires*, a pair of black-framed eyeglasses with sharp pins attached to the inside of lenses, pointing into the eye-balls. They accompanied his book *L'Optique moderne* (1963), ironically at the beginning of the revival of the post-war artist's book with Ed Ruscha's *Twenty-six Gasoline Stations* published in the same year, with its ambition to reach a wide audience and to be sold in the gasoline-station store.

CITIES

Baltic States

Tallinn/Tartu

When Estonia gained independence in 1918, having previously been part of the Russian Empire though ruled by a Baltic German elite, there were at most only three generations of artists of Estonian origin. Their artistic education had been mainly in other European countries, the first Estonian art school having been founded in Tallinn as recently as 1903.

The first Estonian literary group, the Young Estonia movement established in 1905, came about as a result of the growing national self-consciousness which developed amongst Estonian students and intellectuals in the provincial university town of Tartu, the centre of Estonian cultural life at this time. Influenced by European modernist trends and French Symbolism, they published five Young Estonia albums from 1905 to 1915 containing original Estonian works alongside translations of other European modernist works. Their chief ideologist, the poet Gustav Suits, proclaimed 'Let us remain Estonians, but become Europeans.' Estonian artists in the first two decades of the twentieth century energetically followed this credo, accumulating experience of the major trends in European art from national romanticism to Impressionism and Expressionism.

Thus much modernist Estonian art of the first part of the twentieth century is a heady mix of 'isms', characterized primarily by a breaking away from the depiction of rural peasant life to experiencing the dynamism of the city. The arrival of the avant garde in Estonia is usually traced to Ado Vabbe's 1914 exhibition at the Vanemuine theatre in Tartu. He had visited Italy, the birthplace of Futurism, and had become acquainted with the Russian avant garde in Moscow, but having studied with Wassily Kandinsky and Franz Marc in Munich from 1911 to 1913 the German Expressionist Group Der Blaue Reiter was a particular influence on his work. In his lifetime, Vabbe embraced many styles from Expressionist painting to Cubo-Futurist book illustrations.

It was not until 1923 that the Estonian Artists' Group was formed, the first Estonian art group with an avowedly formalist programme embracing Cubism and Constructivism. Led by Jaan Vahtra, it had a southern sub-group in Tartu-Võru and another in Tallinn. Vahtra had studied in both Riga and St Petersburg, and Latvian contacts were influential in promoting the Constructivist movement in Estonia. Unlike Vabbe, the group considered Expressionism too pessimistic for a dynamic young state and looked instead towards the ideas expounded by Ilya Ehrenburg and El Lissitzky in *Veshch-Gegenstand-Objet* which championed art as a means of restructuring the human environment.

This is particularly well demonstrated by the innovative poet Johannes Barbarus' *Geomeetriline inimene* (*Geometric Man*) (Tallinn, 1924) illustrated by Vahtra. Barbarus had visited Paris and interpreted the visual signs of the city in the language of Cubism and Constructivism, imitating Guillaume Apollinaire, Blaise Cendrars and others. *Paris 2: a Verse with Contrasts* has two poems proceeding on either side of a vertical line, the left-hand poem representing a dull, sleepy provincial Estonian town, the right-hand one representing the dynamic metropolis of Paris. It ends with the words 'Edasi, edasi!' (Forward! forward!)

Other influential members of the Estonian Artists Group were Mart Laarman, editor of the *Book of New Art* (1928), an almanac which aimed to explain the group's programme to a wider public, and Arnold Akberg, the most committed Estonian Constructivist. Other artists who had embraced Cubo-Constructivism did so only briefly. Eduard Ole, for example, was soon seduced by art deco, and Juhann Raudsepp's Cubist sculptures of the early 1920s gave way to Realist work as he was invited to create monumental public sculptures, though in his later years, some still displayed elements of geometric formalism.

The graphic artist Eduard Wiiralt trained at the influential Pallas art school, founded in Tartu in 1919, and in Dresden. In both schools he was influenced by the German derivative of Expressionism, Neue Sachlichkeit, as can be seen in his drawings, prints and book illustrations from the early

OPPOSITE:
Johannes Barbarus, *Geomeetriline inimene*, 1924. Illustrated by Jaan Vahtua, leader of the Estonian Artists Group.

(BL Cup.410.e.91)

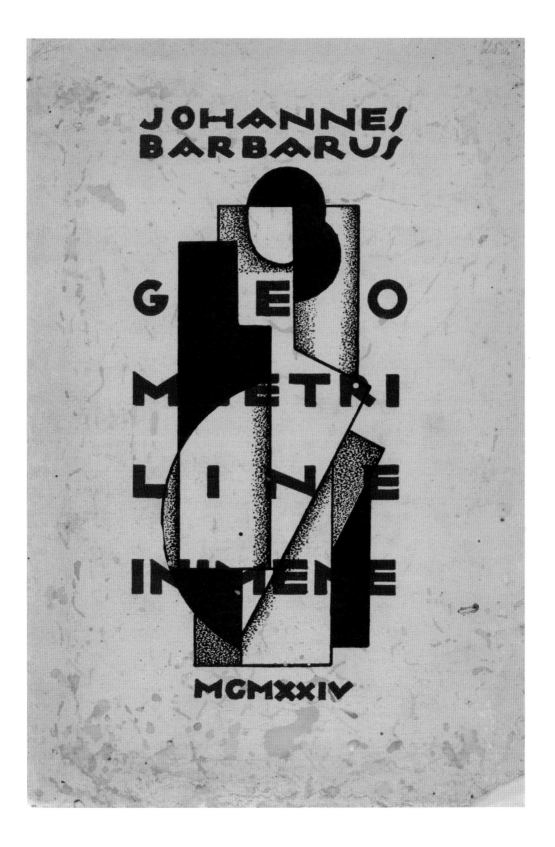

1920s depicting prostitution, poverty and the darker side of the city life he experienced in Germany. He was also the first Estonian artist to depict the seamier side of Tartu life with his drawings of beer halls and tumble-down wooden houses.

By the 1930s, however, the avant garde had been almost entirely rejected by Estonian artists as the impetus to build a viable nation state in an increasingly hostile geopolitical environment led to the adoption of a conservative cultural policy known as the 'silent age', characterized by a return to Realism and a clear expression of the national ideal.

Riga

In Latvia, as in Estonia, the late development of a national consciousness based largely on folk traditions was the product of centuries of rule by a colonial Baltic German elite, as a result of which the developing indigenous Latvian art scene was dominated by a veneration of folk tradition and the peasantry characterized by Impressionist rural landscapes, genre scenes and national song festivals. Yet by the beginning of the twentieth century Latvians made up almost half the population of multi-ethnic Riga, the third largest industrial city in the Russian Empire. Architects fully embraced art nouveau, transforming the city with elaborately ornamented buildings. The rise of a Latvian middle class made Riga the centre of a national awakening characterized by the Young Latvia movement. Due to the solid industrial base socialism flourished, culminating in the 1905 revolution led by the Latvian Social Democratic Workers' Party. The arrival of the avant garde in Riga may be pinpointed to summer 1910, when four events coincided to rock the nascent Latvian art establishment's essentially conservative nationalism: Russian sculptor Vladimir Izdebsky's huge Salon at the International Exposition featuring nearly eight hundred works by 150 artists, including experimentations with Cubism, Futurism, Expressionism and Neo-primitivism; the St Petersburg Union of Youth exhibition, described by the modernist Niklāvs Strunke as 'an exploding bomb in quiet provincial Riga'; the First Latvian exhibition and Voldemārs Matvejs' manifesto 'Russian Secession' in which he stated: 'We do not paint nature but only our attitude to nature...we rape nature because

great beauty is found in violation and anomaly.' Matvejs, also known as Vladimir Markov, believed that artistic rebirth should be sought via study of primitive art forms as opposed to the rational canons of the European tradition. This influence may be seen most clearly in the work of Latvian sculptors such as Jēkabs Kazaks, Teodors Zaļkans and Marta Liepiņa-Skulme. The First Latvian exhibition was the first group show for ethnic Latvian artists, previously discriminated against by the Baltic German establishment and – while predominantly traditionalist in outlook – included the iconoclastic Matvejs, despite the anomaly that he spoke Latvian only unwillingly and wrote his manifestos and polemical works such as his essay 'Faktura' (Texture) in Russian.

After the death of Matvejs in 1914, the mantle of leading modernist personality and organiser of artistic events and soirées was assumed by Jāzeps Grosvalds with assistance from his contemporaries Kārlis Johansons and Aleksandrs Drēviņš until 1916, when with Riga besieged by German troops they moved to Russia – where they were to play a leading role in Russian avant-garde circles, along with their Latvian contemporary Gustavs Klūcis.

At this time, the Latvian traditionalists and modernists in St Petersburg met every Thursday evening in a café for relatively good-humoured debates, but after the war hostilities broke out again between the two groups. In 1919 Romans Suta, influenced by Vladimir Mayakovsky's concept of *proletkult*, decorated Soviet-occupied Riga with monumental Soviet propaganda and a battle scene depicting the rival groups of artists struggling for supremacy. In the same year when the city authorities refused the newly returned avantgardists studio space, they barricaded themselves in the Jēkabs Barracks, defended by heavy artillery, and set about their artistic endeavours. At the end of that year, however, the Riga City Art Museum organized a retrospective exhibition of Latvian art at which the most distinctive group were the self-styled Expressionists. In March 1920 the modernists founded the Riga Artists' Group and organized an exhibition featuring many Cubist works which further scandalized conservative circles.

The traditionalists retaliated, feeling ever more marginalized as modernist work was bought for museums and galleries and modernist artists were given posts in the administration. The

conservative academic Richard Zariņš led a group of artists in the creation of around a hundred parodies of modernist artworks under the pseudonym R. Kasparsons, promoting this new style as 'ballism', and succeeded in duping the modernists into believing it was genuine. Despite this episode, Latvian modernism went from strength to strength in the 1920s, with a synthesis of Cubism and Constructivism characterized by Strunke's *Man Entering a Room* and Suta and Aleksandra Beļcova's stunning ceramics produced at the Baltars workshop. The artists would gather in Suta's mother's Sukubs club (an amalgam of the Latvian words for Suprematism and Cubism) decorated with modernist art, furniture and murals.

Modernist design was also on display at the Latvian National Opera where Suta, Strunke, Skulme and Sigismunds Vidbergs all produced outstanding set and costume designs. Close contact was maintained with artists abroad and the journal *Laikmets* presented Soviet and Western modernism to Latvian readers. Andrejs Kurcijs's essay 'Active art' (1923) was one of the few articulated Latvian modernist manifestos. He derived the terminology of 'activism' and 'active art' from the German literary trend and complemented it with the artistic principles of Fernand Léger and the French Purists.

By the 1930s, as in Estonia, the eroding of the spirit of internationalism and economic depression took its toll on the Riga avant-garde art milieu, whose output became more romantic and conservative, though a few individuals like the flamboyant Kārlis Padegs continued to fly the modernist flag in their approach to life as performance, embracing a grotesque and provocative choice of themes – such as Padegs' *Madonna with a Machine Gun* (1932).

Vilnius/Kaunas

Early twentieth-century Vilnius was the cosmopolitan capital of a province of the Russian Empire with a multi-ethnic population including Poles, Lithuanians, Russians and Belarusians with a significant Jewish element. After the relaxation of oppressive Russian control around the time of the Russian revolution of 1905, artistic life began to thrive. Between 1864 and 1904 the teaching of Lithuanian was banned, as was the printing of Lithuanian books in the Latin script. After this ban was lifted in 1904, there was a resurgence of

Lithuanian culture, including art and literature.

The Lithuanian Arts Society, founded in 1907 with the support of the major Lithuanian modernists Vytautas Kairiūkštis and Mikalojus Konstantinas Čiurlionis and with Antanas Žmuidzinavičius as its President, brought together the progressive artistic efforts of Lithuanian artists dispersed around Europe and fostered relations with St Petersburg, Moscow, Kyiv, Cracow and Paris via which information about Futurism, Cubism and Expressionism was brought to Vilnius and absorbed by local artists. The painter Ferdynand Ruszczyc was influential in the founding of the Polish-oriented Vilnius Artists' Circle which met clandestinely in his flat from 1910 to 1914 to promote aesthetic self-education and new art forms such as photography.

From 1915 to 1918 Vilnius was occupied by Germany and thereafter changed hands a number of times between Poland and Russia, only briefly belonging to Lithuania. In 1922, when it was made part of Poland, ethnic Lithuanians left the city, which led to a primarily Polish and Jewish population. In 1919 Vilnius University reopened as Stefan Batory University; Ruszczyc headed the Department of Fine Arts and brought in leading representatives of the Polish avant garde such as Zbigniew Pronaszko and Benedykt Kubicki.

In the face of Polonization, many Lithuanian modernists decamped to Kaunas, but Kairiūkštis, the most prominent, settled in Vilnius in 1921 having spent many years in Russia, immediately before his return studying under Pavel Kuznetsov at VKhUTEMAS in Moscow. Kairiūkštis and Władysław Strzemiński collaborated in May 1923 in organizing the New Art Exhibition, one of the first shows of Constructivist art outside Russia, Kairiūkštis himself showing twenty works. His abstract painting drew on the principles of Suprematism, he experimented with photography and photomontage and designed avant-garde typographic styles and magazine covers for journals such as *Zwrotnica*. The other participants, Szczuka, Kryński, Stażewski, Zarnower and Puciatycka, went on to found a modernist collective operating mainly in Warsaw, which published the avant-garde journal *Blok*. The other influential Lithuanian modernist who remained in Vilnius was Vladas Drėma, who aimed to create a modernist national style as a reaction to Polonization combining elements of folk

styles and patterns with Cubist and suprematist concepts.

From 1920 to 1940 Kaunas was the alternative centre for Lithuanian modernists who had deserted Vilnius and took inspiration from the work of Čiurlionis, the foremost Lithuanian artist, composer and cultural figure of his age. During his lifetime he was hailed primarily as a composer and wrote the first Lithuanian pieces for chamber and symphony orchestras. In all he wrote more than 250 compositions for piano, string instruments, orchestra and choir. He started painting when already known as a composer, having studied art in Warsaw and Vilnius. Much of his best work was completed in the period 1907–11 while he was living in Vilnius and St Petersburg, where his work was discussed in *Apollon*. His near-abstract gouaches were exhibited in Paris in 1910; other works were shown at the World of Art group exhibition in St Petersburg (1911–12) and in the second exhibition of Post-Impressionists in London (1912–13). In his art he drew upon the rhythms of Lithuanian folk music and encompassed elements of the Lithuanian landscape, combining them all with a mystical symbolism. Čiurlionis believed himself to be a synaesthete, perceiving colours as music and vice versa. Many of his paintings bear the names of musical pieces such as fugues and sonatas. Often in financial difficulty and suffering from poor mental health, he died in 1911. By 1925 a museum had been built in Kaunas to house his works.

Initially Lithuanian literature was more receptive of modernist movements than art, as demonstrated by the *Four Winds* literary journal published between 1924 and 1928 which introduced movements such as Dadaism and Expressionism. Kaunas School of Art was founded in 1923 and the new generation of Lithuanian artists educated there, many of whom continued their studies in Paris, were influential in introducing more radical avant-garde ideas into Lithuanian art via the Society of Independent Artists and ARS group. The group's manifesto published in 1932, edited by Juozas Petrėnas, a member of the Four Winds group, stated: 'We can clearly see the absence of a deeper search or the imitation of long-worn-out forms kills our art. We are ready to serve this new era of our reawakening homeland and create a style for this era.' By the late 1930s, Lithuanians had developed a thriving artistic life, organized exhibitions and retained links with other European centres with a central role played by avant-garde artists alongside their more conservative colleagues.

Janet Zmroczek

Barcelona

The Catalan capital Barcelona was a more outward-looking city in the late nineteenth and early twentieth centuries than Castilian Madrid. It witnessed the flowering of *modernisme*, the Catalan variant of art nouveau. Notable exponents of *modernisme* included the architects Lluís Domènech i Montaner and Antoni Gaudí, the painter and writer Santiago Rusiñol and the poet Joan Maragall. Although Gaudí continued his highly individualistic work until his death in 1926, by 1906 *modernisme* was seen as overly aesthetic, and was giving way to *noucentisme*. Initiated by Eugeni d'Ors, this movement 'of the new century' or 'of the 1900s' was urban, middle class and markedly nationalist. It coincided with the creation in 1914 of the Mancomunitat, the assembly of political representatives from the four provinces of Catalonia, which was responsible for establishing a number of important Catalan cultural institutions. In the visual arts and literature, *noucentisme* is generally seen as a return to order, to Classicism and greater social cohesion after the individualism of *modernisme*. The substantial single issue of the journal *Almanach dels Noucentistes* (1911), edited by Ors, was however without a single message or manifesto and surprisingly eclectic. The avant garde in Barcelona needs to be seen against the background of *noucentisme*, at certain times emerging from it, at others provoked by it.

Spain's neutrality during the First World War attracted a number of foreign artists to Barcelona: Serge Charchoune and Hélène Grunhoff in 1914, Albert Gleizes in 1916, Robert and Sonia Delaunay to nearby Sitges in 1917; and most notably Francis Picabia who published the first four issues of his Dadaist periodical *391* in the city the same year. Picasso returned from Paris to Barcelona in 1917 also, while Joan Miró was still studying and working in the region. The central figure in the contemporary art world during this period was Josep Dalmau, who in 1911 had opened his Galeries Dalmau in Barcelona. It was there in 1912 that the first avant-garde art exhibition was held in Spain, the Exposició d'art cubista, while in the same year Dalmau exhibited paintings from Picasso's Blue Period and works by Joaquim Torres-García, then still under the influence of *noucentisme*. The Uruguayan painter and illustrator Rafael Barradas, who had come to Spain in 1914 via France and Italy, lived in Barcelona from 1916 until 1918. He had a joint exhibition at the Galeries Dalmau in 1917 with Torres-García, who by then had been exposed to Barradas' Futurist influence. Dalmau mounted Miró's first one-man show in 1918. With the end of the war most of the foreigners left the region, while native artists were free to travel abroad. Barradas, however, moved to Madrid where he became one of the most influential figures of the avant garde in Spain.

The first truly avant-garde movement in Catalonia may be dated to 1916 and the appearance of the unnumbered first issue of *Troços* (*Pieces*), founded by Josep Maria Junoy, a poet and art critic closely associated with Dalmau. The content set a pattern for similar subsequent publications with its mixture of art criticism and verse, often calligrammatic and related thematically to the visual arts. Editorship of *Troços* later passed to the poet J.V. Foix, who changed its spelling to *Trossos*. Junoy later published a collection of poems entitled *Poemes i cal·ligrames* in 1920, including a version of his earlier visual poem 'Oda a Guynemer' in memory of the French air ace Georges Guynemer. It earned him the praise of Guillaume Apollinaire.

It was the presence of Miró, Torres-Garcia and Barradas that gave greatest impetus to this first expression of the avant garde in Barcelona. All three artists contributed to the publications initiated by Joan Salvat-Papasseit, arguably the most significant Catalan avant-garde writer in spite of his early death at the age of thirty. In 1917 he founded the periodical *Un enemic del poble* (*An Enemy of the People*; 18 issues, 1917–19) whose subtitle 'Fulla de subversió espiritual' (Leaflet of Spiritual Subversion) indicates a radicalism, already manifest in his socialist politics. Salvat-Papasseit was subsequently editor of two other periodicals, *Arc-voltaic* (*Arc-Lamp*; a single issue of 1918) and *Proa* (*Prow*; 2 issues, 1921). The significant feature of the three publications was the collaboration between writers and artists, already manifest in *Troços*. A female figure by Miró appeared on the cover of *Arc-voltaic*, while the drawing by Barradas on an inside page is an example of his *vibracionismo*, a variant of Italian Futurism illustrating the pulsating dynamism of the modern city. The texts included Italian and French versions of Torres-Garcia's 'Art-evolució (a manera de manifest)', a call for individuality and constant change in art which had already appeared in Catalan in *Un enemic*

L'IRRADIADOR
DEL PORT
I LES
GAVINES

CNNUBI

POEMES D'AVANTGUARDA

del poble the previous year. Salvat-Papasseit contributed a calligrammatic poem describing the city of Barcelona. Torres-Garcia and Barradas (with a portrait of the author) illustrated Salvat-Papasseit's first volume of poetry, *Poemes en ondes herzianes* (*Poems in Hertzian Waves*), published in 1919. The following year he issued *Contra els poetes amb minúscula. Primer manifest català futurista* (*Against Lowercase Poets. First Catalan Futurist Manifesto*), a call for an unspecified modernity in poetry. *L'irradiador del port i les gavines* (*The Harbour Light and the Seagulls*) appeared in 1921, and also included a number of visual poems. The poet who showed most clearly contemporary influences from France and Italy was Joaquim Folguera, who published Catalan versions of Italian Futurist poems and works by Apollinaire in the *noucentiste* journal *La Revista* (1917). Some of these were republished in his posthumous *Traduccions i fragments* of 1921.

The end of the early Catalan literary avant garde coincided with the military *coup d'état* of 1923 that imposed the dictatorship of Miguel Primo de Rivera, abolished the Mancomunitat and effectively suppressed Catalan nationalism. Dalmau meanwhile continued his work in Barcelona, mounting an exhibition by Picabia in 1922 and Salvador Dalí's first one-man show in 1925. Miró moved to Paris and Dalí to Madrid, but neither ever severed their links with Catalonia. The early deaths of Folguera and Salvat-Papasseit had left Foix as the sole major literary figure of the Catalan avant garde. He published the prose poems *Gertrudis* (1927) and *KRTU* (1932), both illustrated by Miró, and had a key role in the important contemporary journal *L'Amic de les arts* (Sitges, 1926–29).

Two of the collaborators on *L'Amic de les arts* were the art critic Sebastià Gasch and the writer Lluís Montanyà. Together with Dalí they produced in 1928 the most strident of avant-garde manifestos in Catalan, the *Manifest antiartístic català*, generally known as the *Manifest groc* (*Yellow Manifesto*) because

of the colour of the paper on which it was printed. It championed modernity: cinema, jazz, contemporary architecture, photography, motor cars and ocean liners; and contemporary figures: Picasso, Juan Gris, Le Corbusier, Stravinsky, Tristan Tzara. Its targets however were specifically local, for it attacked modern Catalan poetry and music, while venerable cultural institutions such as the music society, the Orfeó Català, were denounced as steeped in the torpor of the past and lacking in boldness and invention.

With the arrival of the Second Republic in Spain in 1931, Catalan nationalism and cultural life were revived. Most prominent among the artistic organizations was ADLAN, Agrupació 'Amics de l'Art Nou' (Association of Friends of New Art) which was founded in 1932 and became the major champion of the avant garde. Its members included Dalí, Miró, Foix, Gasch, the composer Robert Gerhard, the architect Josep Lluís Sert and other members of the association GATCPAC (Grupo de Arquitectos y Técnicos Catalanes para la Arquitectura Contemporánea). ADLAN mounted three Miró exhibitions, the first Picasso retrospective (1936) and the Exposició logicofobista which included almost all avant-garde Catalan artists. It also organized shows devoted to leading figures of the European avant garde: Alexander Calder (1933) and both Hans Arp and Man Ray (1935). There were concerts of contemporary music too, especially jazz, film showings, poetry readings (by García Lorca, for example). In 1934 ADLAN and GATCPAC were responsible for the special issue devoted to twentieth-century European art of the classy cultural magazine *D'ací i d'allà*. Miró designed the cover and an accompanying *pochoir*. All this creative energy was crushed by the fascist uprising of 1936 and the ensuing Spanish Civil War.

Geoff West

OPPOSITE:
Joan Salvat Papasseit,
L'irradiador del port i les
gavines, 1921
(BL, new acquisition)

Belgrade

Zenit and Zenitism

Zenit, the International Review for New Art was the key avant-garde magazine in the newly created Kingdom of Serbs, Croats and Slovenes. Zenit was published from 1921 to 1926, initially in Zagreb and from 1924 in Belgrade. The founder and director, editor and publisher and the chief ideologist of the Zenit programme was the poet and critic Ljubomir Micić. During the six years of its existence Zenit introduced many innovations into the heterogeneous culture of Yugoslavia, displayed receptiveness to radical foreign art, and promoted all forms of modern artistic expression: film, theatre and dance, design and architecture, typography and graphic layout. Zenit brought together a wide circle of Yugoslav and foreign collaborators and published articles in their original languages and scripts. The number of Yugoslav Zenit contributors varied during this period because of frequent conflicts and polemics, particularly between the avantgardists and modernists. The most significant Zenit authors apart from Micić were Boško Tokin and Ivan Goll (co-authors of 'Zenit's manifesto'), Branko Ve Poljanski (Branko Micić), Dragan Aleksić and Marijan Mikac, and among the artists the visual contributions of Mihailo S. Petrov and Josif Klek (Josip Seissel) epitomized Zenitist art and painting. Some of the graphic works by El Lissitzky, László Moholy-Nagy and Louis Lozowick among others were created especially for Zenit. The most valuable visual contributions to Zenit were examples of new approaches to art and graphic design, ranging from those influenced by Expressionism in the early issues to Constructivist designs based on the Russian avant garde, Bauhaus, Neo-plasticism and other sources. One complete issue of Zenit was devoted to young Czech artists, and Ilya Ehrenburg and El Lissitzky edited issues 17–18 (1922), dedicated to new Russian art. In its international orientation Zenit collaborated with Central European reviews such as the Hungarian Ma, Romanian Contimporanul, Polish Blok and Bulgarian Plamk.

The trans-Yugoslavian avant-garde movement Zenitism offered, as its own unique contribution, the symbolic figure of 'Barbarogenious', a forceful, healthy and original young man, a native of the Balkans, a new man and a new creator who would awaken, rejuvenate and transform the old and exhausted civilization of Europe. With this utopian concept of barbarism as a cultural model, Zenitism made a passionate and creative demand for total change in art and throughout the world. Proclaiming the 'Balkanization of Europe' at the beginning of the 1920s, Zenit was acknowledged and welcomed into the family of the most prestigious international avant-garde reviews.

Zenit was also active as a cultural body, with its own publishing house and art gallery; Zenitists organized theatrical and musical events, matinées and evenings with lectures, and so on.

In 1924 Micić organized the First Zenit International Exhibition of New Art in Belgrade. For the first time the Belgrade and Yugoslav public could see avant-garde works by about twenty-six artists from eleven countries, classified as Expressionism, Futurism, Cubism, Constructivism, Purism and Zenitism. The Russian and Ukrainian emigrants El Lissitzky, Archipenko, Zadkine, Kandinsky, Grünhoff and Charchoune were most strongly represented; Lozowick represented the United States; Peeters, Belgium; Balsamdjieva, Kachulev and Bojadjieff, Bulgaria; Delaunay and Gleizes, France; Medgyes and Moholy-Nagy, Hungary; and, among others, Paladini and Prampolini represented Italy. Biller, Foretić, Gecan, Petrov and Klek represented the diversity of Yugoslav art. Yugoslav Zenitist art was shown at the First Contimporanul International Exhibition in Bucharest in 1924 and at the Exhibition of Revolutionary Art of the West in Moscow in 1926.

After six years of avant-garde innovation Zenit was banned in December 1926 amid accusations of disseminating Bolshevik propaganda. Micić left Belgrade for Paris, where he continued to publish Zenitist novels and poetry, in French. Zenitism was influential in the formation of the Slovenian avant garde, and after Zenit ceased publication Tank (1927–28) carried on as the cultural model of Slovene Constructivism, created by Avgust Černigoj and Ferdo Delak.

OPPOSITE:
Branko Ve Poljanski,
Tumbe, 1926

(BL R.F.2005.a.457)

In 1926 in Belgrade and in 1927 in Zagreb Ve Poljanski organized a representative exhibition of contemporary French modern painters. His last avant-garde performance, in 1927 in Belgrade's main square, was a free distribution of his books published in the Zenit collection, *Tumbe* (*Upside Down*) and *Crveni Petao* (*The Red Rooster*). He subsequently left for Paris, where he made a living as a painter. In 1930 he exhibited in the gallery of the Polish poet Leopold Zborowski and published the 'Panrealist manifesto'.

Belgrade Surrealism

The Surrealist programme was articulated in Serbia in the 1920s by a group of young Belgrade artists and poets, including Milan Dedinac, Marko Ristić, Dušan Matić, Rastko Petrović, Aleksandar Vučo and Monny de Boully (Salmon Moni de Buli). Some of these were editors of the magazines *Putevi* (*Roads*) 1922–24, *Svedočanstva* (*Testimonies*) 1924–25 and *Crno na Belo* (*Black on White*) 1924; in 1926 Dedinac published *Javna ptica* (*Public Bird*), a Surrealist poem with photomontages; Đorđe Kostić, Oskar Davičo and Đorđe Jovanović published the magazine *Tragovi* (*Traces*) 1928–29 and Zvezdan Jovanović, *50 u Evropi* (*50 in Europe*) 1928–33. The Belgrade Surrealist group established contacts and co-operation with André Breton, Paul Éluard, Louis Aragon, André Thirion and other French Surrealists. The crowning point of this collaboration was the seminal multi-media publication of Serbian Surrealism, the almanac *Nemoguće – L'impossible* in 1930, which established a platform for the Belgrade Surrealists.

Apart from programme texts, original contributions by Serbian Surrealists included photographs (Nikola Vučo), photograms (Vane Bor), photocollages, collages, photomontages and assemblages (Ristić, Aleksandar Vučo and Matić) in which they proposed new visual structures, innovation and experimentation with new media, primarily with photography and film.

As a sequel to the almanac *Nemoguće – L'impossible*, the Belgrade Surrealists published their official review *Nadrealizam danas i ovde* (*Surrealism Here and Now*) in 1931–32. In 1932 the Belgrade Surrealists staged the first Surrealist Exhibition at the 'Cvijeta Zuzorić' Art Pavilion in Belgrade, where they displayed their editions and publications, together with about twenty-five paintings and drawings by Radojica Živanović Noe. In 1933 the Belgrade Surrealists were disbanded following the imprisonment of Davičo, Jovanović and Koča Popović for their alleged revolutionary activities.

Milan Grba

OPPOSITE:
Werner Gräff,
Here Comes the New Photographer! (*Es kommt der neue Fotograf!*), 1929

In this manual for the new photographer, Gräff provides details of how to execute close-ups, photograms and other New Vision strategies.

(BL RF.2006.b.90)

Berlin

Berlin in 1900 was Europe's youngest national capital and still finding its place as a political centre, let alone a cultural one, for the recently unified Germany. This changed during the period under discussion, which saw Berlin develop into an international centre for the avant garde.

An artists' secession movement was established in Berlin in 1898. Like their Vienna and Munich counterparts, the Berlin Secessionists were protesting against academic conservatism, and they in turn came to be considered too reactionary for some as Expressionism became the predominant artistic and literary style in the years immediately preceding the First World War. Expressionism in the visual arts received new impetus with the arrival of artists from the Dresden group Die Brücke (The Bridge) in 1910, and it was one of these, Max Pechstein, who led a New Secession, which later split again to form the Free Secession in 1914.

Pechstein and his Brücke colleague Ernst Ludwig Kirchner, like original Secessionists Käthe Kollwitz and Max Slevogt, became prominent in poster art and book illustration. This art form was especially significant as Berlin also became a focus for avant-garde writing, which flourished in the city's literary cafés. Most famous of these was the Café des Westens, nicknamed 'Café Grössenwahn' (Café Megalomania). Its regulars included Jakob van Hoddis, whose poem 'Weltende' (End of the World, 1911) was a landmark in Expressionist literature, juxtaposing apocalyptic and comic images and language to describe the collapse of old certainties; and Georg Heym, a major talent lost to a premature death in 1912.

A posthumous edition of Heym's poems with woodcuts by Kirchner magnificently combines Expressionist art and literature, but the two came most vitally together in the Expressionist periodicals of the time. Chief among these were Franz

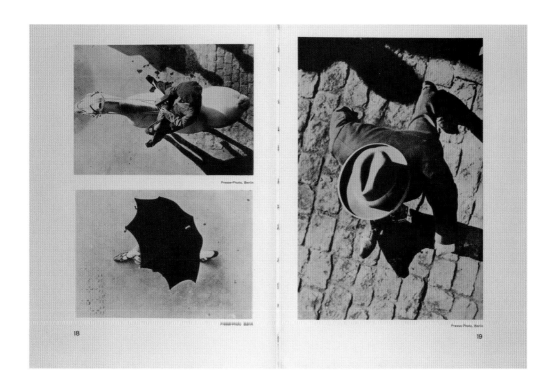

18

19

BERLIN

77

Pfemfert's *Die Aktion* and Herwarth Walden's *Der Sturm* (*The Storm*), with their striking reproductions of artwork and publication of new poetry, drama and prose. Walden in particular was a brilliant entrepreneur of the arts, who turned *Der Sturm* into an international avant-garde brand; there were *Sturm*-sponsored literary evenings and travelling exhibitions, a *Sturm* gallery and theatre, and series of *Sturm* books by and about contemporary writers and artists.

If some Expressionists welcomed the outbreak of war in 1914 as the embodiment of their apocalyptic visions, their excitement was short-lived in the face of all-too-real horrors. Yet despite the trauma of war and defeat and the social, political and economic upheaval that followed, by the mid-1920s Berlin was enjoying a golden age as a modern industrial metropolis and a focus for international art and culture. Nonetheless, writers and artists politicized by the war and the failure of post-war revolutions kept alive the image of human suffering, exploitation and poverty beneath the glittering surface. George Grosz's merciless line

drawings of bloated capitalists, brutal militarists and the wretched poor are a prime example. Grosz was involved in Berlin's Dada movement, but like other Berlin Dadaists such as the left-wing publisher Wieland Herzfelde he had an overtly political stance that gave Dada a sharper edge of social criticism than in its other manifestations. Grosz later became associated with Neue Sachlichkeit (New Objectivity), not an organized movement but a term used to describe the rejection of Expressionism in favour of a style no less deeply personal but rooted in a clear perception of social reality. In literature the term was applied to writers such as Alfred Döblin, whose novel *Berlin Alexanderplatz* (1929) is the great literary depiction of 1920s Berlin.

Theatre in Berlin had long had a political edge, and after the war this became more pronounced and deliberate, nowhere more so than in Erwin Piscator's 'Proletarian Theatre'. Piscator sought to use theatre as a means of political education, redefining the classics with radical new production styles as well as presenting

OPPOSITE:
Georg Heym,
Umbra vitae, 1924.
Woodcuts and design by
Kirchner.

(BL C.107.dg.15)

Helmar Lerski,
Everyday Heads: Unknown People (Köpfe des Alltags: unbekannte menschen), 1931

Lerski was involved in many Expressionist films, including *Metropolis* (1927). This studio study of heads uses studio lights and mirrors to give dramatic effects, but also reflects the New Vision interest in everyman – the sitters came from employment agencies.

(BL, new acquisition)

modern works by both German and foreign authors. A similar desire to make theatre a tool of social change rather than mere entertainment drove Bertolt Brecht as both writer and producer, but he and composer Kurt Weill also achieved one of the great popular – and entertaining – successes of the decade with *Die Dreigroschenoper* (*The Three-penny Opera*).

Drama was also increasingly available through the medium of film. *Die Dreigroschenoper* was itself filmed, and Brecht scripted and directed *Kuhle Wampe*, set among the unemployed poor of late 1920s Berlin. But it was the stark chiaroscuro, styl-ized sets and brooding atmosphere of Expression-ist masterpieces like Robert Wiene's *Cabinet des Dr Caligari* and Fritz Lang's *Metropolis* that ensured German film of the period a place in cinema history. Meanwhile Walter Ruttman's 1927 docu-mentary *Berlin, Sinfonie der Grossstadt* (*Symphony of the City*) broke new ground in portraying the everyday life of the city – a visual counterpart to Döblin's near-contemporary *Berlin Alexanderplatz*.

However, perhaps the most enduring and popular modern image of inter-war Berlin comes from a much later and very different film, the musical *Cabaret*. This imagining of the city in the period just before Hitler came to power reflects a certain truth: a contemporary *Guide to Decadent Berlin* offers a similar picture of bohemian cafés, cabarets, nightclubs and low-life bars. Cabaret itself was certainly an important feature of Berlin's cultural scene. Literary cabarets such as the Expres-sionist Neopathetiker had existed before 1914, but post-war Berlin saw a boom in cabaret as pure entertainment. Although this had fewer intellectual pretensions, serious writers such as Brecht still wrote for (and sometimes performed in) cabaret, notable artists illustrated posters and programmes, and sharp political satire played a major role. Jazz music and sexual frankness placed even the most frivolous cabarets firmly in the progressive camp, and most were swiftly closed when the Nazis came to power.

This was, of course, what put an end to the avant garde in Berlin, as elsewhere in Germany. The Nazi regime sought to crush all that was progressive and perceived as 'un-German' in the arts, although the Nazis themselves were not averse to sly borrowings from the vocabulary of modernism, for example in the films of Leni Riefenstahl. However, such borrowings in the service of a narrow and vicious ideology were a world away from the flourishing of modern art which had characterized Berlin's 'golden twenties'.

Susan Reed

Brussels

Surrealism in Belgium is usually identified with René Magritte. He was, however, just one member of a group of avant-garde writers and artists who launched Surrealism in Belgium in the mid-1920s. The original nucleus of the group comprised the writers Paul Nougé, the group's chief polemicist and theorist; Camille Goemans and Marcel Lecomte; as well as the musician André Souris. They had collaborated on *Correspondance* (1924–25) which consisted of twenty-two single-sheet critical parodies of the works of leading contemporary French and Belgian writers. Magritte and his friend the composer, collagist and poet E.L.T. Mesens joined them in 1926, followed by the writer Louis Scutenaire in 1927.

The post-war period was marked by a revolt against the values that had resulted in the slaughter of the First World War. Young Belgian artists eagerly caught up with international avant-garde movements such as Cubism, Futurism and Constructivism. Belgium's first Dadaist, Clément Pansaers, remained a marginal figure in Brussels, though he had a formative impact on Lecomte. Later Mesens and Magritte collaborated to produce two Dadaist periodicals, *Oesophage* (1925) ('available in the best hair-dressing salons') and *Marie* (1926).

When Magritte came to Brussels to study at the École des Beaux-Arts he met artists such as Pierre-Louis Flouquet and Victor Servranckx, whose Cubo-Futurism and Constructivism he initially shared. He also made contact with the architect Victor Bourgeois who, with his brother Pierre, founded the periodical *7 Arts*, the leading Brussels modernist periodical of the 1920s. The 7 Arts group promoted the fine and the applied arts on an equal footing and aspired to unite art and society. Theo van Doesburg, Filippo Tommaso Marinetti and Le Corbusier came to give lectures in Brussels.

The 7 Arts group dominated the Brussels avant-garde scene in the 1920s, so it is not surprising that the young Nougé should have launched *Correspondance* with an attack on *7 Arts*: 'The coming of a new art hardly concerns us. Besides art has been demobilised, one must rather live.' The Paris Surrealists André Breton, Paul Éluard and Philippe Soupault were also among the targets of *Correspondance*, thus achieving the aim of attracting the recognition of the Paris group while also retaining a distinct identity. Breton and Eluard came to Brussels in June 1925 and Nougé and Goemans signed the manifesto *Revolution First and Always*, albeit characteristically issuing a tract of their own in September to clarify their position.

The Brussels Surrealists wanted to challenge norms of thought and behaviour by subverting expectations, but in a calculated manner from within. Plainly this stress on premeditation is at odds with the Paris Surrealists' harnessing of the unconscious through techniques such as automatic writing, dreams and trances. The Brussels group rejected individual stardom and public recognition, choosing instead self-effacement and collective action. Nougé likened their activities to the covert operations of thieves. The writers published little, sometimes under a pseudonym or even anonymously, and privileged short forms such as poems, aphorisms and tracts. The periodicals they edited were cheaply produced. Magritte, by contrast, was openly productive but he always retained his ordinary bourgeois appearance and worked in a corner of his sitting-room, rather than in a proper studio. Despite being a founder member of the Belgian Communist Party, Nougé did not want to follow the political or artistic line of any official political party and the Brussels group steered clear of the twists and turns of the Paris group's contorted relationship with the Communist Party.

Nougé and Magritte collaborated on *Some Writings and Drawings* (1927), a spoof school textbook, claiming that the poems and drawings within were newly discovered works by Clarisse Juranville, the author of numerous improving works for young minds. Nougé's poems, masquerading as exercises in conjugation, infiltrate subversive content, while Magritte's drawings do not illustrate the text and fail to provide any practical information. Souris composed a cantata, allegedly based on rediscovered notations by Juranville. In contrast to the Paris Surrealists' contempt for music, the Brussels group encouraged the Surrealist sensibility to express itself in music too.

By the mid-1920s Magritte was reaching his mature style. He became interested in the problematic relationship between objects, words and images, as exemplified in the now iconic image of a pipe with the label 'this is not a pipe' in 'blackboard' script which first appeared in the Brussels periodical *Variétés* (15 January 1929). On his return

BULLETIN INTERNATIONAL

DU

SURRÉALISME

N° 3 Publié à Bruxelles

par le Groupe surréaliste en Belgique

20 AOUT 1935 PRIX : 1,50 Fr.

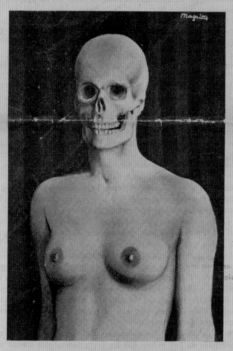

LA GACHEUSE

SOMMAIRE

1) LE COUTEAU DANS LA PLAIE.
2) André BRETON : Discours au Congrès des Ecrivains pour la défense de la Culture

Illustrations de René MAGRITTE et Max SERVAIS

to Brussels after a three-year stay in Paris, where he mixed with the Surrealists in André Breton's circle, Magritte and his wife rented a ground-floor flat in Jette, a suburb of Brussels. This was to be his home for the next twenty-four years. The Brussels Surrealists took to meeting there every Saturday. Many of the titles of Magritte's paintings were devised by his friends in his sitting-room. They also helped invent images and wrote collectively or individually about his work – this time under their own names, eschewing their preference for self-effacement when it came to promoting Magritte's work. Nougé's preface to the catalogue of the Magritte one-man show organized by Mesens in 1931 emphasizes the subversive quality of Magritte's paintings, comparing the power of his work to alter our view of the world with the undermining of the social order by communist agitators.

The 1930s saw close collaboration between the Brussels and Paris Surrealist groups. Mesens now played a key role, drawing on the expertise he had gained in art dealing, publishing and public relations to become in effect the 'entrepreneur' of Belgian Surrealism. Breton and Éluard guest-edited a special issue of the Brussels periodical *Variétés*, with Mesens acting as intermediary. The two groups collaborated on a collective defence of the patricide Violette Nozière which Mesens published in Brussels under his Nicolas Flamel imprint (1933). The international exhibition of mainly Surrealist works organized under the auspices of the periodical *Minotaure* and hung by Mesens was held in the Palais des Beaux-Arts in Brussels in May–June 1934 (Magritte's *The Rape* and Dalí's *The Great Masturbator* were discreetly shown behind a curtain). Breton came to Brussels in June to deliver his lecture 'What is Surrealism?' to coincide with the exhibition and it was published with Magritte's *The Rape* on the cover. Mesens, with the collaboration of his close friend Eluard, edited a special issue of the Belgian periodical *Documents 34* (June 1934), drawing contributions from both groups.

When a new Surrealist group led by Achille Chavée was founded in Wallonia in 1934, Mesens was keen to seize the opportunity to form a cohesive 'Belgian' group within international Surrealism. The two groups jointly signed a manifesto, *The Knife in the Wound*, against the Franco–Soviet pact of mutual assistance, and collaborated on the second *International Bulletin of Surrealism* issued under the banner 'The Surrealist Group in Belgium' (20 August 1935).

Mesens subsequently played a pivotal role in promoting Surrealism in England when he moved to London in 1938.

From its launch in 1924, Brussels Surrealism had constituted the most committed and united group outside Paris, spanning three generations under the leadership of Nougé, Marcel Mariën and Tom Gutt. The painter Paul Delvaux was never a member of the group, although he exhibited with the Surrealists from the mid-1930s. Related Brussels-based movements include Christian Dotremont's Revolutionary Surrealism, the international COBRA group (1948–51) co-founded by Dotremont and the Phantomas group (1953–80).

Teresa Vernon

OPPOSITE:
Bulletin international du surréalisme, No.3 (20 August 1935). The cover reproduces René Magritte's gouache 'The Spoiler'.

Bucharest

The major representatives of the Romanian avant garde belonged to the inner circle of the avant-garde movements in Europe. Many played an important part in the birth of the European avant garde. Urmuz (Demetru Demetrescu Buzău), who spent his life in complete anonymity and committed suicide at the age of forty, was the precursor of the Absurd. His prose, written before 1910 and published after his death in 1923, earned him posthumous fame among the Romanian avant garde. Tristan Tzara (Samuel Rosenstock) initially wrote poetry in Romanian, at the age of sixteen co-editing the modernist magazine *Simbolul* (*The Symbol*, 1912), and after settling in Switzerland invented Dadaist literature and helped launched Dadaism at the Cabaret Voltaire in Zurich in 1916. Victor Brauner was a renowned avant-garde painter, as was Marcel Janco (Marcel Iancu), the painter and architect who inaugurated the artistic avant garde and disseminated modernism in Bucharest. In the central area of Bucharest Janco designed urban residences, family houses and villas. In his practical and theoretical work Janco laid the architectural foundations of the modern movement in Romania. Janco's wide interests also included the theatre, for which he designed costumes and stage sets. Constantin Brancusi (Brâncuşi) was one of the most important sculptors of the twentieth century; Eugene Ionesco (Eugen Ionescu) was one of the foremost playwrights of the Theatre of the Absurd.

Many of the Romanian avant-garde writers, sculptors, painters, designers and architects (Brauner, Janco, Mattis-Teutsch, Maxy, Michăilescu and Petraşcu, among others) ventured abroad at different times into the international avant garde and returned home to resume their work in Romania while maintaining connections with the European movements. Others who did not return kept in close touch with their friends in the avant garde back home and contributed to the Romanian artistic and literary environment. For example, Tzara from Zurich and Benjamin Fondane/Fundoianu (Benjamin Wexler) from Paris produced articles and poetry for the Bucharest avant-garde reviews. Brancusi travelled from Paris to show his work in Bucharest and regularly sent pieces to the exhibitions of the group Tinerimea Artistică (The Artistic Youth). On the other hand Romanian sculptors (Petraşcu, Codreanu, Ladea and

Constantinescu) came to Brancusi's studio in Paris to learn. This studio was also a well-established meeting-place for the Romanian avant garde, frequently visited by Tzara, Fondane and Brauner, for example.

Constructivist magazines and manifestos 1922–28

After his return to Bucharest in 1922, Janco, together with Ion Vinea (Eugen Iovanaki), founded the review *Contimporanul* (*The Contemporary*) 1922–32. Contributors included, apart from Romanian artists and writers, international figures such as Theo van Doesburg, Hans Arp, Francis Picabia, André Breton, Filippo Tommaso Marinetti and others. The publication maintained a close relationship with similar foreign reviews such as *L'Esprit nouveau*, *Der Sturm*, *Zenit*, *Blok*, *Disk* and *De Stijl*. Special issues were dedicated to architecture, theatre and cinema, and Brancusi. Apart from including literary articles with a sociopolitical orientation in the early issues, translations of selected avant-garde manifestos, reviews and discussion of modern art, theoretical works on abstract art and architecture, each issue was illustrated and printed in fine typography. By mid-1924 *Contimporanul's* aesthetic doctrine was Constructivism. In issue 46 (1924) Vinea published 'Manifest activist către tinerime' (Activist Manifesto to the Young), moving *Contimporanul* to the forefront of the Romanian avant garde with its radical rejection of the art and literature of the past. Six months after *Contimporanul's* manifesto, Ilarie Voronca (Eduard Marcus), Stephan Roll (Gheorghe Dinu) and Brauner published the only issue of the magazine *75 HP* (horsepower). In *75 HP* the painter Brauner and the poet Voronca created the original innovation of *Picto-poetry*; Voronca published theoretical articles and the manifesto 'Aviograma' and

OPPOSITE:
Ion Vinea,
The Paradise of Signs
(*Paradisul suspinelor*), 1930
(BL YF.2004.b.1805)

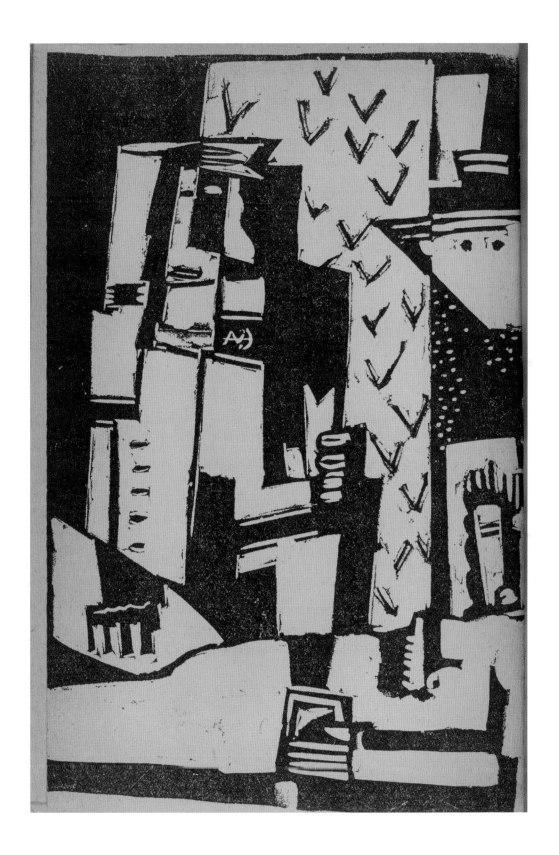

Brauner exhibited his picto-poetry in a one-man show. The magazine 75 *HP* was succeeded by its sister publication *Punct. Revistă de artă constructivistă internaţională (The Point. Review of International Constructivist Art)*, 1924–25, directed by Scarlat Callimachi and edited by Brauner, richly illustrated with linocuts by Janco, Brauner, Petraşcu and Mattis-Teutsch and containing contributions by Vinea, Roll, Callimachi and others. Thanks to the participation of Tzara, the periodical included contributions from French and Belgian writers and artists. *Punct* was continued by *Integral. Revistă de sinteză modernă (The Integral. Review of Modern Synthesis)*, 1925–28. Directed by Voronca, *Integral* had two editorial offices, one in Bucharest – F. Brunea-Fox (Filip Brauner), Ion Călugăru (Buium Croitoru), Max Herman Maxy and Voronca – and the other one in Paris – Fondane and Mattis-Teutsch. The first issue of *Integral* presented the manifesto of the Integral group and its 'integralist' ideas; the second issue was devoted to Brancusi, and no. 12 was a special issue devoted to Italian Futurism. *Integral* paid more attention than *Contimporanul* to the visual arts. All the covers of this review were printed in various colours and abundantly illustrated with typographical designs by Maxy. Together with Janco, Maxy was the main organizer of the avant-garde exhibitions in Bucharest. In 1925 Maxy founded a workshop of Constructivist art associated with *Integral* (Atelierul de arte constructiviste *Integral*), and this activity ran parallel to his teaching at the Academy of Decorative Arts modelled on the German Bauhaus. The Academy had an exhibition room (The Permanent Art Deco Salon for the Modern Interior) where temporary exhibitions were held.

Toward Surrealism: 1928–39
The years 1928–39 marked the second phase of the avant-garde movement in Bucharest. The magazine *Unu (One)* 1928–32, 1935, edited by Saşa Pană and Moldov (Marcu Taingiu); and the group of writers, painters and artists around this magazine (Pană, Bogza, Cosma (Ernest Spirit), Voronca, Roll, Brauner, Herold, Perahim, Maxy) were increasingly influenced by Surrealism. In the first issue Pană published his manifesto and among other texts offered to readers the poetry of an inmate of the psychiatric clinic in Bucharest. *Unu* published work by Man Ray, Breton, van Doesburg, Aragon,

Éluard, Mayakovsky, and others. In 1930, beginning with *Urmuz*, the Unu publishing house embarked on a decade of publishing activity. After *Unu* Surrealism was sustained by a succession of short-lived magazines: *Alge (Seaweeds, 1930–31, 1933)*; *Muci (Snot, 1932)*; and *Viaţa imediată (Everyday Life, 1933)*, which published a manifesto called 'Poezia pe care vrem să o facem' (The Poetry We Wish to Write) signed by Geo Bogza, Paul Păun, Jules Perahim and Gherasim Luca (Zollman Locker).

Avant-garde group exhibitions
Manifestations of the visual arts in Bucharest were linked to avant-garde magazines and sponsored and organized by the groups around them. Arguably the most important avant-garde event in Bucharest was the First Contimporanul International Exhibition held at the headquarters of the Fine Arts' Union at the end of 1924 with the participation of Maxy, Janco, Mattis-Teutsch, Brauner, Brancusi, Petraşcu and Solomon. The foreign exhibitors came from Belgium, Poland, Hungary, Czechoslovakia, Germany, Sweden and Yugoslavia. The exhibition presented paintings, sculptures, prints and interior decorations. Apart from the *Contimporanul* exhibitions (1929, 1930, 1932, 1935 and 1936), other notable exhibitions were Faclă (Torch) on the occasion of Marinetti's visit to Bucharest in 1930, the Group of Fine Arts Criterion in 1933 and the Fine Arts Group in 1934.

Maxy's house in Bucharest was a regular meeting-place for left-wing artists, actors and writers, famous for literary readings, lectures and sociopolitical debates. The Enache Dinu café (owned by Roll's father) was another rallying-point for the youngest of the avant-garde generation headed by Pană, Roll and Bogza. In this literary circle *Unu* was born.

Milan Grba

Budapest

Around 1907, when Cézanne, Gauguin and Matisse were first exhibited in the Hungarian capital, various radical artistic groupings formed in Budapest. This period also saw several Hungarian artists visit or settle in Paris. The appearance of an avant-garde movement in Hungary was denoted by the exhibition in 1909 of the Seekers group. Their style emerged from Cézanne, Fauvism, Expressionism and Futurism. Changing the group's name to 'The Eight', members Lajos Tihanyi, Róbert Berény, Béla Czóbel, Dezső Czigány, Ödön Márffy, Dezső Orbán, Bertalan Pór and leader Károly Kernstok continued to seek the role of art in leading an attack on social conventions alongside an aesthetic rebellion against bourgeois cultural values. The philosopher György Lukács's essay 'The Ways have Parted', the first theoretical contribution to Hungarian Post-Impressionism, articulated their final break with tradition. The movement, having no publications of its own at this time, used the literary journal *Nyugat* (West), among others, as a forum. Béla Bartók's *Allegro barbaro* marked the beginnings of modernism in Hungarian music.

Lajos Kassák, who became the key figure of the Hungarian avant garde, published free verse in 1912 and founded the journal *A Tett* (*The Deed*) in 1915, influenced by *Die Aktion* of Berlin. His charismatic personality and social-ethical views drew similarly left-minded artists and writers from the lower and lower-middle classes, most of whom had attained their intellectual stance without much formal education. They considered themselves closer to the masses, and therefore better equipped to effect social change through the power of art and literature. Kassák's journal published articles discussing avant-garde art alongside Expressionist and Cubist illustrations. A central characteristic of *A Tett* was its uncompromising anti-militarism. The September 1916 international issue bravely included works by authors from countries fighting against Austria–Hungary. The authorities banned the journal outright.

Kassák started a new publication, *Ma* (*Today*) in November 1916. This periodical was mainly concerned with art and literature, but the social and political ideas remained. The *Ma* circle was not a static set of writers and artists, rather a loose network with Kassák practically alone as a constant from beginning to end. Kassák's article 'The poster and the new painting' in the first issue promoted the poster as an 'agitator' by its very nature. Initially *Ma* did not nurture a preference for any single style; its exhibitions, lectures and own pages sampled numerous manifestations of international avant garde, introduced progressive artists from Russia to the Netherlands, promoted Bartók and modern music alongside new poetry, founded an innovative theatre under János Mácza and presented the radical aesthetics of Béla Uitz, József Nemes-Lampérth, Sándor Bortnyik and János Mattis Teutsch. They viewed the proletariat as bearer of a new culture, demanding a social revolution. '*Ma* does not want another school of art, it wants an entirely new art and outlook on the world', wrote the journal's art critic Iván Hevesy. In the midst of political debate, Anna Lesznai represented a drift towards the primeval in her folkloristic drawings, and Béla Kádár's paintings blended the naïve with Expressionism.

The term Activism was first used by Kassák in February 1919 and *Ma* gave itself the subtitle 'Activist art journal' soon thereafter. In March 1919 the dictatorship of the proletariat or Commune was proclaimed, which during its 133 days inspired a heightened avant-garde productivity. Radical art schools were organized, Activist performances were widely attended, László Péri and Kassák's wife Jolán Simon played leading roles. To gain support from the populace, poster propaganda was thriving. Uitz's 'Red soldiers, forward!' and Mihály Bíró's 'Man with hammer' used Expressionistic tools, while Bertalan Pór combined Futurist and Expressionist elements in 'Proletars of the world, unite!' Róbert Berény's posters recruited for the Commune's defence. In painting, Bortnyik's poster-like *Red Locomotive* was significant as a communist propaganda tool. Activists' works, including works by László Moholy-Nagy, were acquired for public collections. The Activists strived to bridge the gulf between themselves and the masses, but the performance of a revolutionary play by János Mácza to a working-class audience ended in ridicule.

Kassák, however, increasingly opposed the communist regime, refusing to fall into (any) line, and advocated the independence of the artist. In July 1919 he published his letter to Béla Kun, whose government he found overly doctrinaire and interfering, and demanded autonomy over what he thought himself more competent to carry

MA

AKTIVISTA MŰVÉSZETI ÉS TÁRSADALMI FOLYÓIRAT

SZERKESZTŐSÉG ÉS KIADÓHIVATAL:	SZERKESZTIK:	ELŐFIZETÉSI ÁR MAGYARORSZÁGON:
BUDAPEST, FERENCIEK-TERE 9.	KASSÁK LAJOS és UITZ BÉLA	EGY ÉVRE 60 K. FÉLÉVRE 30 K.

MARIA UHDEN: RAJZ

ÁRA 3 KORONA.

out than any politician. Unsurprisingly *Ma* was labelled 'an excrescence of bourgeois decadence' and proscribed. The Commune's defeat in August triggered political reprisals, and a mass flight of artists and authors ensued, mainly to Vienna and Germany. The Treaty of Trianon produced a devastating outcome for Hungary: the country lost 60 per cent of its population and two thirds of its territory.

Some avant-garde artists retreated from Budapest to provincial towns. The architect Farkas Molnár founded the Pécs Artists' Circle, and Mácza edited a journal in Kassa (Košice, by then in Czechoslovakia). In Budapest, Tivadar Raith started the journal *Magyar Írás* (*Hungarian Writing*) in 1921, devoted to new art and literature; Molnár later wrote on architecture for it. Actor-playwright-poet Ödön Palasovszky attempted to revive modernist life in the capital, presenting experimental stage performances in workers' centres. His manifesto *Új Stáció* (*New Station*, 1922) called for a collective art for the masses. The Mentor Bookshop became a hub, hosting an exhibition of 'Modern Graphic Art' in 1923 featuring Kádár, Máttis-Teutsch, Uitz, Bortnyik and others. During this period, however, the avant garde in Hungary was somewhat fragmented and mostly isolated from the latest international trends, and it was the journal *Ma* during its Vienna heyday and the Hungarian exiles in Germany that provided a lifeline for the home front.

Once the dust settled on post-Commune reprisals, the avantgardists filtered back from exile, returning en masse upon the closure of *Ma* in Vienna in 1925. Bortnyik and Molnár, both back from the Bauhaus, had a joint exhibition at the Mentor Bookshop, marking the revitalization of the Budapest avant garde. Ernő Kállai's book *Új magyar piktúra* (*New Hungarian Painting 1900–1925*, 1925) with Moholy-Nagy's cover design, was an important theoretical work on modern painting.

Kassák and the young poets around him, Andor Németh, József Nádass, Zoltán Zelk, Gyula Illyés and Tibor Déry, started a new journal, *Dokumentum* (*Document*), which endeavoured to represent Constructivist ideology. They were, however, soon forced to suspend the journal, along with *Hungarian Writing*, for financial reasons.

Palasovszky's Dadaist Green Donkey Theatre had its first performances with the participation of Hevesy, Lazicziusz, Bortnyik, Molnár and others. Named after Palasovszky's pantomime and Bortnyik's painting *Green Donkey*, the theatre remained a notable, but exceptional and short-lived, example in Hungary.

Berény, Kassák and Bortnyik used graphic design to reach the mass audience they had always craved. Bortnyik opened a design school workshop based on his Bauhaus experiences, and also to implement the role of the 'artist as social creator' advocated by Kassák in his *Book of Purity* (1926).

In architecture the avant garde was represented by the journal *Space and Form*, a few Constructivist public and residential buildings of the 1930s, and Molnár's villa designs utilizing Bauhaus ideas.

Kassák's 1928 journal *Munka* (*Work*) concentrated more on society and politics until banned for political reasons in 1939. Its observational and reporting character was highly compatible with its dominant visual genres, photography and photocollage. The avant-garde photography of the 1920s, especially some of Moholy-Nagy's works, evolved into a strongly socially minded style in Hungary. *Munka* was no longer a truly avant-garde platform, as an older Kassák retrospectively implied: 'My previous papers had been rowdy, revolutionary, startling . . . like avant-garde journals in general. *Work* was as modest as its title, it wished but to work.'

The authorities launched a renewed attack on modern art. Teachers with a modern spirit were dismissed from the Academy of Fine Arts, police raided classes and expelled students for 'subversive' material found, including socio-photomontages. Subsequently most left Hungary yet again for Berlin, Paris and the Netherlands.

Ildiko Wollner

OPPOSITE·
Ma, Vol.4 No.6 (1919)
(BL C.194.c.20)

Copenhagen

'To make the picture burst forth, make the lines explode against each other, the colours jar with their strong power and force, to represent reality, as it is, when one experiences it most strongly', wrote Harald Giersing in 1917. He was regarded by many as the spokesman for a new generation of Danish artists – amongst them Swane, Isakson, Rude, Scharff and Nielsen – who had travelled to Paris in the years leading up to the First World War and been inspired by the avant-garde art they found there.

During the First World War itself, Copenhagen experienced an artistic heyday. This was owing to two factors: firstly, that war made travel more difficult and most Danish artists returned to the capital (along with an influx of artists from other Scandinavian countries) and, secondly, Denmark's neutrality, which resulted in favourable economic conditions that sustained a flourishing art market. As well as the established annual Kunstnernes Efterårsudstilling (Artists' Autumn Exhibition), a new artists' association was formed in 1914, taking its name, Grønningen, from its first exhibition venue, a hastily built structure which, because of its brightly decorated exterior, came to be known as the Indian Shack. During the war years there were also several exhibitions organized by the German art expert Herwarth Walden; the one in 1918, International Art: Expressionists and Cubists, included a wide variety of European modernists. All these factors helped to create a vibrant and stimulating atmosphere, within which the avant garde – Futurism, Cubism and Expressionism – was central.

The artist Axel Salto captured the sense of excitement at belonging to a movement beyond national boundaries: 'Like a powerful phalanx, the "New Art" advances; Frenchmen, Russians, Germans, Scandinavians, Poles, Spaniards, artists of all countries are on the march. Art stands at the entrance to a new, rich land of plenty…It is becoming more and more obvious that artistic ability is on the increase among young art here in Denmark.' An important outlet for the Danish debate about the 'New Art' lay in the polemic journal Klingen. Inspired by the German Der Sturm, it contained contributions by many prominent artists such as Karl Larsen and Vilhelm Lundstrøm, and was regarded as the mouthpiece of Danish modernism. As well as debating art, reviewing exhibitions and reproducing artwork, it included poetry by writers including Emil Bønnelycke and Tom Kristensen, and distinctive aphorisms by Giersing ('Everything new is good, because everything good is new.').

After the fervour of the war years, 1920s Copenhagen did not have the same artistic intensity. Leading artists again travelled abroad, coming home only for short periods. However the artists known as 'de Fire' (the Four) – Lundstrøm, Salto, Larsen and Johansen – returned to Copenhagen on a regular basis to set up exhibitions and so try to keep enthusiasm for the New Art alive. Debate on art continued but was increasingly set in the wider context of social and political ideas and demands for action and reform. The most influential avant-garde forum for debate of this decade was the journal Kritisk Revy, edited by a group of young architects led by Poul Henningsen. Its subject matter was initially functionalist architecture, but its coverage widened to encompass sharp social criticism and cultural discussion.

Dadaism also left its mark on Copenhagen at this time, through the painter Eugène de Sala (a member of the Sturm Group and provider of the cover for Merz no. 6, October 1923) and the poets Rudolf Broby-Johansen and Harald Landt Momberg. The publication of Broby-Johansen's collection of poetry Blod. Ekspressionære Digt (Blood. Expressionist Poems) from 1922 has in later times been regarded as a ground-breaking moment in Danish literature, not just because of the poems' new syntactical style but in their social criticism. The poems dealt with taboo themes, including prostitution and abortion, and within five days of publication all unsold copies of the book were confiscated. At his trial Broby-Johansen famously

OPPOSITE:
Linien, No.1 (15 January 1934). This journal was key in introducing Surrealism to Denmark.

(BL X.955.3345, 1984 facsimile)

linien

15 jan. 1934 **1**
1 aar nr. **1**

pris: 50 øre

Engang var elverfolk realiteter i menneskets fantasi. Hos heiberg (elverhøj) glædede man sig over dem æstetisk. I dag beskæftiger man sig overhovedet ikke med dem. Dog beskæftiger bjerg sig endnu med amoriner.

Heiberg og guldalderdigtningen benyttede sig af clicheer. Det var æstetiseren. Der er et svælg imellem os og denne romantik. Vor kunst er en afbildning af de i vort sjæleliv (dybet) eksisterende realiteter — deraf ordet: sur-realisme.

eller bille.

richard s. mortensen: kvindens bøn.

linien

er en sammenslutning af abstrakt-surrealistiske kunstnere, der for første gang i aar afholder en samlet udstilling; denne udstilling vil blive gentaget hvert aar, og vi vil bestræbe os for til stadighed at samle den kunst, der maa betegnes som nyskabende — denne sammenslutnings organ bliver tidsskriftet: *linien*.

Naar nye tanker i en mindre kreds har vokset sig tilstrækkelig stærke, opstaar et naturligt krav om at sprede dem ud til et større publikum. Tiden har det i sig, at en saadan kreds sjældent staar alene; indenfor andre kulturfelter danner sig lignende cirkler, hvis ideer er aandsbeslægtede. I en tid som den, vi lever i for øjeblikket, hvor modsætningerne bliver større og større, er det nødvendigt for ligesindede indenfor alle felter at slutte sig sammen — skabe en kulturel front.

Dette blad fremkommer som et vaaben i den intellektuelle ungdoms haand mod den overhaandtagende reaktion indenfor kunst og videnskab.

Initiativet er taget af en kreds unge malere og

TEGN SUBSKRIPTION PAA MINOTAURE i ILLUMs BOG-AFD.

5 Numre (3 Special- og 2 ordinære Hefter); pr. Aargang Pris Kr. 31,—.

Bøger om Kunst. - Billige Kunstserier. Tidsskrifter. Alle Reoler frit tilgængelige

delivered his own defence speech, in itself seen as a work of the avant garde, which has become almost as well known as the poems themselves.

In the 1930s a new artistic movement made its impact felt on the city – this time it was Surrealism and a group of artists known as 'the abstract artists'. The leading figure during this time was the painter Vilhelm Bjerke Petersen. He had studied under Paul Klee and Wassily Kandinsky at the Bauhaus School in Weimar, which had influenced his book *Symboler i abstract kunst* (*Symbols in Abstract Art*), published in 1933. Together with Ejler Bille and Richard Mortensen, he formed the group Linien (The Line), with a journal on experimental art of the same name, aimed at a broad Scandinavian readership. Its intention was to bring together artists of different persuasions and to set Danish art within an international context. Its opening editorial refers to the journal as 'a weapon in the hand of the intellectual youth'.

Linien's first exhibition was in 1934 and included pictures by, amongst others, Kandinsky, Max Ernst and Joan Miró. However, within a short time there were disagreements within the leadership of Linien regarding the nature of Surrealism. Bjerke Petersen broke away from the group and started his own journal, *Konkretion*. In 1935 he arranged the International Art Exhibition – Cubism – Surrealism, held at Den Frie Udstilling (The Free Artists' Building), which was significant in that the works of Danish artists were shown in a wider context than before, alongside those of artists from other Scandinavian countries but also alongside their European counterparts, such as Dalí and René Magritte. One of the Danish contributors to this exhibition was the controversial artist William Freddie – some of whose works during the 1930s were considered pornographic, and confiscated.

The first four decades of the twentieth century had seen Copenhagen assume a more prominent position in the wider European art scene, brought about initially by the very special circumstances of the First World War and then fostered by a lively and stimulating cultural debate.

Barbara Hawes

Cracow

Before the First World War Cracow was a peripheral city of the Austro-Hungarian province of Galicia. However, the city had maintained its leading position as a centre of Polish culture and art. It was there that the first independent exhibitions had been organized in 1911–13, manifesting avant-garde tendencies through the works of such artists as Tytus Czyżewski and the Pronaszko brothers. Together with Leon Chwistek and Stanisław Ignacy Witkiewicz, they set up in 1917 the first Polish avant-garde group Formiści (Formists), until 1919 known as the Expressionists. Their programme showed the influence of Cubism, Expressionism, Dadaism and Futurism with reference to Polish folk art. Artists sharing an interest in the new artistic trends were accepted in the group because the Formists had no doctrine. The core of their philosophy was 'the autonomy of the form'. The group attracted painters, poets, sculptors, stage designers and even dancers. Rita Sacchetto (wife of August Zamoyski), a world-renowned dancer, was a member of the group performing a 'Formist dance' at the accompanying events. In the period 1917–22 the Formists organized four exhibitions in Cracow and a few in Warsaw, Lwów and Poznań attracting a good deal of attention. They published their own periodical, Formiści (6 issues, 1919–21). It included works by Futurist poets Bruno Jasieński, Stanisław Młodożeniec and Anatol Stern, and also translations of European poets such as Vladimir Mayakovsky and Guillaume Apollinaire. The typography was not a strong point of their publication.

Although the members of the group were loosely connected, their aim was to form a unique Polish movement with reference only to European avant-garde trends. In 1922 the Formists broke up – some artists showed interest in Futurism, some joined the more traditional arts groups, while others decided to go their own way.

Cracow was also a cradle of Polish Futurism, rooted in native Formism with the influence of Italian and Russian Futurism. In 1918 the leading figure of Polish Futurism, the poet Jasieński, together with Młodożeniec and Czyżewski, initiated the Futurist Club Katarynka (Hurdy-gurdy), which was meant to be a place of meetings and avant-garde events. A number of Futurist publications were issued by Katarynka. Their aim was to create modern art based on a new civilization and liberated from the domination of traditional stereotypes. Poetry readings, rallies, Futurist concerts (e.g. a piano placed on a cart), balls and street happenings were meant to shock and attract attention and often ended in brawls provoking police interventions. In 1921 two publications Nuż w Bżuhu (A Nife in the Stomak) and A Manifesto Concerning the Immediate Futurization of Life, both edited by Jasieński, caused scandal and were immediately confiscated by the censors. The manifestos demanded the futurization of all aspects of life and conformed to the reformed orthography and typography. 'Artists to the street!' 'Art must be a surprise!' – proclaimed Futurists. Futurism reached its peak in 1921–22, but the year 1923 saw the decline of the movement in Poland. Other avant-garde movements replaced Futurism. Although the Futurists failed to spread new art, their activities made a significant impact on future Polish avant-garde movements.

Zwrotnica (Railway Switch, 1922–27), a journal funded, edited and issued by Tadeusz Peiper, was the first attempt at using functional typography. He deliberately chose the name of the publication to signal a change of direction in artistic trends, like a railway switch, from the final phase of Futurism to the new tendencies in Polish art. The name however sometimes caused amusing incidents. The journal had been purchased by a provincial engineer who immediately returned it with a note saying that a respectable bookshop should not send a serious reader such a trivial publication. Zwrotnica was the main forum for the Polish avant garde of the period. Peiper paid a great deal of attention to its graphic layout, which is why such artists as Władysław Strzemiński and Mieczysław Szczuka began almost at once to collaborate with Zwrotnica, as Kazimierz Podsadecki was to do later. Peiper's connections with many European art communities contributed to a section on European avant-garde trends with texts and illustrations of prominent artists such as Marinetti, Tzara, Léger, Le Corbusier and Malevich. Zwrotnica propagated the cult of the new society with its symbol the machine and also the belief that technological improvements would bring about positive changes in society. Peiper in his articles formulated the most radical avant-garde theory to appear in the 1920s – this won him the title of the 'Pope of the Avant-garde'. Poets Jan Brzękowski, Julian Przyboś

LINJA

front ogólny

głos poezji idącej

(1931—1933)

and Jalu Kurek, attracted by Peiper's work, edited the second series of *Zwrotnica* (1926–27) and later on formed a poetic group called the Cracow avant garde. The group manifested itself through a series of poetic volumes published by *Zwrotnica*. The journal ceased publication due to the conflict with other literary journals in the country and ultimately the lack of funds.

The continuation of *Zwrotnica* was the journal which focused on new poetry, called *Linja* (*Line*) (5 issues in 1931–33), edited by Kurek, Przyboś and Brzękowski and designed by Podsadecki.

Poznań

Poznań, the principal city of western Poland (Wielkopolska) remained within the German state until the end of the war. In 1918 Poznań artists, inspired by German Expressionism, formed the group Bunt (Revolt) concentrated around the journal *Zdrój* (*Fountain*) which was founded by Jerzy Hulewicz, graphic artist, writer and editor.

Bunt artists rebelling against set canons and provincialism in Polish art, politically advocating independent Poland and social transformation, could be considered as the first Polish avant garde. Members of Bunt had close contacts with the Cracow Formists as well as the Berlin magazines *Die Aktion* and *Der Sturm*. The group included painters and graphic artists Stanisław Kubicki and his German wife Margarete, Władyslaw Skotarek, Stefan Szmaj, poet Artur Bederski and sculptor August Zamoyski (who later joined the Cracow Formists). The first exhibition took place in Poznań in April 1918. Later exhibitions were also organized in Berlin, Cracow and Lwów as well as Poznań in collaboration with the Formists, the Łódź Jewish group Jung Idysz and the German group Die Kommune. The Bunt members represented the Polish art community at the 1922 Congress of International Progressive Artists in Düsseldorf.

In 1929, to commemorate the tenth anniversary of Poland's independence, the Universal Exhibition of Art was held in Poznań – former

Formists and members of Bunt showed their works, as did members of the Warsaw Constructivist group Praesens.

Zdrój, a literary and art journal, was a forum for collaboration between Polish writers and artists as well as for Polish and German artistic contacts. In *Zdrój* Bunt artists published literary articles and manifestos – for example 'Us' and 'To the Holy Rebel' by Hulewicz, and 'What we want' by Jan Stur. The important feature of the journal was illustrations in the form of Expressionist woodcuts, linocuts and drawings. These dealt with religious and typical Expressionist motifs – love, ecstatic dance, psychiatric illness and depression. *Zdrój* took up such activities as publishing its own literature series (20 books in total), organizing public lectures and literary evenings. Associated with *Zdrój* was the publishing house Ostoja founded by Hulewicz, which published Expressionist poems and plays illustrated with Expressionist prints.

Bunt's political polarization led to the disintegration of the group in 1920. It was succeeded by a new literary group, Zdrój.

Magda Szkuta

OPPOSITE AND RIGHT:
Linja (1931–33)
(BL RH.9.X.1733)

Florence

Florence, long an important artistic and cultural city, became in the first years of the twentieth century also a centre of the avant garde, largely on account of the publication there of some innovative journals.

Lacerba, one of the most important of Futurist publications, appeared between 1 January 1913 and 22 May 1915, its publication being fortnightly until January 1915 and thereafter weekly. In all, sixty-nine issues were produced.

The journal was the creation of Ardengo Soffici and Giovanni Papini, both of whom had previously worked together on other Florentine journals such as *Leonardo* and *La Voce*; curiously, it was their disagreement with Giuseppe Prezzolini, the editor of *La Voce*, that led to the foundation of *Lacerba*, yet Attilio Vallecchi, the publisher of *La Voce*, financed and printed the new journal. The title, suggested by Soffici, comes from the *L'Acerba*, an allegorical-didactic poem by Cecco d'Ascoli, a contemporary of Dante burnt at the stake for heresy. The word, which translates as 'sour' or 'young', implies a spirit of revolt against traditional values and received ideas. The removal of the apostrophe from the title was intended to arouse curiosity about its meaning.

Papini was a man of letters who never quite understood the Futurists and disagreed with their total rejection of artistic tradition. Soffici – a painter, critic and poet – was, on the other hand, an important link between the French and Italian avant garde. He had lived in Paris between 1900 and 1907 where he befriended Picasso, Georges Braque, Juan Gris, and men of letters like the Symbolist poet Jean Moréas, Max Jacob, Blaise Cendrars and Guillaume Apollinaire. He was initially critical of the Futurist manifesto and impatient with Filippo Tommaso Marinetti's self-publicity and bombastic style (*marinettismi*). His outspoken criticism, in an article in *La Voce*, of the 1911 Futurist Exhibition at the Padiglione Ricordi in Milan prompted a 'punitive' expedition to Florence by Marinetti, Boccioni, Carrà and Sironi; it resulted in Boccioni's slapping Soffici and an ensuing scuffle at the Giubbe Rosse café, the meeting-place of the city's literary and artistic avant garde, and a second fight at the railway station the following morning. The two groups were later reconciled after mediation by Gino Severini.

Between 15 March 1913, when collaboration with the Futurists began, and August 1914, when the journal turned instead to campaigning for Italy's entry into the war, *Lacerba* became one of the most typographically adventurous journals in Europe. It included intricate and imaginatively designed 'Words-in-Freedom' (with spectacular ones by Cangiullo, Severini, Soffici and Carrà); original works by artists; and photographic reproductions of their art, manifestos and music scores. There were contributions from all Futurist artists (with the exception of Giacomo Balla), especially Umberto Boccioni and Carlo Carrà (both with theoretical texts and original artworks), and Marinetti wrote for most issues. Soffici's contacts also brought in a number of distinguished contributors from abroad – there were drawings by Picasso and Alexander Archipenko, and articles by Jacob, Ambroise Vollard and Apollinaire. French contributions were published in the original language – with the exception of Apollinaire's *L'antitradition futuriste* which was translated into Italian for greater effect.

Though relations between *Lacerba* and the Futurists soured following publication in February 1914 of a critical article by Papini, contributions by Futurist writers and artists continued to appear in its pages. From August, however, the journal became increasingly concerned with campaigning for Italian intervention in the war, and that change was confirmed when Papini became sole editor in January 1915. Publication of the journal ceased with Italy's entry into the war, its final issue having the heading 'Abbiamo vinto!' ('We have won!')

The journal carried advertisements for related publications also published by Vallecchi, such as *L'almanacco purgativo* (1914), *I manifesti del futurismo* (1914) and works by Papini and Soffici. It also promoted editions of works by writers such as Pietro Aretino and Choderlos de Laclos, who were

OPPOSITE:
Ardengo Soffici,
BÏF..., 1915
(BL, new acquisition)

considered to be free (and therefore kindred) spirits, and publicized exhibitions like the first Futurist exhibition in Florence (30 November 1913–15 January 1914). Both Soffici and Papini later published collections of their articles for *Lacerba*. Soffici's *BÏF&ZF+18 simultaneità e chimismi lirici*, one of the great Futurist books, was published first in 1915, shortly after *Lacerba*'s demise, in folio and then again in octavo in 1919.

L'*Italia futurista* was the second important avant-garde journal published in Florence. Its fifty-one issues appeared between 1 June 1916 and 14 February 1918, filling the void created by the demise of *Lacerba*. It was the Futurist organ during the war, publishing for the first time various manifestos – *La nuova religione della velocità* (1916, I, 1), *Cinematografia futurista* (1916, I, 10) and *La danza futurista* (1917, II, 21). Its contributors included Marinetti, Boccioni, Francesco Cangiullo and Giacomo Balla, but it also published poetry by Arnaldo Ginna, S Emilio Settimelli, Bruno Corra and Maria Ginanni, whose concern with the occult veers between Symbolism and Surrealism. The journal ceased publication after the move of Settimelli to Rome at the end of 1917. Ginna, an editor of the journal as well as a contributor, also directed the film *Vita futurista* (1916) written by Marinetti, Carrà, Settimelli and Balla.

Quartiere latino (24 October 1913–28 February 1914, 8 issues) was founded and directed by Ugo Tommei and, like *Lacerba*, printed by Vallecchi.

It numbered several *Lacerba* names among its contributors – Corrado Govoni, Italo Tavolato and Camillo Sbarbaro – besides publishing articles on Papini and Prezzolini and reviewing exhibitions in Florence, including the Futurist exhibition of 1913.

The Mask (1908–29), a theatrical journal, was founded and edited by Edward Henry Gordon Craig, theatre director, designer and theorist. His production of Ibsen's *Rosmersholm* had been staged at the Teatro della Pergola in Florence in 1907, and Craig then settled in the city, where he founded – in 1913 – the Gordon Craig School for the Art of the Theatre. His innovative and visionary theories about stage lighting and theatrical production, which included the idea of replacing actors with marionettes, may have influenced Balla and Depero.

It should also be remembered that Giorgio de Chirico painted his first Metaphysical canvases of town squares in Florence following the artistic epiphany he experienced in 1909 in the city's Piazza Santa Croce. It was therefore appropriate that when the Maggio Musicale Fiorentino – destined to become one of the major music festivals in Europe – was established in 1933, de Chirico was invited to design the sets and costumes of the festival's inaugural production (Bellini's *I Puritani*), becoming the first in a long line of distinguished artists to contribute to the festival.

Chris Michaelides

Kharkiv

At the beginning of the twentieth century, Kharkiv, until 1934 the capital of the Ukrainian Soviet Socialist Republic, was a dynamic industrial and cultural centre, with a flourishing university. Kharkiv artists participated in the international modernist dialogue. Advocates of Russian Futurism regularly visited during their 'tours of the provinces'. Alexander Shevchenko, the leading theoretician of Neo-primitivism, was born there. Various groups of avant-garde painters emerged prior to the First World War: Yevgeny Agafonov's Blue Lily studio (1907–12) and the Ring group (1911–14). The Kharkiv Guild of Arts started in 1914. During the hungry years of the revolution, Velimir Khlebnikov found refuge in the village of Krasna Poliana near Kharkiv, the home of the Syniakov family. The Neo-primitivist artist Maria Syniakova, one of five sisters – the 'muses of Russian Futurism' – produced vibrant watercolours of the horrors of war, and illustrated books by the Liren poets Aseev and Bozhidar. In 1917 the group Union of Seven (Mishchenko, Kosarev, Bobritskii, Diakov, Kalmykov, Tsapok and Tsybis) was founded, and the following year it held its exhibition with a lavish catalogue *Seven plus Three* (Gladkov, Mané-Katz and Yermilov) reproducing their works. Similar reproductions appeared in 1919, in the *Collection of New Art*.

In the 1920s Kharkiv was at the forefront of the new 'proletarian culture'. Cultural life boomed, and most literary organizations moved their headquarters there. By 1921–22 Kharkiv had outstripped Kyiv in the number of its literary publications. In 1925 the playwright Mykola Kulish moved to Kharkiv, and in 1926 Les Kurbas relocated his Berezil Theatre (the renamed Molodyi Teatr) there. Avant-garde composers Anatolii Butsky and Naum Pruslin wrote atonal music for Berezil, and the founder of the (USSR-wide) Association for Contemporary Music, Nikolai Roslavets, was in the early 1920s director of the Kharkiv Conservatoire.

The New Generation

The third stage of Ukrainian Futurism began in October 1927 with the founding of the journal *Nova Generatsiia* (*New Generation*) under the editorship of Mykhail Semenko, who had spent the previous two years in Odessa involved with the most revolutionary art form: cinema. Semenko served as chief editor at VUFKU (the All-Ukrainian Photo-Cinema Administration), encouraging talented Ukrainian writers to adopt the new art. Two of these, Yuri Yanovsky and Maik Johansen, worked with Alexander Dovzhenko, who reinterpreted Surrealism and Dadaism in a Ukrainian context.

The thirty-six issues of *New Generation* focused on 'proletarian art'. Initially it urged the destruction of old forms, but when the editors recognized that this would not help build a new society, they actively propagated Constructivism and Suprematism. Contributors included poets (Geo Shkurupii and Oleksa Vlyzko), film and theatre artists (Marko Tereshchenko), graphic artists and photographers (Dan Sotnyk), and especially architects (Mykola Kholostenko and Ivan Malozemov). There was a strong emphasis on industrial design and city planning. German and Europe-wide developments in these fields were closely monitored. In 1925–28 the first Soviet skyscraper (Derzhprom) was built.

The Panfuturist philosophy of art as a single universal process, rejecting national introspection, meant *New Generation* fostered an international climate. Titles, sub-titles and summaries appeared in French, German, English and Esperanto. Foreign associates included Herwarth Walden, László Moholy-Nagy, Enrico Prampolini, Johannes Becher and Rudolf Leonhard, as well as figures from Georgia and Russia (Eisenstein, Mayakovsky, Rodchenko, Shklovsk and Vertov) and also (in spite of official disapproval of contact with émigrés) the Paris-based film-maker Eugene Deslaw, who had left Ukraine when the Soviets came to power. Mikhail Matiushin wrote an article, 'An attempt at a new sensation of space', especially for the journal; Walden's 'Art in Europe' appeared in *New Generation* in 1928. *New Generation* gave considerable coverage to German Expressionism and the Bauhaus movement; several times it advertised *Der Sturm*. After Malevich's expulsion from Moscow, Semenko published a series of his articles on modern art.

New Generation is renowned for its design. All three artistic directors (Meller, Sotnyk and Petrytsky) paid great attention to layout, typography and illustrations. *New Generation* and its sister publication in Kyiv – *Avant-garde Almanac of Proletarian Artists of the New Generation* (1930, edited by Shkurupii) – were considered to be a laboratory where 'scientific workers in art' conducted 'experiments'. The most striking examples of its Futurist prose

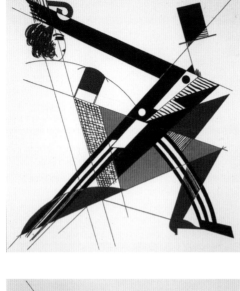

A. Petrytsky,
Theatre designs
(*Teatral'ni stroi*), 1929.

Costume designs for the
ballet 'Eccentric Dance',
choreographed by Kasyan
Goleyzovsky, 1922.

(BL C.185.bb.3)

are Andrii Chuzhyi's novel *The Bear Hunts the Sun* (in which the text was laid out in the style of 'concrete poetry'), Favst Lopatynskyi's eleven-page film-script *Dynamo*, and Leonid Skrypnyk's 'screened novel' *The Intellectual*, presented as a film-script on which the author – himself a film-maker – gives a commentary.

New Generation ceased publication under pressure from the authorities in December 1930. Dmytro Horbachov called it 'the last voice of the Soviet avant-garde, a voice that remained unconstrained, militant, and European'.

Avant-garde and Spiralists

In 1926 *New Generation* acquired a rival as the flagship of revolutionary art in Ukraine: a new literary-artistic association called Avant-garde, headed by Valerian Polishchuk. Members included artists Heorhii Tsapok, Oleksandr Levada and Vasyl Yermilov. *Avant-garde* took as its symbol the spiral (loved by another Kharkiv-born Constructivist, Vladimir Tatlin). The Spiralists saw man as part of a 'universal collective'. Proclaiming 'Art is an expression of the culture of nations and an era should become better through international contacts', they aimed to nurture the spirit of revolutionary artists of both East and West. They sought materials from abroad for their publications: the newspaper *Era of Construction*, three issues of *Bulletins of Avangard* and, ultimately, the journal *Artistic Materials of Avant-garde* launched in 1929 – which, like *New Generation*, used French, German and Esperanto, but also Yiddish. The Spiralists saw themselves as the acme of Kharkiv Futurism: a full-blown proletarian Constructivist movement, realizing the goals about which *New Generation* merely theorized.

Kharkiv Constructivism

Post-revolutionary art in Kharkiv is termed the 'Yermilov period' after Yermilov who, with Bernard Kratko, founded in 1919 the Educational-Industrial Workshops, somewhat similar to Vkhutemas in Moscow and the Bauhaus in Germany. Following the Constructivist aim of 'art in everyday life', Yermilov's work included propaganda trains and automobiles painted with slogans; designs for revolution-day parades; decor for the Kharkiv Circus, the Red Army Club and Kharkiv Actors' Club; and even cigarette packets. The book *The*

Ukrainian Revolutionary Poster (1932) contains examples of his posters. An adept of Minimalism, Yermilov constantly experimented with materials and textures – nails, screws, wrought copper, forged metal and processed wood – which he combined with collage techniques (photographs, newspapers and magazine clips) as in his wall-newspapers shown at the Pressa Exhibition (Cologne, 1928).

In the 1920s Yermilov was greatly involved in book design, being the first artist in Ukraine to use photomontage for book covers. At the 1922 Leipzig International Graphics Exhibition Yermilov's graphics, book designs and posters won a gold medal. His cover for the magazine *Avant-garde* (1929) with its lower case 'a' became an iconic symbol of the movement. Other prominent artists (Vasyl Krychevsky, Vadym Meller, Tsapok, Vlyzko and Adolf Strakhov) produced striking book covers in Constructivist style.

In the 1920s to early 1930s Constructivism was the dominant style in Ukrainian theatres; Meller, Oleksandr Khovstenko-Khvostov and Anatol Petrytsky were its main exponents. Meller's designs for Kurbas' production of *The Union Secretary* by Upton Sinclair (1924) won a gold medal at the 1925 Paris Exposition internationale des arts décoratifs et industriels modernes. Petrytsky came to the Kharkiv Opera after working for Kasyan Goleyzovsky at the Moscow Chamber Ballet and designing the production of Gogol's *Vii* at the Ivan Franko Ukrainian Dramatic Theatre. His deluxe album *Theatre Designs* appeared in 1929.

In 1932 the Soviet authorities declared Constructivism 'nationalistic' and harmful. By 1937 most avantgardists who had not emigrated had been killed, died in exile or were silenced for decades. Kurbas, Kulish and Polishchuk were shot in Solovki. Boichuk's School of Neo-Byzantine style was destroyed. Maik Johansen, Shkurupii, Oleksa Slisarenko and Semenko were also shot.

Olga Kerziouk

The interplay of artists from different ethnic and cultural backgrounds (Ukrainian, Russian and Jewish) produced a fruitful artistic milieu. Kyiv-based journals *In the World of the Arts* (1907–08), *Art and Printing* (1909), *Art* (1911) and *Art in Southern Russia* (1912–14) discussed developments in Western Europe and Russia. Significantly, the First Izdebsky Salon moved from Odessa to Kyiv in 1910 before moving to St Petersburg and Riga.

Kyiv artists generated some of the first avant-garde activities in the Russian Empire. Their début was the November 1908 Link Exhibition, where the main contributors were the Burliuk brothers, Oleksandr Bohomazov, Vladimir Baranoff-Rossiné and Alexandra Exter. In 1914 came the Ring Exhibition, highlighting the work of Bohomazov. Artists from Moscow and St Petersburg participated, and the Kyivans exhibited in both Russian capitals. Before the First World War many Ukrainian artists visited Paris; they had a Cercle des Ukrainiens club in the Latin quarter.

An influx of population, industrialization and modernization all fostered Kyiv's emergence as the centre of the avant garde. Its electric trams (the first in the Russian Empire) form a potent image in Bohomazov's Futurist paintings and drawings, which with their bold lines and sense of speed are reminiscent of the Italian Futurists.

During 1917–22, a strong indigenous avant garde with a unique Constructivist style in both painting and theatrical design developed. Vadym Meller and Exter designed costumes for the ballerina Bronislava Nijinska; Exter developed a unique teaching system at her Kyiv studio (1918–19). In 1919 the collection *Hermes* was launched with poems by Liren members Nikolai Aseev and Grigory Petnikov and associates of the Kharkiv Futurists: Ilya Ehrenburg, Osip Mandelshtam and Nikolai Evreinov.

In 1916 Les Kurbas came to Kyiv from Galicia and founded the experimental Young Theatre, which in 1919 was incorporated into the new First State Theatre of the Ukrainian Soviet Republic. Here (1920) he staged a landmark adaptation of Taras Shevchenko's epic *Haydamaks*. In 1922 he renounced his earlier aestheticism, and founded the Berezil Theatrical Association, which aimed at serving the proletarian revolution. This, in Kyiv and (from 1926) in Kharkiv, became the focal theatre in Ukraine. Kurbas' training technique emphasized

'mime-dance' over voice-work. Characters were to be conveyed by body and voice control; musical rhythm unified the whole work. Significant productions included *Oedipus Rex* (1918), Shakespeare in Ukrainian and *Jimmie Higgins* – the first-ever production to synthesize film and live actors (predating Erwin Piscator's work by several years). In 1925 photos from Kurbas' productions were highly acclaimed at the Exposition internationale des arts décoratifs et industriels modernes in Paris.

The Ukrainian Academy of Arts (later the Kyiv Art Institute) founded in 1918 by the government of the Ukrainian National Republic brought together the cream of Ukrainian talent: Vasyl Krychevsky, Yuri Narbut, Abram Manevych and Mykhailo Boichuk. Viktor Palmov and Kazimir Malevich joined later. In 1925 Vladimir Tatlin became head of the Theatre, Cinema and Photography Faculty. The Academy maintained contact with the most recent developments in Western art. Boichuk, the founder of the Ukrainian school of monumental art, visited the Bauhaus in 1926–27 and partially modelled his Mezhyhiria Art and Ceramics Institute (founded 1928) on it.

Ukrainian Panfuturism

In 1910 David Burliuk founded the first (Russian-language) Futurist group, Hylaea, in his family estate in southern Ukraine. Ukrainian-language Futurism began in 1913, when the twenty-one-year-old poet Mykhail Semenko and painters Vasyl Semenko and Pavlo Kovzhun formed the Kvero (Latin quaero: 'I seek') group, scandalizing the Ukrainian literary establishment with their calls for the 'destruction of art' and 'overthrow of idols'. In February 1914, when Ukrainians were celebrating the centenary of the birth of Taras Shevchenko, their national bard and symbol, Semenko published his poetry collection *Audacity*. Its preface

OPPOSITE:
Start-signal for the Future (*Semafor u Maibutnie*), No.1 (May 1922). Cover by Oleh Shymkov.

(BL C.191.b.14)

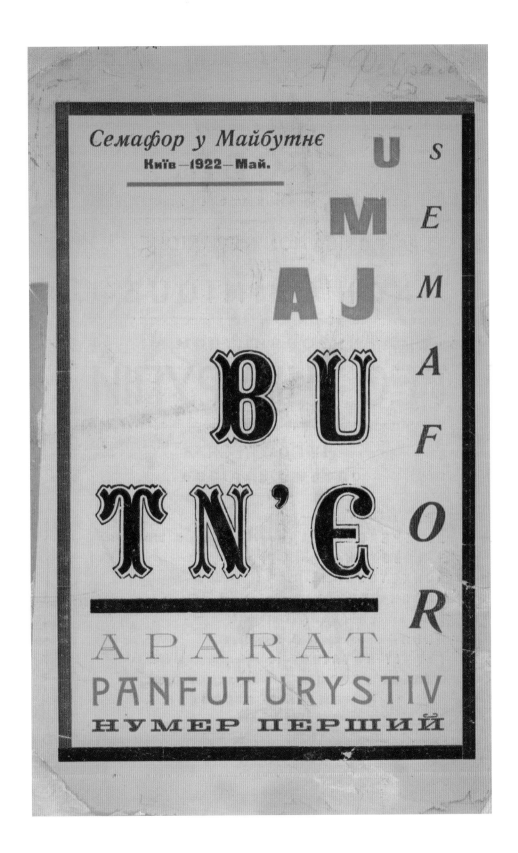

Семафор у Майбутнє
Київ—1922—Май.

U S E M A J BU TN'Є A F O R

APARAT
PANFUTURYSTIV
НУМЕР ПЕРШИЙ

(effectively the first manifesto of Ukrainian Futurism) proclaimed 'where there is a cult, there is no art', and (referring to Shevchenko's masterpiece *Kobzar* (*Minstrel*) – to Ukrainians second only to the Bible) concluded sacrilegiously: 'I am burning my Kobzar.' His second collection of poems, *Quaerofuturism*, quickly followed.

The First World War broke up Kvero. Vasyl Semenko was killed in action in 1915. A photograph with his face painted with Futurist designs and his picture *City* (1914) in the background has survived. Kovzhun survived the war but settled later in Lwów/Lviv. Mykhail Semenko spent the war years as a telegraphist in Vladivostok, writing prolifically. In 1919, back in Kyiv, he organized the group Flamingo which published some of his Futurist collections, illustrated by Alexandra Exter's protégé Anatol Petrytsky.

The second period of Ukrainian Futurism began with the foundation of the Association of Panfuturists (Aspanfut) in 1921. The Panfuturists embraced the entire avant-garde spectrum, though particularly esteeming Marinetti's Futurism, Dada and German Expressionism. *Semafor u Maibutnie* (*Start-signal for the Future*) and *Cataofalque of Art*, both of 1922, typify the group's objectives: to bury traditional art and to erect on its grave a new 'meta-art' of the future. *Semafor* included manifestos in French, German and English ('What do we want?'). 'The liquidation of art is our art', the Panfuturists declared. They promoted Dada through translations from the *Dada Almanach* (Berlin, 1920). The journal featured Tristan Tzara's *Negerlieder* and Richard Huelsenbeck's 1918 *First Dada Speech in Germany*. Geo Shkurupii wrote on Marinetti and noise-music. There were poems by Shkurupii, Oleksa Slisarenko and others. Semenko's eight-part 'Transoceanic Cable Poem' opened the journal.

With its striking colour cover and layout, *Semafor* made a strong visual impression. It used both traditional Cyrillic script and its own Latin-script transliteration, reflecting the group's aim of merging East and West.

In 1924 Semenko published his own collection of Futurist verses, for which he usurped Shevchenko's title 'Kobzar', thus completing the debunking Ukrainian cultural icons promised in his first manifesto a decade earlier. His Dadaist 'poezo-painting' *Barber* implies that it is time to consign the Renaissance masters to the dustbin of history. Later, in Kharkiv, Semenko developed his universalist Panfuturism further while remaining one of Ukraine's most prolific writers (he published thirty books between 1913 and 1936). His innovative language abounds in neologisms and in terms from technology and the natural and social sciences.

Futurist works of this era show the influence of other art forms. *The Panfuturists' October Collection* (1923), illustrated by Nina Henke-Meller, established a symbiosis between poster and poetry. Meller used the principle of montage for Maik Johansen's 1925 'cinematographic' novel *Adventures of MacLayston, Harry Rupert, and others*.

Film studios in Kyiv and Odessa developed an avant-garde tradition and film-making flourished under the producers Alexander Dovzhenko and Ivan Kavaleridze; the former corresponded with the émigré film-maker Eugene Deslaw, whom he met in Paris in 1930.

Local groups of Futurists were active in other cities: Kom-Kosmos in Kharkiv, Yugolef in Odessa, and the Moscow-based Village and City group for Ukrainian writers in the Russian Soviet Federated Socialist Republic.

Kultur-Lige
A major contribution to Kyiv's avant garde came from the Jewish Kultur-Lige (1918–25), which aimed at creating a contemporary Jewish culture for the Diaspora, 'from Moscow to New York, from London to Johannesburg'. In 1920 it held the First Jewish Art Exhibition of Sculpture, Graphics and Drawings (Epstein, Ryback and Lissitzky). Several of its prominent artists later moved elsewhere, but its Art School in Kyiv (director Mark Epstein) survived until it was closed by the Soviet authorities in 1931. The Kultur-Lige's own publishing house was renowned for its graphic art: El Lissitzky illustrated some ten Yiddish publications. Issachar Ber Ryback (1857–1535) worked as a book illustrator and a designer for Jewish theatres. In 1923 he published in Berlin an album of lithographs depicting Jewish types in Ukraine.

Olga Kerziouk

Leiden

The Netherlands escaped direct involvement in the First World War. They were spared the ravages of battle, but the first decades of the twentieth century were, as in the rest of Europe, a period of upheaval and turmoil. In literature this ferment manifested itself in the emergence of new styles and attitudes which turned violently against the work of predecessors. The university town of Leiden may primarily be remembered as the birthplace of Rembrandt, but it also gave birth to one of the few Dutch artistic journals that gained international recognition.

The journal *De Stijl* (*The Style*) and the movement associated with it were founded in 1917. The initiator was Utrecht-born Christiaan Emil Marie Küpper, who under the name of Theo van Doesburg was active as an architect and painter. Piet Mondria[a]n was the best-known figure among his co-founders. The architect and designer Gerrit Rietveld was another notable member of this group. What brought these artists together was the search for laws of equilibrium and harmony that would be applicable to life, society and art. The dominant style of work was one of austere abstract clarity, the basis of which was formed by the rectangle; the use of black, white and grey; and the primary colours red, blue and yellow. Some critics have labelled this Constructivist orientation as typical for the Puritan spirit of the northern Netherlands.

The literary involvement of *De Stijl* has been influential in (and restricted to) the development of modernism in the Netherlands. The journal entered the field of literature in April 1920 with a manifesto signed by van Doesburg, Mondriaan and another co-founder, Anthony Kok. From then on the journal devoted considerable space to verse, prose and manifesto-like essays. With the exception of a few poems, all these contributions came from the pen of I.K. Bonset, the pen-name of van Doesburg himself (possibly a rewriting of *Ik ben sot* – Dutch for 'I am mad'). Publication of poems by Kurt Schwitters and other Dadaists reflects the cosmopolitan outlook of the editors of *De Stijl*. There were, moreover, positive references to the work of French Surrealists such as André Breton and Louis Aragon. Bonset claimed that his serialized novel *Het andere gezicht* (*The Other Vision*) was

De Stijl, Vol. 5 (1922). Back cover with advertisements for avant-garde magazines and books.

(BL LR.411.a/7a)

DE STIJL

**MAANDBLAD VOOR DE MO-
DERNE BEELDENDE VAKKEN
REDACTIE THEO VAN DOES-
BURG MET MEDEWERKING
VAN VOORNAME BINNEN- EN
BUITENLANDSCHE KUNSTE-
NAARS. UITGAVE X. HARMS
TIEPEN TE DELFT IN 1917.**

I 1 1917

1

the first attempt in Dutch to apply the technique of automatic writing. Van Doesburg was an internationalist. He visited Berlin and Weimar in 1921 and the following year taught at the Weimar Bauhaus, where he associated with Raoul Hausmann, Le Corbusier, Ludwig Mies van der Rohe and Hans Richter. He was interested in Dada at this time and worked with Schwitters, Jean Arp, Tristan Tzara and others on the review *Mécano* in 1922.

The general bias of the movement associated with the journal was anti-scientific, anti-philosophical and anti-psychological. Rationality was suspect, individualism the relic of an antiquated age. The responsibility of the modern mind was to re-establish the harmonious relationship between the universal and the individual. The literary aim of the journal was to revitalize the word and restore the significance it had lost in the work of predecessors. Traditional syntax may have been adequate for their limited individualistic ambition, but it was not capable of expressing the contemporary collective experience. The poetical search was for the inner meaning of the word through a variety of techniques that included typography, orthography, and so on. *De Stijl* contributed significantly to the shaping of modern typography and to the merging of word and image. As was the case for many avant-garde poets, there was a close relationship between literary theory and practice in Bonset's work. In fact, poems seemed to be created to

illustrate his theoretical opinions rather than the other way round. The theory/manifesto of art appeared of greater relevance than the creation of literary works itself.

To create, in van Doesburg's mind, was an act of heroism. The editors of *De Stijl* introduced such notions as the heroic activity and heroic spontaneity of the mind, expressions reminiscent of Filippo Tommaso Marinetti and the Italian Futurists. In retrospect, we realize the implicit danger of such phrases. Futurism in art and fascism in politics were never far removed from one another. Van Doesburg's anti-Semitic feelings show clearly in his writing and in one of his essays he calls up visions of book burning to destroy the works of predecessors he despised. *De Stijl* shares a general tendency with other avant-garde movements at the time. Seeking means for diffusion of their ideas, artists turned to manifestos, public performances and collective art shows. In order to enhance the social significance of art, avant-garde theorists not only had to question the notion of subject-centred reason (individualism), but also the status and function of art as an institution within society.

The final issue of the journal (no. 90) was published in 1932 by Mrs van Doesburg in memory of her husband, after whose death in 1931 the group disbanded.

Jacob Harskamp

OPPOSITE:
De Stijl, Vol.1 No.1 (1917).
The cover image has been seen as symbolising the union of art and architecture.

(BL, LR.411.a/7a, 1983 facsimile)

Lisbon

José de Almada-Negreiros, author and graphic artist born in colonial São Tomé, began publishing drawings and writings in Lisbon in 1913. In 1915 he collaborated on the new journal *Orpheu*. *Orpheu* (two issues, January–March and April–June 1915) was the voice of the new poetic generation of men in their twenties. Mário de Sá-Carneiro's contributions use the Futurist innovations of an extended character set, trademarks and onomatopoeia. Alvaro de Campos (alias Fernando Pessoa) adds polyglottism to onomatopoeia. (He appears never to have experimented with visual poetry.) *Orpheu* was adversely criticized by Júlio Dantas. But Almada had his revenge.

The twenty-three-year-old Almada issued his so-called manifesto in 1916; eight pages long, printed on wrapping paper, its print run was tiny. Almada insults Dantas, then aged forty, a historical novelist and dramatist representative of the old school. He uses the now-familiar modern rhetoric of onomatopoeia (*Pim* to represent a gunshot) and the typographic pointing hand; everything is in capitals, with an occasional run of exclamation marks. *Pim* (pronounced 'peeng' with a nasal twang) sounds more like a pea-shooter than a revolver. And the *Manifesto* was more properly a personal squib than a declaration of artistic conviction. The opening:

> ENOUGH PUM ENOUGH!
> A GENERATION THAT ALLOWS ITSELF
> TO BE REPRESENTED BY A DANTAS IS A
> GENERATION THAT NEVER WAS! IT IS A
> DEN OF BEGGARS, NE'ER-DO-WELLS AND
> BLIND MEN! IT IS A REAM [sic] OF CHARLA-
> TANS AND BRIBE-TAKERS, AND IT CAN
> ONLY BEAR FRUIT BELOW ZERO! DOWN
> WITH THE GENERATION! DEATH TO
> DANTAS, PIM! A GENERATION WITH
> DANTAS ON ITS BACK IS AN IMPOTENT
> MULE! A GENERATION WITH DANTAS AT
> THE PROW IS A CANOE ON DRY LAND.
> DANTAS IS A GIPSY! DANTAS IS HALF
> GIPSY!

Some of the insults were patently ludicrous: 'Dantas is Dantas!'; and Almada accuses Dantas of being 'badly dressed', when he was in fact famous for his fine clothes. Dantas did not reply, and the two men – who frequented the same Lisbon haunts, such as Bertrand's bookshop – continued to greet each other when they met.

Almada's contact with Pessoa began with Pessoa's negative review of one of Almada's exhibitions around 1913. Almada told Pessoa he was ignorant of art, and from then on they were fast friends.

The Café A Brasileira in the Chiado district of Lisbon was a meeting-place for men of letters and had an exhibition space; Almada had an exhibition there in 1925. Pessoa, rootless by nature and therefore not a home-loving man, was a devotee; Almada portrayed him seated in A Brasileira with pen, *bica* (espresso) and cigarette.

Pessoa spent his formative years in South Africa and settled in Lisbon in 1905, earning his living translating English and French commercial correspondence. He hardly ever left the city again. Around 1914 he developed the idea of writing through a number of 'heteronyms' which allowed him to write in different styles because 'I am probably an hysteric-neurasthenic'. He invented biographies for his heteronyms. One of them, the Glasgow-educated naval engineer Alvaro de Campos, is the most easily identifiable with the avant-garde spirit, singing first of the excitement of city life and later of life's futility. Pessoa published little outside periodicals in his lifetime.

Besides proving its European credentials with poems by Guillaume Apollinaire in the original and translations of Filippo Tommaso Marinetti and others, and articles on art, *Portugal Futurista* (1917) included Almada's prose 'Futurist ultimatum to the Portuguese generation of the twentieth century', in which in Marinettian style he praises the regenerating power of war (at the time Portuguese troops were dying on the Allied side in the First World War) and a prose text by Alvaro de Campos (alias Pessoa), *Ultimatum*. Campos (not necessarily Pessoa) echoes Almada's gratuitous insults about the literary *ancien regime*:

> Get out, George Bernard Shaw, vegetarian of paradox, charlatan of sincerity, cold tumour of Ibsenism, fixer of unexpected intelligentsia, Kilkenny-Cat of yourself, Calvinist *Irish Melody* with words from the *Origin of Species*!

Barry Taylor

José de Almada-Negreiros,
self-portrait from his
A invenção do dia claro, 1921

(BL 12256.de.12)

London

The Bloomsbury Group differed from other European avant-garde movements of the period in that it did not produce a manifesto or publish a journal as such to disseminate its ideas. This was entirely consistent with the kind of avant garde Bloomsbury represented: an attention to domestic space rather than public spectacle, and an exploration of the complexity of internal thought processes rather than a championing of outburst and display. The title of the group is also unprogrammatic; it is simply named after the area of central London where they used to meet (and where some lived).

In 1917 Leonard and Virginia Woolf established the Hogarth Press, named after their home, Hogarth House in suburban Richmond. This was partly as a therapeutic activity for Virginia Woolf, who had suffered a number of breakdowns, but also as an outlet for emerging writers. In 1922 they published Virginia Woolf's first experimental novel, *Jacob's Room*, in which she attempted to develop characterization through the description of thoughts and feelings rather than external dialogue. The book was considered a new development in narrative form, a method of writing known as 'stream of consciousness' – a technique which can be seen in Woolf's major novels *Mrs Dalloway* (1925), *To the Lighthouse* (1927) and *The Waves* (1931).

Interiority did not mean insularity: in the arts, Roger Fry was largely responsible for introducing the work of artists such as Cézanne, Van Gogh, Picasso and Matisse to the British public when in 1910 he organized the exhibition Manet and the Post-Impressionists at the Grafton Galleries. This was followed by the second Post-Impressionist exhibition in 1912, which included work by Duncan Grant, Vanessa Bell and Fry – it received a hostile reception, even though the Post-Impressionism they promoted was little more than anti-Impressionism.

Partly in reaction to the exhibitions, Fry founded the Omega Workshops in July 1913 in Fitzroy Square with co-directors Bell and Grant. The aim was to produce decorative objects, textiles and furniture and to undertake interior design commissions which would in part break down the distinction between fine and applied art. The Omega Workshop would also provide its young artists with a regular source of income. The timing of this enterprise was unfortunate – the outbreak of the First World War had severe economic consequences and this, combined with the breaking away of several artists – most notably Wyndham Lewis – meant the Omega struggled to survive. It eventually closed in June 1919.

Vorticism

The name of a literary and artistic avant-garde movement, Vorticism appears to have been coined in 1913 by the American poet Ezra Pound, who spoke of the point of maximum energy and a whirlpool of human imagination. It was a British synthesis of Cubism and Futurism. The viewer's eye was to be drawn into a spiralling Cubist-based vortex of dynamic shapes and forms. Vorticists were interested in a formal vocabulary to express the dynamic modern machine age.

The Vorticist group emerged from the Rebel Art Centre, which had been formed after Lewis split from Fry's Omega Workshop. London at this time was in fact a place of several jostling artistic groups, but Vorticism is noticeable for having a literary element as well as a visual one. Artists and poets attracted to the group included Jessica Dismorr, Henri Gaudier-Brzeska, Cuthbert Hamilton, William Roberts and Jacob Epstein, but Lewis and Ezra Pound were the main champions of the movement. The Centre was at 38 Great Ormond Street off Queen Square, not far from the Omega Workshop showroom in Fitzroy Square. A space on the first floor was created to show works, hold meetings and lectures. Vorticist artists decorated these rooms. There were Saturday afternoon gatherings to which invitations were issued to view new works displayed on easels. Serving tea was

OPPOSITE:
Surrealist objects and poems,
London Gallery, 1937
(BL 11649.g.63)

Surrealist
Objects & Poems

LONDON GALLERY, LTD.

delegated to the female artists (Kate Lechmere recalled), Lewis insisting the organizing of tea parties was a job for women, not artists.

In 1915 the Tour Eiffel Restaurant (1 Percy Street, W1) was a popular meeting-place for Vorticists, as it was for the Imagist poets. There was a first-floor dining-room with Vorticist decorative schemes and bright, vibrant, jarring colour schemes by Helen and Wyndham Lewis: wall panels, light fittings and jaunty tablecloths and decorations. A later group portrait of the Vorticists by Roberts pictures the artists at the restaurant.

Despite being influenced by Italian Futurism, Vorticism was fuelled by a sense of patriotic indignation against what Lewis saw as the pretentions of Filippo Tommaso Marinetti and his Italian associates to be Europe's leading avant garde. Marinetti had visited London in 1914: Lewis, T.E. Hulme, Epstein and Gaudier-Brzeska disrupted his recital of 'The Battle of Adrianople'. The only English Futurist was C.R.W. Nevinson, who accompanied Marinetti on the drums at this performance. His address, 5 Belsize Studios, is given on the 'Contre l'art anglais' manifesto of

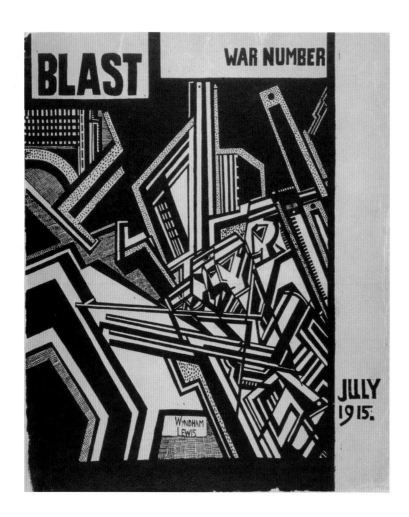

Blast, July 1915. Woodcut by Wyndham Lewis.

11 June 1914. D.H. Lawrence was also much impressed by Marinetti.

The Vorticist movement emerged as aggressively if contradictorily nationalistic. *Blast*, the Vorticist journal, was published in only two issues, in 1914 and 1915. Probably taking its cue from an earlier manifesto by Guillaume Apollinaire, the magazine lists people, monuments and institutions humorously 'blasted' or 'blessed'. The list is paradoxical and idiosyncratic: it blasts, for example, England, the years 1837 to 1900 (i.e. the reign of Queen Victoria), the British climate, the Bloomsbury Group and Lyons tea shops. However, it blesses English eyes, Shakespeare, seafarers and hairdressers – the latter two because they battle against elemental forces. There was also a strong interest in the urban: 'June night' by Dismorr is an avant-garde prose poem published in the second issue of *Blast* which maps a journey criss-crossing London from the suburbs to the centre (on the no. 43 bus, no less). In Dismorr's 'London notes', also in the second issue of *Blast*, there are fragmentary perceptions of the British capital: compression of space and time, the jostling crowd, the fast movement and rapid-fire sensations exemplify a modernist approach.

The Vorticists held only one exhibition, at the Dore Gallery, 35 New Bond Street, in 1915. The Rebel Art Centre had already closed; opening in spring 1914, it had foundered after just four months because of quarrels among the co-directors, difficulties in funding and squabbles over the distribution of the first issue of *Blast*. The Vorticist movement then essentially broke up under the pressure of the First World War. Lewis and Roberts served on the Western Front, enduring life in the trenches, and the sculptor Gaudier-Brzeska and Hulme were killed in action. The experiences of the war destroyed the Vorticist idea of man's compatibility with the machine in the modern world.

The war had meant that Great Britain was largely immune from Dadaism. Indeed, its only contribution was the suppression in March 1919 of Johannes Baargeld and Max Ernst's Dadaist *Der Ventilator* by British troops occupying Cologne. Not that London was immune from post-war continental developments. The Haarlem-born bookseller Anton Zwemmer created a specialist art bookshop at 78 Charing Cross Road. He was the sole British distributor for *Cahiers d'art*, *Minotaure* and other continental magazines, and opened a gallery at 26 Litchfield Street, where he showed Dalí's first one-man exhibition in London (1934) and the last exhibition of the abstract 7 & 5 group led by Ben Nicholson. In film there was the Academy Cinema, founded by Elsie Cohen. After an initial run at the vacant Windmill Theatre and a repertoire of silent pictures, its premises in Oxford Street saw a programme of premieres such as the new sound films, *Kameradschaft* and *The Blue Express*.

It seemed that André Breton's 1924 *Manifesto of Surrealism* might go unnoticed. It was not until 1935 that an English Surrealist group was mooted by Roland Penrose and David Gascoyne in Paris. Gascoyne had written the first Surrealist poem in English, 'And the seventh dream is the dream of Isis' published in *New Verse* (October 1933) and the *First Manifesto of English Surrealism* (May 1935). The signatories of the fourth *International Surrealist Bulletin* (September 1936) included Eileen Agar, Edward Burra, David Gascoyne, Henry Moore, Paul Nash, Roland Penrose and Herbert Read (a contributor to *Minotaure*), as well as Sheila Legge, who appeared on its cover – shown in Trafalgar Square with her head covered in roses. The International Surrealist Exhibition opened at the New Burlington Galleries on 11 June 1936 and had over 25,000 visitors: Dalí notoriously appeared dressed in a deep-sea diving suit to give his lecture.

Both the English Surrealists and the communist-influenced Artists International Association were now preoccupied with the fight against international fascism, and the debate about which art 'style' – Surrealism, Constructivism or Socialist Realism – was the true modern art, became irrelevant. In a way Mass Observation, the study of everyday life in Britain, initiated by Tom Harrison, Charles Madge and the Surrealist painter, Humphrey Jennings, but also indebted to the work of the Polish sociologist, Florian Znaniecki, produced the last manifesto of the period.

Richard Price, Candida Ridler and Duncan Heyes

Madid

The Gran Vía, 'Madrid's Broadway' (built 1910–33), embodies the evolution of the modern style in architecture in Spain. It was constructed in three stages, moving west to east; thus a walk up the street is a walk through time. The Gran Vía embodied the *felices veinte* (happy twenties) of Spain. Although the country as a whole remained agrarian and illiterate, the upper and middle classes in the great cities did nicely out of Spanish neutrality in the First World War.

The Gran Vía was a beacon of modernity, thanks to its colossal buildings (the tallest in Spain since the cathedrals) and a new type of consumer experience. Here were the first plate-glass shop windows – the Gran Vía was itself dubbed 'Spain's shop window' – displaying new cars, cinemas and El Bebé Inglés, a children's outfitters. Almacenes Madrid-París, opened in 1923, was Spain's first department store.

The plan of the Gran Vía cut through a web of medieval streets. All its buildings were tall. The tallest was the headquarters of Telefónica, the national telephone company. Keen on self-advertisement and a major employer of women outside domestic service, the company saw itself as modern. The firm's owners were American, and the Telefónica building (architect Ignacio de Cárdenas, 1929) follows American models. Towering 81 metres, with antennae on its roof which took its height up to 103 metres, and a red-lit clock, it was the tallest building in the country. Its clean – some would say austere – geometrical lines sing of art deco; however, the architect lost his modernist nerve and the façade is topped with a pediment derived from the monuments of the Spanish Habsburgs.

The Gran Vía offered the public a dozen huge cinemas, such as the Palacio de la Prensa (architect Pedro Muguruza, 1924–26). The fifteen-floor ship-like Capitol building (architects Feduchi and Eced, 1930–33) was multi-functional, with its dance hall, cinema, own orchestra, café, tea rooms, hotel, studios and air conditioning.

Old forms of sociability persisted alongside the new. Men of letters continued to meet at *tertulias* (literary salons) held in cafés as they had done since the eighteenth century. But women's *tertulias* opened in private houses. Spain had its flappers and flirts, but these were more numerous in racy novels than in everyday life. The painter Maruja

Mallo and her friends caused a scandal when they walked down the street bare-headed: 'They looked at us as if we were naked', she recalled.

Ramón Gómez de la Serna was the chief introducer (and ironist) of Futurism from his publication of Filippo Tommaso Marinetti in the journal *Prometeo* in 1909 to *Ismos* of 1931. He declaimed avant-garde manifestos written on rolls of toilet paper.

Ramón claimed to be the inventor of the *greguería*, a humorous image-based aphorism; its name, he said, derived from the sound of a flock of sheep. Commonly accompanied by a shop dummy which he dubbed his girlfriend, he held court at *tertulias* in a series of cafés and restaurants. His work often hinted darkly at a ludic kinkiness, typified in his *Senos*, a collection of lyrical (verbal) character sketches of breasts.

In Diego Rivera's portrait Ramón is holding his book El *Rastro*, a kaleidoscopic account of the Madrid flea-market, a place of everyday Surrealism where unrelated objects are thrown haphazardly into juxtaposition.

Ismos describes no fewer than twenty-five modern movements: Apollinairismo, Picassismo, Futurismo, Negrismo, Luminismo, Klaxismo, Estantifermismo, Toulouselautrecismo, Monstruosismo, Archpenkismo, Maquinismo, Lhoteísmo, Simultanismo, Jazzbandismo, Humorismo, Lipchitzismo, Tubularismo, Ninfismo, Dadaísmo, Charlotismo, Suprarrealismo, Botellismo, Riverismo, Novelisimo and Serafismo.

Ramón's chief haunt, the Café Pombo, was the scene for what has been seen as the end of avant-garde innocence in Spain. On 8 January 1930 Ramón hosted a banquet in honour of the writer and progressive film-maker Ernesto Giménez Caballero. Antonio Espina took exception to the presence of the Italian fascist *escenógrafo* Giulio

OPPOSITE:
Diego Rivera, portrait of
Ramón Gómez de la Serna,
from Ramón's *Ismos*,
Madrid, 1931

(BL 12488.r.14)

Bragaglia and brandished a wooden gun while making a speech. Ramiro Ledesma Ramos exclaimed 'Vivan los valores hispánicos' and brandished a real pistol. The avant garde gave way to right-wing politics.

Spanish reactions to the avant garde were unappreciative. More famous than any Spanish manifesto of the period was (and still is) José Ortega y Gasset's *La deshumanización del arte* (1925). This rambling rant against modernism names few names, and the only Spaniard quoted is Picasso. He identifies seven tendencies: the dehumanization of art, the avoidance of living forms, the work of art as nothing but a work of art, art as nothing but a game, an essential irony, the avoidance of all falsity; 'art, according to the young artists, is without meaning'.

The simplified geometrical shapes of avant-garde graphic art and its potential for whimsy found expression in a number of popular forms.

Cartoonists quickly adopted it as a staple of their style. Children's illustrators also were quick to recognize its appeal. The Celia stories by Elena Fortún (1929 onwards) speak for the absorption of the avant garde into bourgeois domesticity. The pictures by Molina Gallent display the anthropomorphism beloved of Surrealists and infants; Celia, a well-to-do little Madrid girl, has a toy aeroplane big enough for her to sit at the controls, and her baby brother has a teddy bear named 'Teddy Bear', possibly bought at El Bebé Inglés.

The stick-men of modernism lent themselves to parody, and such parodies appeared in humorous magazines as early as 1910.

Turning the pages of periodicals of the time bears out Jaime Brihuega's contention that the longest-lasting achievement of the Spanish avant garde was in advertising.

Barry Taylor

Milan

In 1900 Milan was the industrial and economic capital of Italy. The new century was ushered in by a period of social unrest that was to culminate in the General Strike of 1904. The death on 27 January 1901 in a hotel near the Teatro alla Scala of Giuseppe Verdi signalled the end of Risorgimento idealism, whereas the brutal suppression of a workers' demonstration in Milan resulted in the assassination by an anarchist of King Umberto I of Italy in Monza in July 1900. The subject matter of early Futurist works often reflects the unsettled times; Carlo Carrà witnessed the killing of the anarchist Ambrogio Galli in a street fight in Via Carlo Farini in Milan during the 1904 General Strike and subsequently produced *I funerali dell'anarchico Galli* (1910), while Umberto Boccioni's *Rissa in galleria (Riot in the Galleria)* (1910) shows civic unrest erupting in the fashionable centre of the city. Milan itself became the protagonist of several key works of the Futurists, ranging from Boccioni's early exultant depictions of the city and its suburbs to Mario Sironi's bleak urban landscapes.

Thanks to Filippo Tommaso Marinetti, Milan became the epicentre of Futurism, especially in the early years of the movement. A man of immense energy and wealth, Marinetti was the creator, indefatigable promoter and chief funder of Futurism. Born in Alexandria in 1876, he lived between 1893 and 1898 in Paris, where he published his first works in French; in 1898 he moved to Milan, which became the base for his publishing activities – conducted initially from his paternal home in Via Senato 2 and later from his apartment at Corso Venezia 61. His most ambitious venture during the first decade of the century was the publication of the literary journal *Poesia*, which he founded in 1905. Though it also published new work from other countries, this was essentially a journal of French and Italian Symbolism. In its revolt against literary and social convention and its exploration of new forms of expression, such as free verse, it laid the foundations for Futurism. The first Futurist manifesto was duly published, in French and Italian, in its February–March issue of 1909, soon after its appearance in Paris's *Le Figaro*, and 'Uccidiamo il chiaro di luna' was included in the journal's last issue in October 1909. Under the imprint Edizioni di 'Poesia', begun in 1907 – and from 1910 its successor, Edizioni futuriste di 'Poesia' – Marinetti also published a large number of monographs, which included some of the key Futurist works – *I poeti futuristi* (edited by Marinetti, 1913), Folgore's, *Ponti sull'oceano* (1914), Carrà's, *Guerra-pittura* (1915), Russolo's, *L'arte dei rumori* (1916), Govoni's, *Rarefazioni e parole in libertà* (1915), and Cangiullo's, *Caffè concerto* (1917). After Marinetti's move to Rome in 1925 Edizioni futuriste di 'Poesia' continued to be published from his Rome address, Piazza Adriana 30. One of the masterpieces of Futurist book production was published in 1933, Tullio d'Albisola's *L'Anguria lirica*, printed on metal sheets and illustrated by Bruno Munari.

The publication of his 'Manifeste de fondation du futurisme' in *Le Figaro*, which laid the literary foundations of the movement, led to Marinetti's meeting with Umberto Boccioni, Carrà and Luigi Russolo, three young Milan-based artists, and also with Giacomo Balla and Gino Severini, who gave Marinetti their enthusiastic support and published the following year two manifestos which extended his theories to the visual arts: the 'Manifesto dei pittori futuristi' and 'La pittura futurista: manifesto tecnico'. These publications were accompanied by a Futurist evening at the Teatro Lirico (15 February 1910), and in 1911 Futurist works were exhibited for the first time as part of a general show, the Mostra d'arte libera held in the Padiglione Ricordi, a former factory of the music and record publishing company. Other events organized in Milan included the first performance on 11 August 1913 of Russolo's first *concerto rumorista* in Marinetti's apartment, and a month later a performance of the same composer's art of noises at the Teatro Dal Verme.

In 1914 an exhibition held in the Famiglia Artistica centre in Milan showed the work of a newly formed group, Nuove Tendenze. Called 'the right wing of Futurism', it was brought together by the illustrator Ugo Nebbia and the painter Leonardo Dudreville to show a more moderate aspect of the avant garde without Futurist extremisms. The exhibition showed works by Dudreville, Achille Funi and Mario Chiattone, but its most notable feature was the inclusion of the Piranesi-like, visionary drawings of the architect Antonio Sant'Elia, which best expressed the idea of the utopian city of the future. Sant'Elia, in fact, defected to the Futurist camp soon after the exhibition closed, and his Futurist architecture manifesto was published in the 11 July 1914 issue of *Lacerba*.

Depero futurista, 1927

(BL, new acquisition)

The deaths of Boccioni and Sant'Elia in 1916 dealt a considerable blow to the Futurist movement, and the large retrospective of Boccioni's work shown in Milan in 1917 marked the end of the heroic period of Futurism. Moreover, later in the year the exhibition in the Galleria Chini of Carrà's first Metaphysical paintings both marked a break with Futurism and announced a return to tradition, an attitude that would gather strength in the immediate post-war years and lead to the formation of the group Novecento Italiano.

The group, formed in 1922, advocated – like the Valori Plastici group in Rome – a return to Classical order and clarity in reaction to the aggressiveness of the pre-war avant garde. A key role in the formation of the group was played by Margherita Sarfatti, who as art critic, journalist and mistress of Mussolini was highly influential in artistic matters during the early years of the fascist regime. She was in particular concerned to restore artistic primacy to Milan, an ambition she pursued through the exclusive literary and artistic salon held in her house, in Corso Venezia 93, which was frequented by Marinetti (who lived nearby) and the sculptors Medardo Rosso and Arturo Martini. The original Novecento group, consisting of seven painters – Dudreville, Funi and Sironi; together with Anselmo Bucci, Gian Emilio Malerba, Piero Marussig and Ubaldo Oppi – had its first exhibition in 1923 at the Galleria Pesaro. There were two major exhibitions later, in 1926 and 1929 at the Palazzo della Permanente, but by then the expansion of the group and its inclusion of artists from different tendencies had led to artistic incoherence.

Besides showing the work of the Novecento group, the Galleria Pesaro also held exhibitions by Carrà and Giorgio de Chirico, and artists like Antonio Donghi and Felice Casorati, all loosely grouped under Magic Realism, and in the 1930s it promoted the Aeropittura movement, which included the work of the second-generation Futurists.

In the 1930s the most adventurous, and courageous, exhibitions were organized by the Galleria del Milione, in Via Brera 21. The gallery, whose name refers to Marco Polo and thereby hints at its exploratory policy, was opened in 1930 and run from 1932 by the brothers Virginio, Peppino and Gino Ghiringhelli, who became the champions of abstract art. Artists exhibited included Max Ernst,

Louis Marcoussis, Hans Arp, Friedrich Vordemberge-Gildewart, Willy Baumeister and Josef Albers; and Italian abstract artists Mauro Reggiani, Lucio Fontana, Osvaldo Licini, Fausto Melotti and Antonio Corpora. In 1934 its exhibition of seventy-five works by Wassily Kandinsky had an enormous impact on the work of Italian artists. The gallery published a bulletin, *Il Milione* (1932–41), and had its own art bookshop, where international art journals could be consulted. It also published Carlo Belli's *Kn*, a theoretical work which Kandinsky called the gospel of abstract art. Several of the artists whose work was exhibited by the Galleria del Milione also contributed to the journal *Campo grafico*, which was founded in 1933 by Attilio Rossi and adopted Bauhaus and De Stijl principles of graphic design.

Graphic invention and exuberance can be seen in abundance in a book published in Milan in 1927: *Depero futurista*, also known as the 'bolted book' because its hole-punched pages are held together by two aluminium bolts. Commissioned and published by Fedele Azari, it is essentially a compendium of Fortunato Depero's typographic designs. Making inventive use of different typefaces and paper colours, it is the apotheosis of the Marinettian Words-in-Freedom.

Chris Michaelides

Munich

It was a Munich magazine *Jugend* (*Youth*), founded in 1896, which gave its name to the German form of art nouveau, 'Jugendstil'. This connection was appropriate since Munich at this period was Germany's leading cultural capital, a centre for artists, writers and musicians. Yet the next three decades would see a steady decline as the city became artistically 'provincial' and politically, in the words of novelist Thomas Mann, a 'stronghold of reaction'.

Back at the start of the century, the satirical magazine *Simplicissimus*, a near-contemporary of *Jugend*, offered a similar platform to the modern artists who designed its bold, coloured title pages and cartoons. It also published literary work by writers such as Frank Wedekind, Thomas and Heinrich Mann, and Hermann Hesse. Although a world away from Berlin's Expressionist journals, *Simplicissimus* was nonetheless on the side of modernity in its visual style, content and outlook.

From the same artistic circles came the cabaret 'Die elf Scharfrichter' (The Eleven Executioners), which set out to attack bourgeois hypocrisy and morality. Some of its members were also among the founders of the artists' group Phalanx, which sought both to provide a forum for exhibitions and to encourage younger artists. The Russian Wassily Kandinsky was involved with Phalanx, and was later instrumental in founding the Neue Künstlervereinigung München (New Munich Artists' Association) in 1909. However, along with others whose style was becoming more abstract, he broke away in 1911 to form a more significant group, 'Der Blaue Reiter' (The Blue Rider); the name reflects the importance of horses and horsemen in Kandinsky's work and that of his co-founder Franz Marc. This group's almanac (1912) was a major programmatic statement of the importance of the individual artist's inner vision and desires in shaping artistic form. It was richly illustrated both with members' own work and with folk art from European and non-European cultures.

The almanac's publisher, Reinhard Piper, also published Kandinsky's collection of dreamlike prose-poems and images, *Klänge* (*Sounds*). Piper was firmly committed to avant-garde art and literature. His other authors included the poets Arno Holz and Christian Morgenstern, whose experiments in wordplay and literary nonsense

defy categorization. Equally hard to classify, although a member of both the Neue Künstler-vereinigung and Der Blaue Reiter, was the artist Alfred Kubin, who used his grotesque pen-and-ink fantasies to illustrate writers such as Poe and Dostoevsky as well as his own Surrealist novel *Die andere Seite* (*The Other Side*), published by Piper's one-time partner Georg Müller. Like Piper, Müller published a number of significant modern writers, and he was responsible for one of Paul Klee's two forays into book illustration, *Potsdamer Platz*, a work by the Berlin Expressionist Curt Corrinth. Klee's only other book illustrations appeared in a translation of Voltaire's *Candide* published by Kurt Wolff, another press of major importance to the avant garde, which had moved from Leipzig to Munich in 1919.

In this immediate post-war period it seemed that Munich would be at the forefront of both political and artistic revolution – although it is perhaps significant that the Dadaists steered clear. The city's short-lived Soviet Republic of 1919 counted the poet and dramatist Ernst Toller and the writer Erich Mühsam as members of its Central Committee, and an 'Action Committee of Revolutionary Artists' was founded in support. Toller's autobiography is bitterly critical of the way an allegedly socialist government crushed the revolution, allowing forces of reaction to take root. Munich's next attempted revolution would be Hitler's abortive putsch of 1923, by which time the city was already a successful breeding-ground for National Socialism.

This atmosphere of political reaction was increasingly echoed in the arts, not least because it

OPPOSITE:
Der Blaue Reiter, 1912
(BL C.107.h.16)

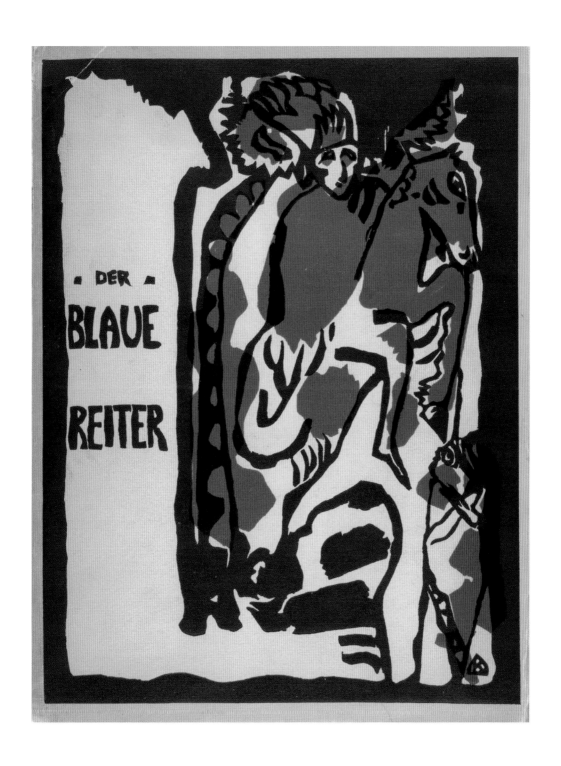

LEFT AND BELOW:
László Moholy-Nagy,
Painting, Photography, Film
(Malerei, Photographie, Film),
1925

This is No. 8 in the
Bauhaus Bücher series,
edited by Moholy-Nagy
and Walter Gropius. It
proclaimed a New Vision
for photography, with the
camera left to record what
is before the lens, and it
promoted a respect for the
inherent qualities of the
medium. The combination
of type and photography
could create a new 'visual
literature'.

(BL X.410/1411)

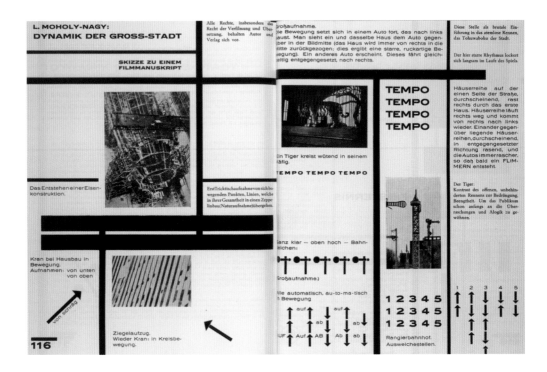

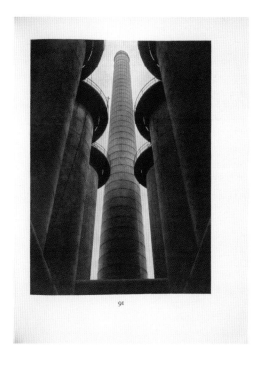

91

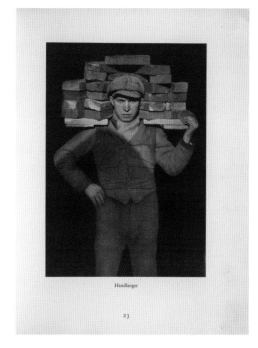

Handlanger

23

drove many liberal and progressive artists and
writers to leave Munich, primarily for Berlin. In
1926 the literary magazine *Der Zwiebelfisch* (*Misprint*)
asked prominent figures in the arts to comment on
Munich's loss of status as a cultural centre to a city
Bavarians had traditionally looked down upon as
the home of unimaginative Prussian stolidity.
The exercise and the soul-searching responses it
produced epitomize the crisis in Munich's cultural
life during the period.

Not all was lost: *Simplicissimus* still published
and promoted work by artists like Georg Grosz
and Käthe Kollwitz, although Munich's home-
grown visual arts remained largely in the idiom
of the pre-war Secessionists or a cautious Neue
Sachlichkeit (New Objectivity). Munich's writers
had never been strong on formal innovation and of

ABOVE LEFT:
Albert Renger-Patzsch,
The World is Beautiful
(*Die Welt ist schön*), 1928

The original title was
Die Dinge (*Things*). What
Renger-Patzsch takes from
the New Vision aesthetic
is the interest in close-up.

(BL YV.1986.b.851)

ABOVE RIGHT:
August Sander,
Face of Our Time
(*Antlitz der Zeit*), 1929

Sander's lifetime project
was a systematic photo-
graphic study of 'Man
in the 20th Century' as
exemplified by groups
and individuals, arranged
by role in German society.
This was an interim report
and was introduced by
Alfred Döblin. It was
suppressed by the Nazis
in 1933.

(BL, new acquisition)

the more liberal authors who remained in the city most were stylistically conservative. However, the content of their work often showed a keen awareness of the cultural issues of the time, as in Lion Feuchtwanger's novel Erfolg (Success) of 1930, which describes the hounding of a state gallery director for his support of modern art.

Cabaret continued to flourish with literary performers such as Joachim Ringelnatz, whose poems were published by Wolff and illustrated by the *Simplicissimus* artist Karl Arnold. As late as January 1933 Thomas Mann's daughter Erika founded an anti-Nazi cabaret Pfeffermühle (Pepper-Mill), subsequently forced into exile. But Munich's most famous cabaret performer was Karl Valentin, who was admired by Bertolt Brecht among others for humour which was both popularly accessible and absurd to the point of surreality. Brecht's own *Trommeln in der Nacht* (*Drums in the Night*) and *Im Dickicht der Städte* (*Jungle of Cities*) were premiered in Munich in the early 1920s, but as in the other arts much of the most progressive talent in the theatre leached away to Berlin.

Even Munich's publishing houses were forced to draw back from modernism: Piper became dependent on nationalistic bestsellers for survival, Wolff closed his firm, and Müller's successors were absorbed into a Nazi-run body. In 1928 the Kampfbund für Deutsche Kultur (Militant League for German Culture) was founded in Munich under the aegis of the Nazi Party to protest against modernism in the arts. Even before 1933 conservatism had the upper hand. Ironically, the next great concentration of modern art in Munich would be for the Nazis' 1937 exhibition Entartete Kunst (Degenerate Art), ridiculing artists such as those of Der Blaue Reiter, who had once made Munich a true international centre of culture.

Susan Reed

New York

The skyscraper profile of New York was inspirational for the European avant garde, who equated New York with modernity. It was also a refuge for European artists and writers fleeing First World War conscription or, later, Nazism and Stalinism. They mixed with the New York avant garde both there and when the latter visited Europe. This section concentrates on the pre-Dada and Dada phases.

Alfred Stieglitz formed Photo-Secession in 1902 with Edward Steichen, Gertrude Käsabier and Clarence H. White. Its aim was to promote photography as an art form. Stieglitz started *Camera Work* (1903–17): this included many tipped-in photogravures, often made directly from the photographer's negative. It also opened up its pages to modern artists such as Matisse and Picasso.

In 1905, Stieglitz opened The Little Galleries of the Photo-Secession at 291 5th Avenue, or 291 as it became known. It held the first solo exhibitions in the United States of artists such as Francis Picabia, Paul Cézanne and Picasso, in the process helping photography to be seen as art. It was also a space where the avant garde could meet.

The International Exhibition of Modern Art of 1913 (or Armory Show) was organized by the newly formed Association of American Painters and Sculptors, and held at the 69th Regiment Armory on Lexington Avenue between 25th and 26th Streets, 17 February–15 March 1913. It included Marcel Duchamp's *Nude Descending a Staircase* and Picabia's *Dances at the Spring*. Whilst it was influential on artists and writers such as Man Ray and William Carlos Williams, many of the exhibits were ridiculed in the press.

Another avant-garde nexus was the 'open house' of poet and patron of the arts Walter Arensberg, and his wife Louise, at their home on West 67th Street. This was initially predominantly literary, including Wallace Stevens; Carl Van Vechten, editor of *Trend*; Donald Evans, whose Claire Marie Press published Gertrude Stein's *Tender Buttons* in 1914; Allen and Louise Norton, editors of *Rogue* magazine; and Walter Pach, an organizer of the Armory Show. Until the Arensbergs moved to California in 1922, their growing circle encompassed poets such as William Carlos Williams and Alfred Kreymborg, artists such as Man Ray, and the European artists who came to New York to escape the war – including Duchamp, who arrived in the summer of 1915.

For Francis Picabia, New York was 'the cubist, futurist, city'. Over for the Armory Show, he met Stieglitz, who exhibited his watercolours at 291; and another member of Stieglitz's circle, Marius de Zayas. In addition to contributing to *Camera Work* and helping at 291, De Zayas acted as a European agent for Stieglitz. He met up again with Picabia when he visited Paris in 1914 and was introduced to Guillaume Apollinaire, editor of *Les Soirées de Paris*. Back in New York, De Zayas was keen to provide a similar forum for art and literature that would reach beyond the walls of the 291 gallery. Helped by Paul Haviland and Agnes Meyer, he persuaded Stieglitz to support a monthly magazine. The magazine, also *291*, was printed in large format on high-quality paper. During its short life of twelve issues published 1915–16, it introduced its readers to a 'proto dada' assemblage of art, poetry and criticism, including Apollinaire's calligrammes as well as De Zayas's own 'psychotypes', a fusion of typography and art. On his return in June 1915, Picabia immediately began to contribute. The July–August 1915 issue of *291* marked the first appearance of his machine drawings, with Stieglitz depicted as a camera on its cover. De Zayas sent copies of *291* to Tristan Tzara and, according to Stieglitz, 'these copies...helped crystallize the original Dada Movement when Picabia returned to France'. Picabia started his own magazine, *391*, whilst in Barcelona in early 1917. Three issues (nos. 5–7) were published in New York when he returned later that year.

Man Ray was part of a radical circle associated with the Ferrer Center. In the wake of the Armory Show, he moved to the artists' colony of Ridgefield, New Jersey, in spring 1913. Many of his associates were writers and he was particularly close to Kreymborg. Man Ray was involved in his first publishing venture, *The Glebe* (1913–14), and also put together a number of his own ephemeral productions, including the *Ridgefield Gazook* (March 1915), a four-page pamphlet which opened into a single folded sheet – and which has been described as 'America's first proto-dada periodical'. Man Ray was a member of the Others group, which Kreymborg had co-founded with Arensberg. The first issue of *Others* appeared in July 1915, featuring contributions by Stevens, William Carlos Williams,

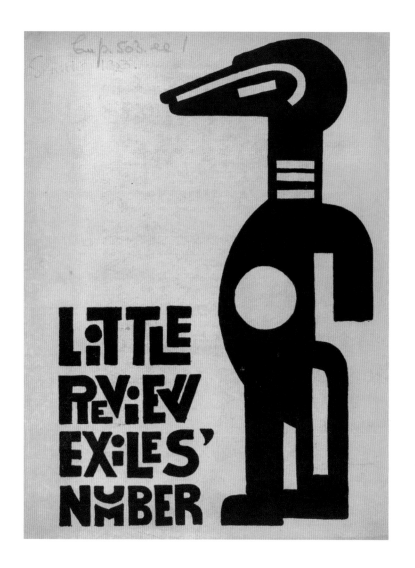

The Little Review: a Quarterly
Journal of Arts and Letters,
Vol. IX No.3 (spring 1923).

Margaret Anderson
founded this influential
review in Chicago in 1914,
but moved to New York in
1917. She took on Ezra
Pound as foreign editor,
and over the next few years
published many modernist
writers of the period. This
issue features contribu-
tions from Léger, Miró
and Cocteau, and the
'exiles' Ernest Hemingway,
Gertrude Stein, H.D.
(Hilda Doolittle) and
George Antheil.

(BL Cup.503.ee.1)

Ezra Pound and Mina Loy. Arensberg's financial support would last only one full year but it continued intermittently until 1919. Kreymborg was also involved (until 1922) in *Broom: an International Magazine of the Arts*, which was produced in Europe (1921–24).

Duchamp, whose 'Nude Descending a Staircase' had caused a stir at the Armory Show, was met on his arrival by Pach, who took him immediately to the Arensbergs. He described New York as 'a complete work of art', and soon began to frequent Arensberg salons and 291. But it was on a trip to Ridgefield with Arensberg in the autumn of 1915 for an Others group outing that he first encountered Man Ray. The two men became life-long friends and collaborators. Man Ray was quick to recognize the revolutionary potential of technology for art and began to experiment using a commercial airbrush, producing a series of 'aerographs'. He had also recently taken up photography to document his own work, when preparing for a show at the Daniel Gallery; later he documented much of Duchamp's work, particularly 'The Large Glass'. In 1916 Man Ray and Duchamp were involved in the founding of the jury-free Society of Independent Artists. Its inaugural exhibition opened in April 1917. *The Blind Man*, edited by Duchamp and Henri-Pierre Roché, appeared at the same time. Just as the society encouraged jury-free exhibitions, Duchamp wanted a publication that would invite anyone to submit whatever they wanted. The rejection of Duchamp's *Fountain* (a urinal that was submitted under the name R. Mutt) led to the resignations of both Duchamp and Arensberg from the society. The second (and last) issue of *The Blind Man* featured an editorial by Beatrice Wood on the rejection of *Fountain*, together with a photograph of it by Stieglitz (who put it on display for a few days at 291). Roché sent a copy of the issue to Apollinaire, who wrote an article on 'The Richard Mutt Case' for the summer 1918 issue of *Mercure de France*. But there were no further issues of *The Blind Man* as Roché lost a chess game to Picabia and the forfeit was to stop publication. However, a few months later Duchamp published his own magazine, *Rongwrong* (a felicitous printer's error for 'Wrongwrong'), edited with Roché and Wood.

In March 1919 Man Ray put together another single-issue publication entitled *TNT*, which he described as 'a political paper with a very radical slant', in an edition 1,000 copies at 50 cents each. It featured poems and prose from his friends, including his wife, Adon Lacroix, Arensberg and Duchamp, Philippe Soupault and Man Ray. Duchamp was away from New York for much of 1918–19, first in Buenos Aires and then in Europe; he had returned by 1920, and he and Man Ray became involved with Katherine Dreier in the founding of the Société Anonyme.

In April 1921 the Société Anonyme held its only official Dada event, just at the point when Dadaist activities were coming to an end in New York. For this Man Ray and Duchamp put out the single issue of *New York Dada*, with a cover by Duchamp, a mock 'authorization' from Tzara to use the term 'Dada', and photographs by Stieglitz and Man Ray. It was circulated amongst friends. Man Ray wrote to Tzara, 'Dada cannot live in New York. All New York is dada and will not tolerate a rival…'. Within a few months both Man Ray and Duchamp had left for Paris.

Duchamp soon returned. For Henry McBride's writings on French art, he designed a spiral-bound publication with each essay appearing in progressively larger type until the final essay, which was presented in very small type; the 'title' consisted of twenty-eight index-type letters, attached by blue tabs at the page edges. With the approach of war Surrealism was dying in Europe but it enjoyed a renaissance in the United States as exhibitions were mounted at Peggy Guggenheim's gallery Art of this Century and the Julien Levy Gallery. In 1927 A.E. Gallatin had opened his Gallery of Living Art. November 1929, in the year of the Stock Market crash, saw the inauguration of the Museum of Modern Art; it was directed by Alfred Barr, who organized Fantastic Art, Dada and Surrealism (1936). A rayograph featured on the cover of the catalogue, and its text by George Hugnet on Dada acknowledged that many of Man Ray's, Picabia's and Duchamp's activities had occurred before there was a word to describe them. Hugnet described them as 'pre-dada'.

Carole Holden

Paris

Paris was the artistic capital of the world in the first half of the twentieth century. The years leading up to the First World War were characterized by great experimentation, and a variety of styles and artistic movements – including Fauvism, Cubism and Orphism – were born there. Paris later became a centre for the 'return to order' tendency – the resurgence of the figurative tradition that was a dominant feature of the European avant garde after the war – as well as for the international Dada and Surrealist movements. The artistic importance of the city was evident in two massive international exhibitions organized there, the essentially optimistic Exposition universelle of 1900, and in 1937 the Exposition internationale des arts et des techniques dans la vie moderne. The latter included Picasso's *Guernica*, the artist's anguished reaction to a recent atrocity in the Spanish Civil War, and future troubles were prefigured by the physical confrontation of the aggressively propagandist German and Soviet pavilions.

For artists, musicians and writers from all over the world, the city was then a magnet, a place synonymous with personal and artistic freedom – especially during the rise of totalitarian governments elsewhere in Europe in the 1920s and 1930s. Filippo Tommaso Marinetti, a skilful propagandist, assured maximum publicity for the first Futurist manifesto in 1909 by publishing it in a Paris newspaper (the right-wing *Le Figaro*), and censorship problems elsewhere secured for the city the first publication by Sylvia Beach, an American expatriate, of James Joyce's *Ulysses* in 1922. Montmartre and Montparnasse, respectively north and south of the city centre, became cosmopolitan areas, peopled by bohemian artistic colonies living and working in studio complexes like the Bateau-Lavoir and La Ruche. Among those housed in the Bateau-Lavoir were Picasso, Juan Gris and Kees Van Dongen; and the writers Max Jacob and Pierre Reverdy; while residents of La Ruche included Ardengo Soffici, Robert Delaunay, Marc Chagall, Chaim Soutine, Alexander Archipenko, Fernand Léger and Amedeo Modigliani, as well as Guillaume Apollinaire and Blaise Cendrars. Cabarets like Le Lapin Agile and cafés like Le Dôme, La Coupole, La Rotonde and Le Select also provided meeting-places for artists and writers, and were fertile grounds for the development of avant-garde ideas.

The possibilities for exhibiting and selling works of art were varied. By 1900 the official Salon, which had dominated artistic life during much of the nineteenth century, had long ceased to be the main outlet for innovative artists. They preferred instead to show their work at rival exhibitions, like the Salon d'Automne or the Salon des Indépendants, or to develop mutually beneficial relationships with commercial art galleries. Dealers such as Ambroise Vollard, Daniel-Henry Kahnweiler, Paul and Léonce Rosenberg and Paul Guillaume were often instrumental in shaping the careers and developing the reputations of the artists they represented by exhibiting their work and selling it to an international clientele. Several art dealers were also publishers of print portfolios and livres d'artiste. Vollard, for example, published Paul Verlaine's *Parallèlement* with lithographs by Pierre Bonnard (1900), and Honoré de Balzac's *Le Chef d'oeuvre inconnu* with woodcuts by Picasso (1931). Kahnweiler published Guillaume Apollinaire's *L'Enchanteur pourrissant* with woodcuts by André Derain (1909) and Jacob's *Saint-Matorel* with illustrations by Picasso (1911) and, later – under the imprint of the Galerie Simon – he published the first works of André Malraux and Georges Bataille and also Gertrude Stein's *A Book Concluding with As a Wife has a Cow* (1926) with lithographs by Juan Gris.

Besides books, a plethora of art and literary journals appeared, ranging from the lavish *Revue*

OPPOSITE:
Guillaume Apollinaire,
Alcools, 1913

Picasso drew many portraits and caricatures of his friend, Apollinaire, in which the poet is depicted as a Pope, as an academician, and even as a coffee pot. The Cubist frontispiece of *Alcools* is rather apt in view of Apollinaire's championship of Cubism. It also demonstrates the close relationship of avant-garde painters and poets.

(BL 011483.bbb.30)

© Succession Picasso / DACS 2007

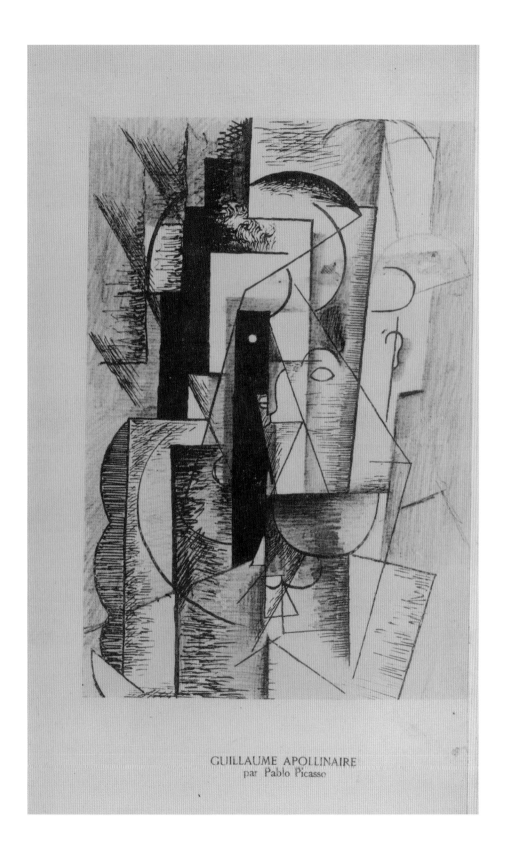

GUILLAUME APOLLINAIRE
par Pablo Picasso

Blaise Cendrars and
Fernand Léger,
*La fin du monde, filmée par
l'ange N.-D*, 1919

Originally intended as a
screenplay, Cendrars' text
was published as a novel
with colour pochoir illus-
trations and typography
by Léger, which suggest
the dynamism of the
modern city. Text and
image merge: the first
sentence ('C'est le 31
Décembre') forms part of
the illustration, which
also repeats other frag-
ments of the text.

(BL L.45/3266)

Gertrude Stein and
Juan Gris,
*A Book concluding with As a
Wife has a Cow*, 1926
(BL, new acquisition)

OPPOSITE:
Il'iazd (pseudonym of
Ilia Zdanevich),
Le-Dantiu as a Beacon, 1923

Ilia Zdanevich was born in
Tbilisi, Georgia. *Le-Dantiu
as a Beacon* was published
in Paris where Zdanevich
had settled. The text is
written mainly in trans-
rational language (zaum)
though it does include
some Russian words.
Sometimes the typography
has a phonetic function,
at others it is purely
ornamental.

(BL C.145.b.15)

blanche (1889–1903), *Cahiers d'Art* (1926–60), *Minotaure* (1933–39) and *Verve* (1937–39) to cheaply produced and often short-lived publications such as Tristan Tzara's *Dada* (the last two issues of which were published in Paris in 1920–21) and Francis Picabia's *Cannibale* (1920) and *391* (1917–24). They were often instrumental in the development of a particular movement, as in the case of Cubism and Apollinaire's *Les Soirées de Paris* (1912–14) and Reverdy's *Nord-Sud* (1917–18). The programme of Surrealism was similarly elaborated by André Breton in *Littérature* (1919–24), *La Révolution surréaliste* (1924–29) and *Le Surréalisme au service de la révolution* (1930–33). Jean Cocteau's *Le Mot* (1914) and Amédée Ozenfant's *L'Élan* (1915–17) enlisted the avant garde to the war effort, and Ozenfant later published with Le Corbusier *L'Esprit nouveau* (1920–25) as a vehicle for their theories of Purist form in painting and architecture. Other important journals included Pierre Albert-Birot's *SIC* (1916–19), Bataille's *Documents* (1929–30) and Jean Arp's *Abstraction-Création* (1932–36).

A number of personalities, impresarios and patrons were prominent in the Parisian avant garde. Apollinaire was a leading art critic, a keen advocate of 'l'esprit nouveau', of everything new and challenging in art, literature and film (in particular he was an admirer of Louis Feuillade's *Fantômas*). He wrote enthusiastically about Fauvism, Cubism, Futurism, Simultaneism and Orphism (a word he coined, as he did 'Surrealism'). His *Calligrammes* (1918) collection of poems includes several typographically daring and complex ideograms. In 1911 his arrest and imprisonment on suspicion of complicity in the theft of the *Mona Lisa* from the Louvre gave him added notoriety.

Littérature, No.18
(March 1921)

(BL X.981/12456, 1978
facsimile)

Like Apollinaire, Jean Cocteau was a man
of many interests and talents – a writer, stage
designer, film-maker, painter and draughtsman.
He constantly experimented in different media,
and his vast and varied output exemplifies the
cross-fertilization of different forms of art which
occurred during this period. He played a key role in
the creation of several of the avant-garde ballets of
the period, notably *Parade*, staged by Diaghilev at
the Théâtre du Châtelet in 1917, and promoted
the music of Les Six. He was able to put his own
imprint on material he adapted from different
sources, ranging from classical mythology in his
play *Orphée* (1926) to Surrealist dream imagery
in his first film, *Le Sang d'un poète* (1930).

The indefatigable impresario of Russian
culture was Sergey Diaghilev who dazzled Paris
first with an exhibition of Russian art he organized
at the Salon d'Automne in 1906 and then from 1909
with the regular visits of his Ballets Russes. The
ballets were magnificent spectacles combining
lavish costumes and decor with great dancing
which delighted and often scandalized Parisian
audiences. The list of composers and artists he
used reads like a *Who's Who* of the European avant
garde. Before the war he mostly drew on Russian
artists, introducing Paris to the music of Stravinsky
and the art of Bakst, Larionov and Goncharova,
whereas during the inter-war years he enlisted the
services of other European composers (Poulenc,
Milhaud, Satie and de Falla) and artists (Picasso,
Matisse, Ernst, Mirò and de Chirico).

Gertrude Stein, an American expatriate, was
a leading patron and collector of modern art in
the pre-First World War years. Her apartment in
27 Rue de Fleurus was one of the most important
meeting-places of the European and American
artistic and literary avant garde and was visited by
Picasso, Juan Gris, Charles Demuth and Duchamp,
and Apollinaire, Cocteau, T.S.Eliot and F.Scott
Fitzgerald. Her novel *The autobiography of Alice B.
Toklas* (1933) gives a vivid account of this milieu,
also described in Hemingway's posthumously
published memoir *A moveable feast* (1964).

Chris Michaelides

Prague

Prague's central position between East and West had throughout its history made the city a natural meeting-point for literary and artistic exchange between the German and Slavonic cultural worlds. With the proclamation of the first Czechoslovak Republic in 1918 under the presidency of Tomáš Garrigue Masaryk, the newly autonomous state – freed at last from centuries of Habsburg domination – could hope to redefine its identity in terms of its own choosing. The legacy of the past, however, continued to be apparent in Czechoslovakia's ability to remain open to international influences while retaining a proudly independent and original spirit of creativity, and to be a source of both strength and, ultimately, of weakness.

Within Dada Czechoslovakia was represented by the anarchic figure of Walter Serner, whose manifesto 'Letzte Lockerung' (Final dissolution) provoked an uproar at the eighth Dada evening in Zurich on 9 April 1919, and who inaugurated the First World Congress of Dadaists in Geneva later that year before leaving the movement, bored and disillusioned, and vanishing into obscurity. In Prague the forces which in the early 1920s sought to mediate between Futurism, Dada, Surrealism and Constructivism crystallized around the Devětsil movement headed by Karel Teige. This group (1920–31) attracted over sixty members, including authors, architects, composers, critics and photographers – some of whom developed links with Cubism, visible in the work of the Tvrdošíjní (Stubborn) group. On 5 November 1920 Devětsil was founded in the Café Union, Prague, by a number of young artists who felt the need for a more progressive and radical orientation in art and politics. While following Dada in their rejection of Western technology and modern art, they embraced simple popular traditions which provided an ideological basis in tune with nationalist enthusiasm for the genuinely 'Czech' past, evident in the Poetic Naivism of the first spring exhibition held in Prague in May 1922. In December of that year the *Revoluční sborník Devětsil* (*Revolutionary Journal Devětsil*) was published, constituting a manifesto of the group's aims and ideas.

From its beginnings Devětsil had established a wide network of international links, including contacts with the Yugoslav review *Zenit*, Enrico Prampolini and the Italian Futurists, Kurt Schwitters and other representatives of Dada, and the French avant garde – including Le Corbusier and Amédeé Ozenfant – as well as Alexander Archipenko and Theo van Doesburg. Many of these exhibited or lectured in Prague and exerted a strong influence on the Czech avant garde, especially following the bazaar of modern arts organized in November 1923, which marked a greater affinity with Dada and Purism. After this exhibition was shown in Brno the following year, Teige and his fellow poet Vítězslav Nezval published the first manifesto of Poetism, an 'art of living' which transcended the contradictions of human life in a playful, sensuous and hedonistic philosophy that delighted in the spirit of the carnival and circus and offered a new aesthetic of creation. It drew the many strands of the international avant garde into a subtle concept of 'poetry for the five senses', encompassing not only visual and verbal poetry but the possibility of olfactory and tactile forms and synaesthetic experiments such as Zdeněk Pešánek's colour piano, used to perform works by Scriabin (1928), his kinetic sculpture *A Memorial for Pilots* (1924–26), and the atonal orchestral, chamber and theatre compositions of Miroslav Ponc.

From 1929 Devětsil lost ground with the establishment of Levá Fronta (Left Front), which gradually assumed its cultural and political functions and took over its architectural branch, an important element of the Czech avant garde as it embodied its capacity for influence on the everyday life and environment of the new Czech citizen. This could be seen in the work of Alois Wachsman, Josef Chocol, Jaroslav Fragner and, above all, Jaromír Krejcar, whose architecture not only for residential buildings but for industrial and commercial premises and transatlantic steamers marked a way forward from Teige's repudiation of modern technology in his efforts to meld art with life.

Krejcar's designs were frequently inspired by the Soviet trend towards industrialization. The USSR, however, provided fewer positive political and cultural models for Teige, whose adherence to party dogma increasingly stifled Devětsil's intellectual and creative freedom and stirred up conflicts within the group. That, in 1931, led to its collapse with the final issue of *ReD*, its main journal, which in 1927 had published the manifesto of Artificialism issued by the painters Jindřich Štyrský and Toyen (Marie Čerminová).

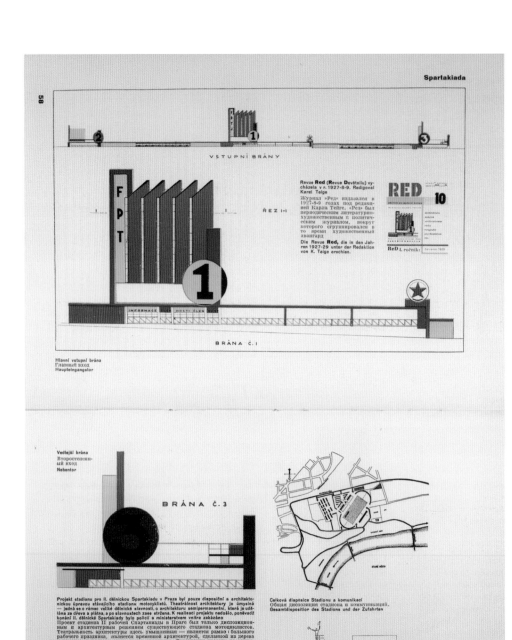

58

VSTUPNÍ BRÁNY

ŘEZ I–I

Revue **Red** (Revue Devětsilu) vycházela v r. 1927-8-9. Radigoval Karel Teige

Журнал «Ред» издавался в 1927-8-9 годах под редакцией Карла Тейге. «Ред» был периодическим литературно-художественным и политическим журналом, вокруг которого сгруппировался в то время художественный авангард

Die Revue **Red**, die in den Jahren 1927-29 unter der Redaktion von K. Teige erschien.

RED 10

BRÁNA Č. I

Hlavní vstupní brána
Главный вход
Haupteingangstor

Vedlejší brána
Второстепенный вход
Nebentor

BRÁNA Č. 3

Projekt stadionu pro II. dělnickou Spartakiadu v Praze byl pouze disposiční a architektonickou úpravou stávajícího stadionu motocyklistů. Theatrálnost architektury je úmyslná — jedná se o rámec veliké dělnické slavnosti, o architekturu semipermanentní, která je udělána ze dřeva a plátna, a po slavnostech zase stržena. K realisaci projektu nedošlo, poněvadž konání II. dělnické Spartakiady bylo policií a ministerstvem vnitra zakázáno

Проект стадиона II рабочей Спартакиады в Праге был только диспозиционным и архитектурным решением существующего стадиона мотоциклистов. Театральность архитектуры здесь умышленная — является рамкой большого рабочего праздника, является временной архитектурой, сделанной из дерева и полотна, и сносится опять после праздника. Реализация проекта не осуществилась т. н. II рабочая Спартакиада была запрещена полицией и министерством внутренних дел

Das Projekt für das Stadion der II. Arbeiterspartakiade in Prag war bloss eine Lösung der Diaposition und Architektur des bestehenden Stadions für Motorradfahrer. Das Theatralische der Architektur ist Absicht — es handelt sich um den Rahmen eines grossen Arbeiterfestes, um einen semipermanenten Bau aus Holz und Leinwand, der nach dem Fest wieder abgerissen wird. Zur Realisierung des Projektes kam es nicht, weil die II. Arbeiterspartakiade von der Polizei und dem Innenministerium verboten wurde

Celková disposice Stadionu a komunikací
Общая диспозиция стадиона и коммуникаций.
Gesamtdisposition des Stadions und der Zufahrten

59

Velitelský můstek je konstrukcí vědomě převzatou z Lisického návrhu řečnické tribuny
Výhodou této konstrukce je maximální viditelnost

34

35

OPPOSITE:
Karel Teige,
The Work of Jaromir Krejcar
(Práce Jaromíra Krejcara),
1933

Typography by Krejcar
with summaries in German
and Russian. Teige's text
recounts the history of
Devětsil and its place in the
European avant garde, as
well as looking at the
work of the functionalist
architect Krejcar.

(BL Cup. 410.g.43)

ABOVE:
F.R. Drtikol,
Woman in Light
(Žena ve světle), 1930

Drtikol was a pictorialist
photographer, preferring
pigment prints to the
avant-garde's silver gela-
tin. The most modernist
aspects to these photo-
graphs are the geometrical
stage devices and the
dynamic viewpoints.

(BL, new acquisition)

Many of the members of the Czech avant
garde were active in a number of fields, hardly
surprising in view of Poetism's joyous celebration
of such a variety of human activities. Some
explored the possibilities of new media directly;
although Czech cinema was still in its very early
stages, Devětsil established the Club for New
Film in January 1927, and several of its members
produced experimental film-scripts. More impor-
tantly, photography featured strongly in the journal
Život (1922), an anthology which anticipated László
Moholy-Nagy's ideas of ciné composition and
typo-photography in the work of Jaroslav Rössler,
also an architect, who drew inspiration from
Constructivism and Purism and influenced Jaromír
Funke, whose photograms and assemblages evoke
the spirit of Poetism in visual terms with sugges-
tions of Constructivism and Surrealism.

Others explored the potential of new techno-
logy to revive and diversify existing forms of artistic

expression, as in Nezval's enthusiastic adoption of themes such as electricity and the telegraph in his collection *Pantomime* (1924, the first work of Czech Poetism, combining picture poems, librettos and a range of other art forms) and Jaroslav Seifert in his early work *Na vlnách TSF* (*On the Waves of the Telegraph*, 1925). Similarly the Osvobozené Divadlo (Liberated Theatre), founded in 1926 as the theatre section of Devětsil, aimed to create and present poetic drama, with the actor-playwrights Jiří Voskovec and Jan Werich blending anarchic humour with the *commedia dell'arte* tradition and drawing the audience directly into the drama by assuming the role of clowns to interact with the public during the intervals.

The direct link between word and image was, of course, typography, one of the chief areas for innovation, as demonstrated by Teige and his followers. Teige defined the principles of typographic design in strict terms, noting the role of title page and cover as 'posters for the book', whose typeface and colours should complement the literary content. In 1925 Jan Fromek's publishing house Odeon began to specialize in avant-garde book design, publishing works designed in the Poetist style by authors including Nezval, Josef Čapek and Vladislav Vančura (the leading Poetist prose writer).

Ultimately Teige's vision of the avant garde yielded to a belief in standardization as the highest form of perfection and the concept of progress as the highest good; in his search for a joyful future for the individual and mankind he unwittingly set out on a path that would entrap and hamper the movement he had founded and make such progress impossible by tying it to a model which finally led to totalitarianism. The influence of the Czech avant garde, however, was not so easily suppressed: in 1984 it was Jaroslav Seifert who would become the first Czech to win the Nobel Prize for Literature.

Susan Reynolds

Rome

In 1900 Rome was still one of the world's great art cities, and an important centre for international exhibitions like the Esposizione internazionale di belle arti, organized in 1911 to celebrate the fiftieth anniversary of the unification of Italy, and, in the following decades, biennial (1921, 1923, 1925) and quadriennial exhibitions (1931, 1935, 1939). It was also one of the major centres of avant-garde activity during the earlier twentieth century, especially during the inter-war years.

Rome was also the embodiment of everything the Futurists stood against – passéism (the cult of the past) and the dominance of the Church. It is, therefore, not surprising that Futurism was officially launched rather late in Rome, on 11 February 1913, exactly four years after the publication of the first Futurist manifesto, and also after the movement had been introduced to other European countries by exhibitions in London, Paris, Brussels, Berlin and Munich. The inaugural events in Rome comprised an exhibition of paintings in the foyer of the Teatro Costanzi (now Teatro dell'Opera) and two Futurist evenings, on the first of which, on 21 February, Francesco Balilla Pratella's *Musica futurista per orchestra* was premiered and Giovanni Papini read his *Discorso di Roma* denouncing the city as a symbol of passéism.

The Galleria Sprovieri became the main focus of avant-garde activities. It was opened in December 1913 to show the art of the international avant garde. An exhibition of Umberto Boccioni's sculptures and drawings was followed by one of paintings by Boccioni, Carlo Carrà, Giacomo Balla, Luigi Russolo, Ardengo Soffici and Gino Severini. In April–May 1914 the International Futurist Exhibition was mounted, showing works by English, Belgian, American, Ukrainian and Russian artists – the last group being particularly well represented with works by Alexandra Exter and Olga Rozanova. The gallery also became the venue for poetry readings by Filippo Tommaso Marinetti and Francesco Cangiullo, and concerts by Pratella and Russolo.

Giuseppe Sprovieri's enthusiasm for the avant garde did not survive the war, and the centre of the avant garde in Rome after the conflict was the Casa d'arte Bragaglia. Located first in the Via Condotti in 1918 and then in Via degli Avignonesi in 1922, the gallery was the creation of the Bragaglia brothers; its driving force was Anton Giulio Bragaglia, a versatile cultural impresario, theatre director, experimental film-maker and photographer who had earlier developed the concept of photo-dynamism, the results of which he exhibited in Rome in 1912 and published in 1913 – notoriously, the Milanese Futurist painters failed to understand the technique. In 1916 Bragaglia founded his own cinema company (La Novissima), which produced three films – *Thaïs*, *Il perfido incanto*, and *Il mio cadavere* – the first two with abstract backdrops by Enrico Prampolini. Between 1918 and 1930 he organized some 160 exhibitions, showing the work of various Futurist and Dadaist groups, of artists as diverse as Balla, Giorgio de Chirico, Gustav Klimt and Max Beckmann, and of Roman groups like the Expressionist Scuola di Via Cavour and the Valori Plastici group. Besides exhibitions, the gallery published two bulletins, *Cronache di attualità* (1918–22) and *Bollettino della Casa d'arte Bragaglia* (1921–24) and mounted theatrical events. The Via Condotti site had its own cabaret, the Gallina a Tre Zambe, and the latter a theatre, the Teatro degli Indipendenti, decorated by Balla, Fortunato Depero and Prampolini. The experimental plays and recitations staged at the theatre included Bertolt Brecht's *The Threepenny Opera*, and works by Luigi Pirandello, August Strindberg, Alfred Jarry and Marinetti. Ivo Pannaggi's *Ballet mécanique* was first presented there in 1922.

This was not the only example of the visual and performing arts being combined by the avant garde. In 1917, on the occasion of the Ballets Russes performances at the Teatro Costanzi, Léonide Massine exhibited his collection of works by Russian and Italian Cubist and Futurist artists in the theatre foyer. This was the second and most enterprising of the company's four visits to Rome; Stravinsky's *Feu d'artifice* (*Fireworks*) was given an abstract staging by Balla which employed variations of light over a brightly coloured set and mechanical shapes replacing the dancers. Depero was also commissioned to design sets and costumes for Stravinsky's *Le Chant du rossignol*, but his designs were so complicated that they proved impossible to execute. They nevertheless influenced Picasso's own designs and costumes for *Parade*, for which he had come to Rome, accompanied by Jean Cocteau, to prepare the forthcoming production of the work in Paris. Depero was more successful the following year with his *Balli plastici*, a five-act performance with music by Alfredo

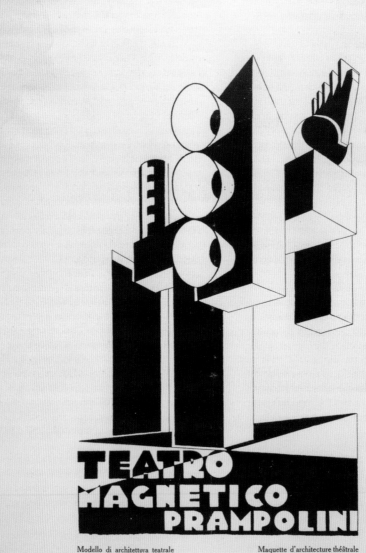

Modello di architettura teatrale
futurista (costruzione luminosa
in legno, m. 5,50×4)

PRAMPOLINI

Maquette d'architecture théâtrale
futuriste (construction lumineuse
en bois, m. 5,50×4)

≡ 12 ≡

Casella, Gian Francesco Malipiero, Tyrwhitt (Lord Berners) and Chemenow (Bartók), which was performed by the Teatro dei Piccoli puppet company at Palazzo Odescalchi.

The short-lived Galleria della Cometa (1935–38) functioned at a time when fascist art dominated the artistic scene and eventually fell foul of Italy's racial laws, but before that it promoted the work of de Chirico, Carrà and artists of the Scuola Romana. The gallery was the creation of Countess Anna Laetitia Pecci-Blunt, a notable art collector and music patron who divided her time between Rome, Paris and New York. Her Concerti di Primavera, which were started in 1933, promoted the music of Stravinsky, Malipiero, Petrassi, Casella, Poulenc, Honegger and Milhaud. The Edizioni della Cometa had a longer life than the gallery, publishing works by some of the most interesting writers working in Rome in the 1930s in limited editions with original engravings by artists of the Scuola Romana.

Several important avant-garde journals were published in Rome during this period: *Roma futurista* (20 September 1918–May 1920) was founded by Marinetti, M. Carli and Emilio Settimelli after publication of the Florentine *Italia futurista* ceased; it was initially the political arm of Futurism, publishing Marinetti's 'Manifesto del partito futurista', but its contents later became exclusively literary and artistic. Cangiullo's 'Il mobilio futurista' (1920) was first published in the journal.

Noi: rivista d'arte futurista (1917–20, 1923–25) was published by Prampolini, who also designed and edited it. The journal, which published Futurist manifestos such as 'Bombardiamo le accademie e industrializziamo l'arte' (1918), was not an exclusively Futurist publication. It also covered other avant-garde movements like Cubism, Dada and Metaphysical art. Contributors included Carrà, Severini and Marinetti. Prampolini was active in Rome in a variety of spheres during these years. An exhibition he organized at the Galleria dell'Epoca in 1918 was the first to include Metaphysical works by de Chirico, Carrà and Alberto Savinio. His international connections ranged from the Zurich Dada group of Tristan Tzara and Hans Arp to the Abstraction-Création movement of the 1930s. Theatre design was a constant preoccupation; in 1915 he published articles on Futurist stage design, and in 1925 he used light effects instead of actors in his Magnetic Theatre. In the 1930s he became one of the major exponents of Aeropittura, painting inspired by aviation, and of abstract art.

Valori plastici was published in Rome from 1918 to 1922 by the painter and collector Mario Broglio. As well as promoting the Metaphysical art of de Chirico, Carrà and Savinio, all of whom were collaborators, it also published for the first time in Italy articles on European avant-garde artists like Chagall, Derain and Kandinsky, and on movements like De Stijl and Der Blaue Reiter. The journal had an international edition published in French and was one of the major publications of the so-called 'return to order' phenomenon which swept through Europe in the years following the First World War; an exhibition of artists associated with *Valori plastici* organized by Broglio in Berlin influenced the Neue Sachlichkeit group. After publication of the journal ceased, Broglio published numerous monographs under the Valori Plastici imprint.

Futurismo (1932–34, from 1933 renamed *Sant'Elia*) edited by Mino Somerzi, attempted, through various manifestos, to promote Futurism as the official artistic movement of fascism.

Chris Michaelides

OPPOSITE:
Noi: rivista d'arte futurista,
1925
(BL 7860.k.22)

St Petersburg and Moscow

The Russian Futurists were a younger generation of artists and writers who wanted to revolutionize both art and language. Their manifestos *A Slap in the Face of Public Taste* and *The Word as Such* expressed a need to invent forms which went beyond rational expression and to make the word rule supreme. Between 1912 and 1917 they produced a number of handwritten, lithographed 'artists' books' with a unity of text and image similar to that found in medieval manuscripts: it helped that the poet and the artist/scribe were often one and the same. The principal artists and poets were Khlebnikov, Kruchenykh, Kamensky, Mayakovsky, the Burliuks, Larionov, Goncharova, Malevich and Filonov. They formed and re-formed themselves into various groups in Moscow and St Petersburg. The Ego-Futurists and the Union of Youth, which included Rozanova and Kulbin, were the most active in St Petersburg. In Moscow the Hylaea group – later known as the Cubo-Futurists – dominated the scene. Hylaea centred round Larionov and Goncharova and took its name from a region in the southern part of the Russian Empire. Hylaea also became the name of one of the main publishers for Moscow Futurist publications. Many of this group came from provincial backgrounds – unlike the upper-class Symbolists whom they wanted to ditch with the classics of the past – and therefore identified with the area where the primitive Scythians had flourished.

Rejecting 'civilized forms of art', the Futurists' visual style was influenced by Russian folk art, iconography and non-European primitive art filtered through a knowledge of Cubism and other contemporary art movements such as Expressionism and Fauvism. To a certain extent Futurism in the Russian context was therefore used as a broad term encompassing all the modern artistic trends encountered by artists such as Goncharova, Larionov and Malevich during their visits to Western Europe.

The Russian origins of Futurism are evident in Natalia Goncharova's *Mystical Images of War* – her response to the First World War – which combines images based on Russian icons and popular prints (*lubki*) with aspects of modern life, as in the lithograph *Angels and Aeroplanes*. The influence of non-European primitive art is visible in Vladimir Burliuk's lithograph for *The First Journal of Russian Futurists* (opp. p. 12) where the image of a horse's head can also be seen as that of a bird. The influence of folk art and children's drawings can be experienced in Goncharova's drawings for Kruchenykh's *Worldbackwards* and Larionov's cover for *Pomada*. Aleksei Kruchenykh and Velimir Khlebnikov's *Game in Hell* – a card game between devils and sinners – exemplifies the deliberate mixing of different styles of lettering using characters which resemble Old Church Slavonic script. Kruchenykh's *Explodity* shows how the letter or word can become image as the shapes of the letters are reflected in the illustrations by Nikolai Kulbin; this also shows the influence of Chinese calligraphy.

To liberate words from their meanings the Futurists made up a transrational (*zaum*) language which they used in poetry to create an effect rather like music, though in the case of Khlebnikov and Kruchenykh giving rise to more of a primeval universal language of sounds. Sometimes the sound takes over completely, as in Khlebnikov's *Incantation by Laughter* (1910) which makes use of only one root word, *smekh* (laughter). To this are added suffixes to make new words with which sentences are made; the poem itself becomes the sound of laughter. Kruchenykh made one of the first attempts in Russian to write in vowels only. The first line of this poem includes the word *Euy* – Kruchenykh's name for 'lily'. This subsequently became the name of the main publisher of Futurist books in St Petersburg. Kruchenykh set out his theories about transrational language in *The Word as Such*. One of the main principles of Futurist poetry was that it should be 'written and read in

OPPOSITE:

S. I. Kirsanov, *Kirsanov is Called upon to Speak (Slovo predo stavliaetsia Kirsanovu)*, 1930. Cover by Solomon Telingater.

In his cover for this book the Constructivist designer Telingater combines inventive typography and photomontage in unusual ways.

(BL C.114.m.19)

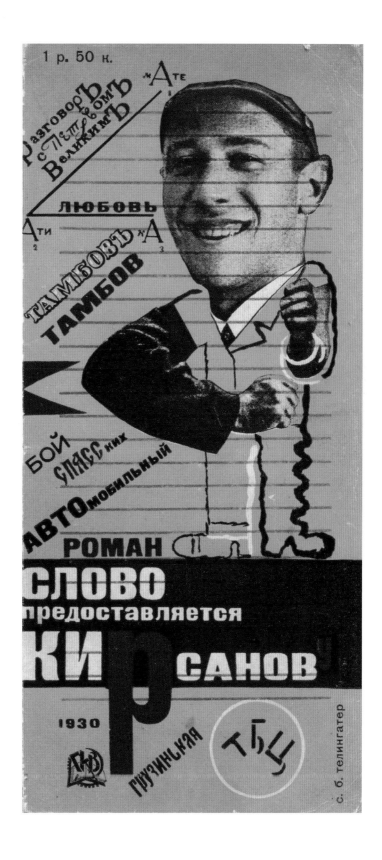

LEFT AND BELOW:
Aleksei Kruchenykh and
Velimir Khlebnikov,
Te li le, 1914.

Title page of Kruchenykh's
section decorated by Olga
Rozanova and the text of
a poem. *Te li le* was hand-
written and reproduced in
colour by hectography. The
book has a nonsense title
and includes Kruchenykh's
poem in transrational
language, 'Dyr bul shchyl'.

(BL C.114.mm.37)

a twinkling of an eye'. Futurist poets would use half-words, chopped-up words and new word combinations, and ignore the rules of grammar and syntax. He included his transrational poem 'Dyr bul shchyl' as an example of the importance of repeating one obviously pronounced consonant within a poem. Sound was obviously important but it did not lead to Dadaistic irrationality and lack of meaning – Kruchenykh actually wanted new meanings to be created out of the pure sound of the word.

The Futurists also wanted to create deliberately anti-aesthetic books which were hand-made and often used rough materials, such as the wallpaper that illustrates Vasily Kamensky's poetry collection *Tango with Cows*. These books sometimes looked like exercise books with tipped-in pages, glued-on labels and different colour papers. They also used staples and rubber-stamps.

The Futurists and their famous café the Stray Dog were the talk of the town in St Petersburg and Moscow in 1913–14. One of the main avant-garde events in St Petersburg was the performance in Luna Park of the Futurist opera *Victory over the Sun*. This is an early instance of performance art. It was sponsored by the Union of Youth and combined the talents of the writer Kruchenykh, the composer Mikhail Matiushin and the artist Kasimir Malevich. Kruchenykh's script was written in 'transrational' style without any narrative or causal logic, sometimes ending up in pure emotive sounds. The music, which distorts conventional operatic forms, makes use of quarter tones and is meant to sound deliberately out of tune. Malevich's costume designs are broken up into geometrical elements foreshadowing the Cubist-inspired costumes of *Parade*. It was this approach to the human figure that developed into Malevich's preoccupation with the geometric, coloured, non-figurative forms of Suprematism, set out as a system in his *From Cubism and Futurism to Suprematism* (1916).

Besides Matiushin the composers most frequently associated with Futurism were Arthur Lourié, Nikolai Roslavets and Sergei Prokofiev. Lourié, who considered himself a Russian Pratella, had several of his works included in Futurist anthologies. His score *Formes en l'air* has been described as a sound script and is Cubist in design with staves omitted to indicate rests. The work of Roslavets had appeared in the manifestos of the Russian Futurists. He established his own system

of harmonic organization built on synthetic chords, which evolved into an atonal serial system similar to Schoenberg's.

One influential visitor to Moscow was the director Edward Gordon Craig. His 1911 Moscow production of *Hamlet* was treated like a monodrama. Vladimir Mayakovsky saw this production and adopted a similar approach to his own play *Vladimir Mayakovsky: a Tragedy*.

Filippo Tommaso Marinetti visited Moscow in 1914. The Russian reception was mixed, with Khlebnikov organizing the distribution of anti-Marinetti posters. Marinetti however showed particular admiration for Kruchenykh's recently published *Te li le* which, like *Zang Tumb Tuuum*, has a nonsense title but, unlike the latter, has few onomatopoeic references. Kruchenykh's book was handwritten, decorated by Olga Rozanova and reproduced in colour by hectography. The irregularity of the handwriting gave words the freedom and increased expressivity of text the Italian Futurists were seeking in their aim to create an irrational art, though the combination of handwritten poetry and illustration was not found in Italian Futurism. A real attempt to create a book in the manner of Italian Futurists – typeset with typographical innovations – was made by David and Vladimir Burliuk in the design for Kamensky's *Tango with Cows*. In the one-page ferro-concrete poem 'Cabaret', there is no syntactic structure and the page is divided into segments (one corner of the book is actually cut off). The text is organized by word association and visual links – mostly nouns and verbs in various types and sizes of font – are grouped around the page, leaving the reader free to let the eye wander over the page as if examining a painting. The book also contains calligrammes such as 'Vasya Kamensky's aeroplane flight in Warsaw', where the poem forms a visual representation of a plane taking off.

Some aspects of Italian Futurism were embraced by the Russian artists and poets. Urban themes are prevalent in Mayakovsky and the glorification of fighting as a source of creativity is reflected in the way the Futurist poets insulted and physically attacked their audiences during readings. While on one hand there were groups such as the Nothingists who had traits in common with western Dada groups, on the other there were poets such as Kruchenykh and Khlebnikov

who looked back to a distant past alien to Italian Futurists interested in the 'now' with its noise, speed and new technology (an interest shared later by the Russian Constructivists). Mikhail Larionov and Natalia Goncharova were somewhere in between. Whereas they both show stylistically an indebtedness to Cubism and Italian Futurism – for example by the use of lettering in their paintings – they seem very Russian in their subject matter and in their artistic contribution to literary works. Even the philosophical ideas behind their Rayonism – an abstract style which depicts the 'crossing of reflected rays from various objects' – were indebted to Russian mysticism. The influence of Russian and oriental primitive folk art on the avant garde was very much in the back of their minds when they set up the Donkey's Tail group in 1912 in opposition to the earlier Western-orientated Jack of Diamonds group.

During the period of the revolution and Civil War, the Futurists sought to gain recognition, believing their own ideas would best serve the new society. Their willingness to work with the Bolsheviks enabled them to publish books extolling avant-garde art and literature, and many Futurists expected to convert the masses by using these art forms. They also found an official role as poster artists: Vladimir Lebedev's *Russian Placards 1917–22* (for the Russian Telegraph Agency ROSTA) with their brightly coloured geometrical figures addressing social issues including alcoholism were particularly successful in fulfilling this role. Poets such as Vladimir Mayakovsky continued to write poetry for the masses in a Futurist style, as for example in his poem 'From street into street', where words are split up and images are treated in parallel in a Cubist manner. Other artists such as Goncharova and Larionov finally settled in Paris, where they created set designs for Diaghilev's Ballets Russes.

By 1922 Futurism had given way to Constructivism. *State Plan for Literature, Left Front of the Arts, Workers' Art* and *Gan's Constructivism* demonstrated that their prime aim was to communicate on a mass scale and to connect art to everyday life. Constructivism had a more scientific and utopian connotation than Futurism. The artists and writers wanted to be known as 'workers' and started workers' clubs to educate the masses. Constructivists included the influential El Lissitzky and

Rodchenko, Altman, Telingater, Stepanova, Klucis, Popova and Kliūn.

The designs of Alexander Rodchenko and El Lissitzky transformed books of poetry by Mayakovsky, where the covers became as striking as posters. In El Lissitzky's cover for Mayakovsky's *For the Voice* the letter 'O' becomes the mouth and voice – the text becomes the image. Not only the cover but the whole of *For the Voice* with its index of symbols is treated as part of the Constructivist design. Throughout the work there is much wordplay, with one letter being used where sounds and letters are shared at the intersection of words. El Lissitzky has in fact devised a 'setting' for Mayakovsky's poems *For the Voice*; by using printed symbols as the ingredients of illustration he transformed the poems 'for the eye'.

Rodchenko used photomontage for book covers and illustrations. He cut up photographs and reassembled them in a way borrowed as much from pioneering Russian film-makers as from the West (Heartfield and Georg Grosz), for example Mayakovsky's *About This*, where Mayakovsky's lover Lily Brik leaps out from the cover with staring eyes and bizarre photomontages accompany the poems inside. Later in the 1920s Rodchenko explored photography for its own sake and used photographs for the covers of journals, with the subjects photographed from unusual angles and the use of converging perspectives of diagonally tipped images. Examples of this are his covers to *Miss Mend* and the journal *New LEF*, which also make use of a strict grid, flat bright colours and distinctly lettered titles.

Rodchenko and El Lissitzky sometimes used photomontage in a slightly different way, taking photographs themselves, using double exposures on the same negative or printing one negative on top of another – as in El Lissitzky's cover for Ilya Selvinsky's *Notes of a Poet*. In Ilya Ehrenburg's *Materialization of the Fantastic* Rodchenko alternates vertical strips of positive and negative images. Solomon Telingater, El Lissitzky and the Stenberg brothers combined typography and photography in unusual ways, mixing different types and sizes of font as well as combining photographed and drawn parts of the human body. Outstanding examples of this are Telingater's cover for *Kirsanov is Called upon to Speak* and El Lissitzky's for *Architecture: Works from the Architecture Faculty at Vkhutemas*.

Vasily Kamensky,
Tango with Cows
(*Tango s Korovami*), 1914.

'Cabaret', ferro-concrete poem.

(BL C.114.n.32)

Constructivist design was also used for posters and film brochures. The Russian film-makers Dziga Vertov and Sergei Eisenstein, with their use of montage in films such as *Man with the Movie Camera* and *Battleship Potemkin*, inspired designers such as the Stenberg brothers to provide poster equivalents. Political and advertising posters also featured experiments with typography and occupied a wide range in style from the abstract suprematist 'Beat the Whites with the red wedge' by El Lissitzky to the photomontage of 'Let us fulfil the plan of the great projects' by Klūcis.

In the early 1920s Russian theatre continued to develop the avant-garde style which centred on the Kamerny Theatre (founded in 1914). This trend was led by radical innovative directors such as Evreinov, Tairov, Vakhtangov and Meyerhold, who, rejecting naturalistic style, showed a preference for simplicity of setting with a synthetic mix of tragedy and farce including clowning and acrobatics. Tairov set out the basis for a new scenic mode in his *Notes of a Director*. Further innovations could be

seen in Vakhtangov's production of Gozzi's *Princess Turandot*, which drew inspiration from the *commedia dell'arte* and oriental theatre and made use of alienation effects where actors came out of character and talked to the audience.

Designers such as Alexandra Exter wanted to abandon the emphasis on the floor of the stage and replace this by horizontal inclined planes with the actor appearing in the middle planes (as in her Constructivist set design for *A Tragedy*). Alexander Vesnin took this further by replacing conventional scenery with a free-standing multi-level structure in *The Man who was Thursday*.

The Soviet government gave Vsevolod Meyerhold the task of transforming theatre for the masses. He used Constructivism to break down the barriers between art and life in an attempt to find a new audience of factory workers and soldiers. He achieved this by creating Constructivist mechanical scenery and using biomechanics in acting. The biomechanical method was an anti-psychological

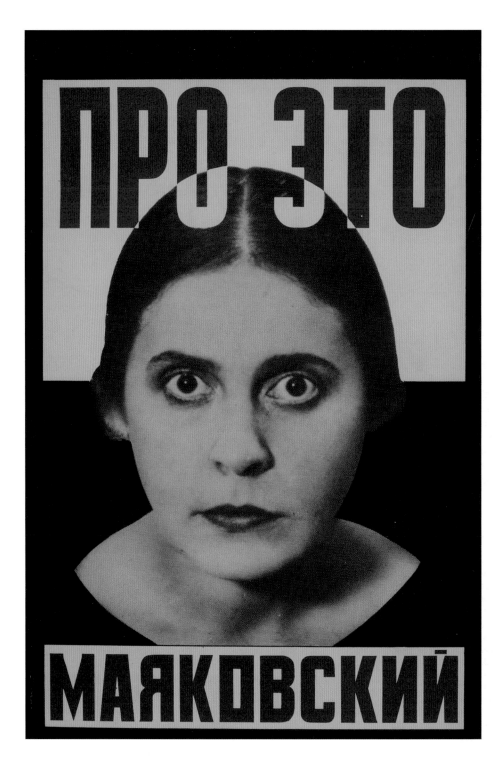

and anti-emotional approach to acting in which actors were trained like athletes and used circus techniques to give the impression of machine-like action (this can be seen in *Tarelkin's Death*). Meyerhold's designers were equally innovatory in applying Constructivist principles to stage design. In *The Magnanimous Cuckold* Liubov Popova created a three-dimensional form, like stage architecture bridging the audience stage divide, and in *Restive Earth* made use of the whole auditorium with multi-media, film screens and montage. Many of these productions used the printed word as an essential ingredient in the set design. One of the most forward-looking developments was the Stenberg brothers' 'in the round' set design for Kurt Weill and Bertolt Brecht's *Threepenny Opera*. The Constructivist approach with its emphasis on geometrical shapes, colour and function was also applied to costume, as for example in Anatol Petrytsky's design for a Moscow production of *Eccentric Dance* and Varvara Stepanova's costumes for *Tarelkin's Death*.

The idea of 'living theatre' and 'mass theatre' played a vital part in promoting revolutionary ideas. The Blue Blouse theatre/jazz group performed as a live newspaper and produced an album with collages illustrating their surreal antics.

The influence of Constructivism could also be felt in Soviet music. Pieces such as Mosolov's *Iron Foundry* with its machine-like brutalistic sound world, and Deshevov's *Rails* attempted to convey – as the Italian Futurists were doing – a sense of noise, speed and the thrill of modern technology.

OPPOSITE:
Vladimir Mayakovsky,
About This (Pro Eto), 1923.
Cover photomontage by
Alexander Rodchenko.

Mayakovsky's lover Lily Brik
appears to leap out from
Rodchenko's cover for *About
This*. Inside, Rodchenko
provides a series of photo-
montages to illustrate the
poem which evokes episodes
in Mayakovsky's love affair
with Lily Brik.

(BL C.131.k.12)

The young Shostakovich wrote incidental music for Mayakovsky's futuristic play *The Bedbug* (designed by Aleksandr Rodchenko) and composed several scores for the films of Constructivist directors.

Rodchenko set up the Working Group of Constructivists in order to create a new environment for a new society: architecture should have new forms, be practical and use modern light materials. Form was to be generated from a building's social function and the building should generally be without symmetry or ornament. There is both an emphasis on communal living (well illustrated in the journal *Let's Produce*) and a sense of shaping a new society as embodied in Vladimir Tatlin's design for a utopian tower: *Monument to the Third International*. The Working Group's ideas were set out in Aleksei Gan's *Constructivism*. A summary of Soviet architectural design to 1924 and projects for the future can be found in Moisei Ginzburg's *Style and Epoch*. A fuller record of Constructivist building achievements 1926–1934 appears in the journal *Contemporary Architecture (Organ of the Union of Contemporary Architects)*, the design of which was taken over by Varvara Stepanova and Telingater in 1929.

Outside this group were more traditional modernists such as Konstantin Mel'nikov, whose workers' clubs are illustrated in the journal *Construction of Moscow*. Constructivist design affected all aspects of Soviet life from clothes and furniture to crockery and street architecture. The Latvian Gustav Klūcis, a leading exponent in the use of photomontage for political propaganda, used this technique to create designs for radio announcers and street kiosks.

In 1932, with the formation of the Union of Artists and Union of Writers, experimentation was officially proscribed. However artists such as Rodchenko, Stepanova and Telingater continued to design Socialist Realist books such as *Reconstruction of Moscow*, with its paper window flaps which the reader can lift to peep into a new-style worker's flat. Other writers and directors suffered various fates: Mayakovsky's identification with social change and experimentation led him into conflict with the authorities and he committed suicide in 1930; Meyerhold lost his theatre in 1936 and was executed four years later.

Peter Hellyer

Tbilisi

Since Soviet power was not established in Tbilisi until the end of 1921, it became a haven for the Futurists who flourished in pre-revolutionary Moscow and St Petersburg. Between 1917 and 1921 Georgian people welcomed the visits of Russian and foreign artists and writers as Tbilisi became the venue for well-known avant-garde celebrities. Here the main avant-garde trends of the period – Cubism, Futurism and Dadaism – expanded from the visual arts to literature, politics and social interaction.

It was a remarkable period for Georgian culture when the country integrated European artistic values, and Tbilisi became the centre of avant-garde art in the Caucasus. Russian Futurists also exploited the potential of the local culture and language which was put to fruitful use in their artistic experiments. This period was also the most multi-cultural in the history of Russian and Georgian Futurism, when the Caucasian lifestyle, oriental traditions and strong European element co-existed creatively.

Here Aleksei Kruchenykh, who moved to Georgia to avoid being called up, joined forces with the Zdanevich brothers, Ilia and Kirill, both Tbilisi natives. The first organized group, the Futurist Syndicate (1917–18), was dominated by their presence, but attracted numerous local talents such as the Georgian painter Lado Gudiashvili and the resident Armenian Futurist Akop Kara-Dervish, as well as a Polish artist Zygmunt Waliszewski. Together they published the almanac *Learn Khudogi*.

In 1918 Kruchenykh and Ilia Zdanevich were joined by the young 'transrational' poet Igor Terentev to create a new group which was called Forty-One Degrees (41°). The name 41° may have referred to the 41st parallel on which Tbilisi and a number of large cities (Madrid, Naples, Istanbul, New York and Beijing) are located. Also the maximum temperature for the human body, 41° subsequently became the name of the main publisher of Futurist publications in Georgia.

Between 1917 and 1919 Kruchenykh published over forty books, mostly duplicated on a mimeograph machine. In the Futurist manner, his books often used mixed papers (including carbon paper) and sometimes varied contents, page order and cover from one copy to another. These books included *F/NAGT*, in which Ilia Zdanevich and

Aleksandr Rodchenko were involved, and *Obesity of Roses* (the British Library copy of this has a collaged cover by Kruchenykh himself).

Some of Kruchenykh's books were handwritten and consisted of transrational (*zaum*) poems with words disintegrating into disjointed syllables or letters, accompanied by avant-garde illustrations (e.g. 'Klez san ba'). Kruchenykh's poetry of this period has three main characteristics: the use of texture, shift and transrational language. As far as sound texture is concerned, Kruchenykh's preference was for the unpleasant textural effects of cacophony. His favourite consonantal sound was 'z' and he would sometimes even substitute it for legitimate consonants in a word. He also showed a liking for the effects of 'shift', where the juxtaposition of two words would produce another from the end of one and the beginning of the other. He would often exploit this to produce scatological or sexual meanings. The creation of neologisms in a transrational language was for Kruchenykh a vital ingredient in his poetry. Here he sought to create a language which did not refer to anything outside itself but which could still arouse the emotions by the combination of certain sounds. Kruchenykh brought together some of his ideas in his second manifesto *Declaration of Transrational Language*, first published in Baku in 1921.

Kruchenykh also used the potential of Georgian phonetics. Georgian words written in the Cyrillic alphabet do not make sense in Russian. In this context they could be used as transrational language which could be decoded and understood only in Georgian. Georgian words functioning as transrational poetry were used by Kruchenykh in many of his Tbilisi publications, such as *Lacquered Tights* (1919). This was entirely typographic. The book has a cover by Ilia Zdanevich and shows great variety and ingenuity in the use of print. He also designed the inventive cover for *Fakt* by Terentev. Though born in Tbilisi, Ilia Zdanevich had studied and worked in Moscow. After his return to Tbilisi, he wrote a number of plays (or *dra* as he called them) in a style derived from Ukrainian puppet-theatre models. The text was mostly written in transrational language though it did include some Russian phrases and words, particularly scatological ones to create a shock effect. A characteristic feature of these plays was that every word was given in phonetic transcription. Also the normal use of

H2SO4: *Literature etc*,
Tbilisi,1924

Cover designed by
Kirill Zdanevich.

(BL RB.23.a.30083)

Aleksei Kruchenykh,
Lacquered Tights
(*Lakirovannoe Triko*), 1919.

Cover by Ilia Zdanevich

(BL C.114.m.23)

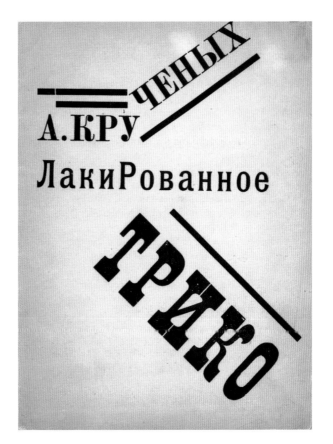

capitalization and punctuation was either abandoned or non-existent.

Many of these plays were published by 41° in Tbilisi, but the most impressive, *Le-Dantiu as a Beacon*, was published in Paris in 1923, where Zdanevich (under the pseudonym Iliazd) continued to use the same imprint. In *Le-Dantiu as a Beacon* (which may have been written in Russia), the typography sometimes has a phonetic function, for example where the vowel of the stressed syllable is given a large capital letter. At other times it has an ornamental function, where large decorated letters and a variety of type forms add to the overall visual effect. There are also further linguistic experiments: one character speaks in vowels only, another speaks in consonants only and others lisp or click. Zdanevich also employs the technique of having several voices enter polyphonically, or together as a chord where syllables coincide. Here the typography resembles a musical score with numbered voice parts and echoes the simultaneous poems of the Dadaists in Cabaret Voltaire.

The main venue for the meetings of the 41° group was called the Fantastic Tavern, a Tbilisi nightclub where prominent figures of the Russian and Georgian avant garde came to recite, perform and lecture. The Fantastic Tavern had in some sense become a descendant of the celebrated Petersburg venue the Stray Dog. With the opening of the Fantastic Tavern, Tbilisi became a continuation of this venue and a new phase of the 'Petersburg myth' of modern urban life as a phantasmagoria. The walls of the Fantastic Tavern were decorated in Futuristic style by Georgian and Russian artists – L. Gudiashvili, I. Nikoladze, I. Zdanevich, I. Degen and A. Petrakovsky.

During this period the Russian and Georgian Futurists published about fifty books and periodicals. The most important and interesting of them is an anthology which was dedicated to a local actress and called *To Sofia Georgievna Melnikova: the Fantastic Tavern* (with cover by Kirill Zdanevich). This multilingual book was created together with the Blue Horn Group of Georgian Symbolist poets, and included poems by Tabidze and Iashvili as well as fold-out typographic compositions by Ilia Zdanevich. These collages display a multiplicity of typefaces on one page with unusual positioning of text segments vertically and diagonally; the influence of Italian Futurists can be seen here.

The illustrations include drawings by Natalia Goncharova and Lado Gudiashvili. The Blue Horn Group co-existed peacefully with the 41° group showing the unique atmosphere of the Tbilisi avant garde in which different artistic groups could co-operate and be creative together.

In 1921 Georgia was forced to become Soviet, and a large number of Russian and European artists left the country. However, the trends that marked the previous years continued and were intensified by the activities of a group of Georgian artists who returned from Paris. This group included David Kakabadze and Gudiashvili.

Among the other events of this period the Georgian Futurists published three journals, all short-lived: H_2SO_4 (i.e. the formula for sulphuric acid); *Literature etc.* as a continuation and an additional issue of H_2SO_4; and *Leftness*. The name of the chemical formula H_2SO_4 was a reference to the group's desire for the destruction of traditional literature and forms of art. The first issue of the journal was published in May 1924, designed by Irakli Gamrekeli and Beno Gordeziani. The design of the journal focused on Constructivist, Futurist and Dada styles. The visual side of the Georgian alphabet, the unusual shape of the letters, was used to create artistic texts – images in the form of a textual collage. These visual poems displayed the freeing of language from conventional meaning in both a visual and verbal sense.

H_2SO_4 continued as *Literature etc.* This journal included visual works, poetry and essays similar to H_2SO_4 in style and theoretical approach. The front page was designed by Kirill Zdanevich, who used the idea of a transrational language, which continued the search for forms that were beyond logic and structure and thus more universal and authentic.

Some Russian poets continued to publish controversial works in Tbilisi during the 1920s. Notable examples of these are Mayakovsky's *Syphilis, Conversation with a Tax Inspector about Poetry* and *To Sergei Esenin* (all published in 1926 with covers by Rodchenko). Aesthetic experiments in Tbilisi went on till 1930 when the authorities repressed those whom they termed 'formalists'.

Anna Chelidze and Peter Hellyer

Vienna

A work by Gustav Klimt recently obtained the highest price ever paid at auction for a single painting. The symphonies of Gustav Mahler, once dismissed as self-indulgent, have become mainstays in the repertoire of orchestras around the world. Freudian analysis is now part of mainstream culture. Klimt, Mahler and Sigmund Freud are only three giants of *fin-de-siècle* Vienna whose presence is felt today. Viennese modernism was characterized by radical artistic, literary and conceptual movements, innovative city architecture and design, the birth of psychoanalysis, the development of twelve-tone music – all the work of a remarkable throng of talented artists and thinkers from intermingling circles.

Capital of the Austro-Hungarian Empire, Vienna at the turn of the twentieth century was dominated by the Habsburg monarchy and its emperor, Franz Joseph I, who cultivated tradition and continuity. Other forces, however, were at work. Dr Karl Lueger, the first socialist mayor of Vienna – popular with the ordinary people – introduced in 1897 an energetic programme of modernization. This included the construction of new hospitals, parks, schools and a metropolitan railway system, an opportunity for the new Jugendstil (Austrian art nouveau) designs of Otto Wagner for the Karlsplatz Stadtbahn station (1899–1901), as well as the Austrian Postal Savings Bank building (1904–06). By the time the fiftieth anniversary of the emperor's reign was celebrated in 1898, artists and intellectuals frequenting Vienna's coffee houses, frustrated with the 'old order' of Franz Joseph and all its stagnation and decadence, were demanding change.

A circle of writers, with the literary critic Hermann Bahr at its centre and including Arthur Schnitzler, Hugo von Hofmannsthal and Karl Kraus, would meet at the Café Griensteidl, and later at the Café Central. Known as Jung Wien (Young Vienna), the group turned away from naturalism in favour of Symbolist and Impressionist techniques, thereby initiating a new movement in Austrian literature that would culminate in the writings of Robert Musil, Stefan Zweig and Joseph Roth. Notably, Schnitzler's novella of 1900, *Leutnant Gustl* is an early example of the 'stream of consciousness' technique in German. Kraus in *Die demolierte Litteratur* (*Demolished Literature*) commemorated in 1897 the closure of the Café Griensteidl,

satirizing the farewell to the old literary movement. A principal organ for their publications was Bahr's own Viennese weekly, *Die Zeit* (1894–1904). Bahr set out criteria as to how literature should change: 'to be modern...not only modern once, but to stay modern always and that means...to be revolutionary at any time'. He advocated flux, movement and change, believing that everything new is better, just because it is younger.

Von Hofmannsthal describes this conscious break with the past, in language and literary matters, in his essay 'Der Brief', the so-called 'Chandos Letter', published in 1902: 'I have completely lost the ability to think or speak in a connected manner about anything.' He expresses a linguistic crisis, a concept that would later influence the language philosophies of the Viennese philosopher Ludwig Wittgenstein, whose *Tractatus Logico-Philosophicus* (1921) was one of the works discussed at meetings of the Wiener Kreis (Vienna Circle) of philosophers, who concerned themselves with epistemology and philosophy of science. The limits of language for von Hofmannsthal and others become the limits of thought, and the modern world becomes too complex to express in words.

Dreams, the unconscious mind and the erotic form the new frontier explored by Freud, who lived and worked in Vienna, publishing his seminal *Die Traumdeutung* (*The Interpretation of Dreams*) in 1899. These also became elementary themes in the experimental art of the Vereinigung Bildender Künstler Österreichs Secession (Association of Austrian Artists Secession) or Wiener Secession (Vienna Secession) movement, founded by a group of Viennese artists in 1897 under its first president, Klimt, in opposition to the prevailing conservatism of the Wiener Künstlerhaus (Vienna Artists' House). They established their own journal, *Ver Sacrum* (1898–1903), as a vehicle for their art and ideas, and constructed their own exhibition hall, designed by Joseph Maria Olbrich. Charles Rennie Mackintosh exhibited in Vienna at the eighth exhibition of 1900. In 1902 Beethoven was the subject of the fourteenth, a *Gesamtkunstwerk*, involving the work of twenty-one artists, under the direction of Josef Hoffmann.

Together with another Viennese artist, Koloman Moser, and backed by the industrialist Fritz Wärndorfer, Hoffmann founded the Wiener

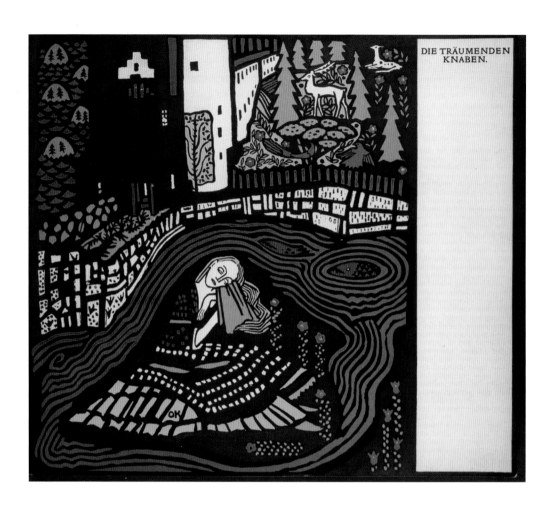

Oskar Kokoschka,
Dreaming Youths
(*Die Träumenden Knaben*),
1908

Foundation Oskar
Kokoschka/2007, DACS

Werkstätte in May 1903, a co-operative of decorative and other artists whose aim was to counter mass production. Their motto was: 'Better to work ten days on one product than to manufacture ten products in one day.' Wiener Werkstätte artists were responsible for the interior design of the Cabaret Fledermaus, completed in 1907; Oskar Kokoschka contributed. His *Die Träumenden Knaben* (*The Dreaming Youths*) was commissioned by the Wiener Werkstätte and published in 1908, in an edition of 500 copies. Dedicated to Klimt, it was a book of Kokoschka's own poetry, ostensibly for children, and illustrated with eight colour lithographs also by Kokoschka – in all, though, full of erotic imagery.

The central figure of the Second Viennese School in music was Arnold Schoenberg. In 1908 he abandoned tonality, embracing atonality – or 'pantonality' – thereby setting aside hundreds of years of Western classical music tradition. The year 1909 saw the atonal compositions *Three Piano Pieces*, *Five Pieces for Orchestra* and the 'monodrama' *Erwartung* (*Expectation*), written in only seventeen days, an Expressionist masterpiece. The Verein für musikalische Privataufführungen (Society for Private Music Performances) was founded by Schoenberg in Vienna in 1918 to perform contemporary, modernist works by a range of composers to a selected audience. Schoenberg was also the principal inventive proponent of structured atonalism with the twelve-note system or *Serialismus* (serialism), first demonstrated in his *Suite for Piano* (1921–23). Anton Webern and Alban Berg – both also Viennese – were Schoenberg's two most famous pupils. Webern presented a distillation of serialism in his *Five Pieces for Orchestra* (1911–13), consisting of just seventy-six bars of music. Berg, however, retained the high romanticism of Mahler and combined it with the twelve-note system, which he structured purposefully to integrate a lot of tonality, notably in the Violin Concerto of 1935, probably his most popular work.

Vienna also became the home of exiles fleeing the rightist takeover of Hungary. In 1920 Lajcs Kassák re-established *Ma* there. The group, which included Uitz, Bortnyik, Simon, Ujvári, Berény and Barta, met at the Schloss Café and soon had links with most West European avant-garde circles. The German-Hungarian theorist Ernő Kállai and László Moholy-Nagy sent writings and illustrations for

Ma, and works by *Ma* protagonists were included in West European journals such as *De Stijl* and *Der Sturm*. Links with the Bauhaus were cultivated through its Hungarian members Moholy-Nagy, Marcel Breuer, Farkas Molnár, László Péri and Fréd Forbát. In Vienna *Ma* became typographically more sophisticated and colourful. It printed picture poems, and its earlier Expressionist images were replaced by geometric forms, graphics with machine-like elements or collages.

For a generation at least, the Austrian capital was a seedbed of avant-garde theories, philosophies, culture and creative expression. Vienna, capital of an ethnically diverse empire of over fifty million people before its dissolution in 1918, was home to a remarkable concentration of artists, designers, thinkers and musicians.

Dorothea Miehe

Vitebsk

In the summer of 1918 Marc Chagall set up the Art School and Museum in his home town of Vitebsk under the auspices of Narkompros (People's Commissariat of the Enlightenment). In the same year a book by Efros and Tugendkhold called *The Art of Marc Chagall* was published. This important monograph with a cover design by Chagall included photographs of many of his early works, which had been left in Western Europe in 1914 on his return to Russia after the outbreak of war. For the anniversary of the Revolution, Chagall created street decorations in Vitebsk. When El Lissitzky and Kazimir Malevich joined the Art School staff in 1919, it became difficult for Chagall to hold on to his position as Commissar for the Arts and Theatre in Vitebsk.

On joining the school El Lissitzky and Malevich began to use the facilities of the Graphics Department to produce books that promoted Suprematism as the correct method for modern art. Suprematism was an abstract approach to art which showed a preference for geometric, coloured, non-figurative forms. Malevich's ideas on Suprematism were elucidated further in the manifesto *On New Systems in Art* published in Vitebsk in 1919. This publication was hand-produced in the Art School by transfer lithography with a linocut cover by El Lissitzky. It was republished in abbreviated form by Narkompros as *From Cézanne to Suprematism* in 1920. The best records of Malevich's painting are *Suprematism: 34 drawings* published in Vitebsk and Nikolai Punin's *First Cycle of Lectures* published in Petrograd.

In 1919 Malevich also set up a new association at the Art School under the name UNOVIS – this was an acronym which stood for Affirmation of the New Art.

The main goal of UNOVIS was to encourage artists to apply the Suprematist style not only to painting, but also to architecture and the design of all types of everyday objects – including posters, book covers, street decorations and porcelain. UNOVIS doctrine also declared that they should group themselves as 'collectives' where they would reinforce the sense of shared social responsibility. Members of UNOVIS included El Lissitzky, Klucis, Senkin, Suetin, Ermolaeva and Chasnik, some of whom became notable architects later on.

To promote the practical approach encouraged by Suprematism, UNOVIS produced a table of Suprematist symbols which could be applied to the design of street decorations, books, posters, porcelain and textiles. A 1919 leaflet advised wearing 'the black square as a sign of world economy' and drawing 'the red square in your workshops as a mark of the world revolution in the arts'. El Lissitzky's response to the idea of Suprematism was to create Prouns. These were paintings with names such as 'Town' which were an amalgam of painting and architecture. He also applied architectural principles to the design of books, regarding typography as the main building block in the construction of a book.

In 1920 UNOVIS, under the name POSNOVIS (Followers of the New Art), performed the first 'Suprematist ballet'. It also mounted a production of Aleksei Kruchenykh's Futurist opera *Victory over the Sun* with costumes designed by Vera Ermolaeva under the direction of Malevich. In 1922 Malevich left for Petrograd where he became the head of the State Institute of Artistic Culture.

Peter Hellyer

OPPOSITE:
Nikolai Punin,
First Cycle of Lectures, 1920.
Cover by Kazimir Malevich.
(BL C.114.mm.34)

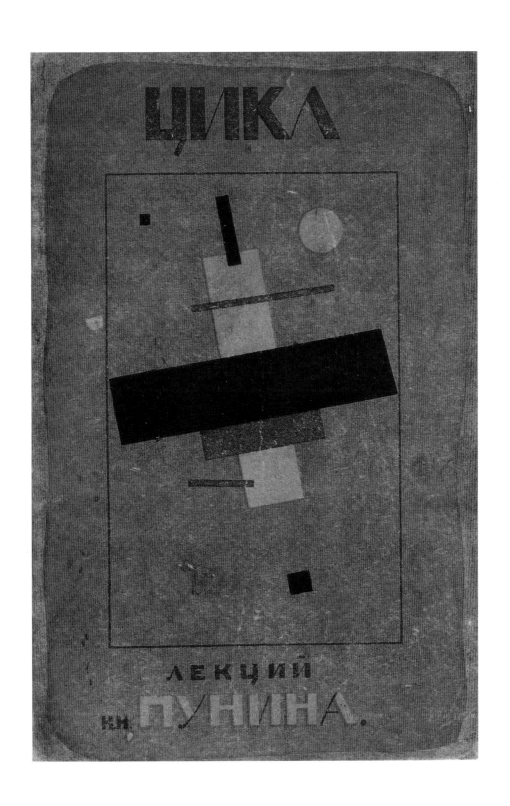

Warsaw

New trends in European art reached Warsaw quickly due to its location in the heart of Europe, stimulating the local artists. After the war Warsaw regained its dominant position in the newly formed country, serving as a magnet for artists from other cities.

Crystallizing round poets Anatol Stern and Aleksander Wat, a Futurist group was established at the end of 1918. The first event, *Subtropical Evening Organized by White Negros* advertised by Henryk Berlewi's loud poster, took place in February 1919 and initiated a series of talks, public appearances and scandals – all with a desire to shock the public. Stern's poetic debut in the 1919 *Futuryzje* resulted in the poet's being sentenced to a year's imprisonment after he had recited his poems in public. Jerzy Jankowski, poet and journalist, was first to publish phonetically spelt poems. *Tram across Street*, issued by the Polish Futurist Press in 1920, was printed on brown paper with the title in black bold type, spread on a poster-style cover – at that time a provocative publication. *The First Polish Almanac of Futurist Poetry GGA* by Stern and Wat (1920), containing a manifesto, 'Primitivists to the Nations of the World', as well as shockingly entitled poems (e.g. 'A muse on all fours or flying skirts'), was confiscated as unfit for distribution.

Futurists very often clashed with the authorities on the grounds of obscene language and the unusual typography of their publications. The culmination of the movement was however reached after the Cracow and Warsaw groups had merged in 1920, and Warsaw was subsequently invaded by Futurism. Futurist slogans gained some popularity; parodies of Futurist poems were recited in cabarets and satirical shows, numerous Futurist publications were issued, accompanied by press polemics and political criticism. The Futurists' anarchistic programme failed to be well received in a society reconstructing its political and social order.

Futurism paved the way for Constructivism. Constructivist ideas were propagated for the first time by El Lissitzky during his short visit in 1921. The year 1924 saw the creation of Blok, the first Constructivist group in Poland, founded by Władysław Strzemiński, his wife Katarzyna Kobro, Henryk Berlewi, Mieczysław Szczuka and Teresa Żarnower. The group consolidated around the issue of construction in a work of art and aimed at transforming the environment: the city, the house,

the painting, the film and the book. However, the artists' wide range of interests led them in different directions: Szczuka mastered his photomontage techniques called poetico-visuals, Kobro focused on calculations of space–time rhythm, Strzemiński on unism, Żarnower on political posters, and Berlewi with his theory of 'Mechanofaktura' and Stażewski concentrated on interior design, posters and adverts. Their first joint appearance was an exhibition in the showroom of an automobile firm, Laurin-Clement, preceded by the first issue of the journal *Blok*. The exhibition was heavily criticized, and Słonimski's aggressive review, which infuriated Szczuka, resulted in a pistol duel and consequently in Szczuka being wounded. *Blok* was concerned with the economy of means and utilitarian beauty, and proclaimed the programme of mechanization of art. Foreign collaborators with Blok included Kazimir Malevich, Hans Arp, Theo van Doesburg and El Lissitzky. Despite the name suggesting unity, members with Blok broke up in 1926 and a new group of architects and painters called Praesens was launched on the initiative of Szymon Syrkus. The group included the architects Syrkus, Lachert and Szanajca and former Blok members Strzemiński, Kobro and Stażewski, the last-named being an editor of its journal under the same name. The group was very active between 1926 and 1929, participating in and co-organizing exhibitions – for example the 1927 Machine Age Exhibition in New York. They were in close collaboration with the De Stijl group. Their programme

OPPOSITE:
Bruno Jasieński
and Anatol Stern,
Earth to the Left
(*Ziemia na Lewo*), 1924

This book of poems designed by Mieczyslaw Szczuka features a photomontage on the cover which includes photographs of the poets with some extracts from their poems. This is one of the first examples of functional typography in Polish publications.

(BL LB.31.b.5155)

emphasized the union of the new architecture with social demands. They contributed to the urban planning, design and construction of residential buildings. Their most spectacular achievement was the pavilions and interiors at the Universal National Exhibition in Poznan, 1929. At the invitation of Praesens, Malevich visited Poland in 1927. He gave a talk on new art and presented a collection of his own works. Ideological disagreements within the group made Strzemiński, Kobro and Stażewski leave Praesens in 1929. After the break-up the group functioned only as a team of architects.

Experiments were also carried out by Polish artists in the field of photography, photomontage and film. The precursor of photomontage was Mieczysław Szczuka, whose Constructivist approach manifested itself in the typographic layouts of *Blok*, political publications and propaganda posters. However, his best achievements were the designs of two volumes of poetry, *Ziemia na Lewo* (*Earth to the Left*) by Stern/Jasieński, 1924, and *Europa* by Stern, 1929. Other artists included Kazimierz Podsadecki, Janusz Maria Brzeski, Karol Hiller with his heliographic experiments and Stefan Themerson whose experiments resulted in Surrealistic collages used for films (e.g. in the first Polish avant-garde film, *Europa*, 1931, inspired by Stern's poem).

Łódź

Group a.r.(for 'revolutionary artists' or 'real avant garde') began the last phase of the development of Constructivism in Poland. The group was founded initially in Warsaw by Strzemiński, Kobro and Stażewski and was geographically scattered, existing by means of correspondence – it eventually moved to Łódź after the Strzemińskis had settled there in 1931. Przyboś lived in Cieszyn, Stażewski in Warsaw and Brzękowski in Paris, where he edited the Polish–French journal *L'Art Contemporain* (1929–30). The programme of the group concentrated on the social aims of art and new visual forms of print. The most important achievement was the foundation of the International Collection of Modern Art on Strzemiński's initiative. At that time Łódź, an industrial town with no previous cultural tradition, was the most active avant-garde centre in Poland. The collection consisted of 111 works of art donated by Polish artists and members

of Abstraction-Création and Cercle et Carré : from Arp, Kurt Schwitters and Fernand Léger to Georges Vantongerloo, van Doesburg and Picasso. It constituted the second permanent gallery of abstract art in a European museum (the first being in Hanover) representing all main avant-garde movements of the time.

Strzemiński also organized a school of modern printing where he could develop his passion for functional typography. The publishing house The a.r. Library was another venture undertaken by Strzemiński – in total seven volumes of poetry and theoretical works were published with his typography. Julian Przyboś' collection of poems *Z ponad* (*From above*) is one of the first and best examples of close collaboration between a poet and artist resulting in the interpretative graphic layout of visual poetry. An attempt to publish their own magazine failed; instead two bulletins (*Komunikat a.r.*) containing the group's programme were issued. Due to Strzemiński's efforts, Łódź was also a venue for international exhibitions on typography (1932–39) in which works by such artists as Moholy-Nagy, Tschichold and Marinetti were shown. The group was active throughout the 1930s, but it lost its impetus around 1934 when the interest in Constructivism began gradually to fade away.

In the 1920s the Jewish group Jung Idysz (Young Yiddish) was active in Łódź. Identified with Jewish Expressionism drawn from Yiddish culture and European modernism, the group embraced such artists as Jankiel Adler, Marek Szwarc, Wincenty Brauner and Mojżesz Broderson, and aimed at expressing their cultural identity.

The group had international contacts with other Jewish artistic communities.

Magda Szkuta

Weimar

The small Thuringian town of Weimar occupies a place in Germany's cultural consciousness out of all proportion to its size. Its 'golden age' of literary Classicism was followed by a nineteenth-century 'silver age', and it was with the deliberate aim of starting a third cultural revival that the cosmopolitan connoisseur and critic Count Harry Kessler took up the post of honorary director at Weimar's Museum of Arts and Crafts in 1903. Pre-war Weimar never became the centre of modern art and culture that Kessler had envisaged, not least due to the town's prevailing political and artistic conservatism. Nonetheless Kessler helped to revitalize the School of Arts and Crafts under the headship of the Belgian designer Henry van de Velde, and was instrumental in the foundation of the Deutscher Künstlerbund (German Artists' League) which brought together Secessionist artists from all over Germany.

Kessler was also deeply interested in the art of the book, and founded the Cranach Press in Weimar in 1913 to promote fine printing. Despite Kessler's support for modern art and his democratic political views, the press produced limited editions for wealthy collectors, and was essentially conservative in its choice of texts and only cautiously modern in their design and illustration. A publishing venture which aimed to reach a wider audience was the firm founded by Gustav Kiepenheuer in 1909. Although initially concentrating on works from and about Weimar's golden age, Kiepenheuer gradually built a reputation for modern art and literature. His journal *Das Kunstblatt* (1913–33) became an important forum for modern European artists.

However, for Weimar's main contribution to the avant garde and modernism we must look to the immediate post-war period and the founding in 1919 of the Bauhaus by Walter Gropius, with a staff drawn from leading avant-garde artists and designers of the day. Absorbing the former School of Arts and Crafts run by van de Velde, the Bauhaus sought to break down the barriers between pure art and practical design and to enhance the way people lived with well-designed and well-made homes and objects. All students had to take a 'Preliminary Course' (*Vorkurs*), initially taught by Johannes Itten, in which they studied art in terms of its basic components – shapes, lines, colours, light and darkness – before going on to put what they had learned into practice in the craft workshops. Much of what we take for granted today in graphic design, typography and, above all, in architecture and household design has its origins in the Bauhaus.

Despite its high ideals of artistic community, the Bauhaus faced both conflict within and opposition from without. Gropius soon fell out with Itten over the school's ideological direction, and in 1923 Itten resigned, unhappy at the increasing influence of Constructivism and Functionalism on the curriculum. Others who departed early were the theatre designer Lothar Schreyer, whose highly stylized and symbolic dramas caused protests among the students, and the sculptor Gerhard Marcks, who disliked the direction taken by Itten's successor László Moholy-Nagy. It was Moholy-Nagy, however, who was responsible for much of what we consider the Bauhaus style today, especially in terms of graphic design. He and Gropius led a move away from traditional ideas of craftsmanship to embrace technology and industry in both design and manufacture.

External pressures came from the state government of Thuringia, which funded the Bauhaus. Ironically for the place which had given its name to Germany's hopeful new republic in 1918, Weimar was still the conservative town which had found Kessler's Secessionist interests and van de Velde's art nouveau hard to swallow, let alone the radical and progressive Bauhaus. Despite the international success of the Weimar Bauhaus Exhibition of 1923, the school was forced to close in Weimar in 1925.

The Bauhaus reopened in Dessau, an industrial town which had developed rapidly in the nineteenth century and which was in many ways a more appropriate location than classical Weimar for a forward-looking institution with a growing interest in industrial production. As a concrete example (in every sense), only one Bauhaus building project had actually been realized in Weimar, but the Dessau Bauhaus was housed in a building designed by Gropius and further buildings followed, both for the school itself and for the city – including a model estate of workers' housing. Indeed it was only in Dessau that the Bauhaus finally developed the permanent department of architecture which had always been central to Gropius' vision.

By the time of the move to Dessau, Moholy-Nagy had become a central figure at the Bauhaus. From 1925 onwards he and Gropius edited a series of *Bauhaus-Bücher*, including Paul Klee's *Pädagosiches Skizzenbuch* based on his Bauhaus lectures; Moholy-Nagy's own work on painting, photography and film; and works on architecture, stage design and the products of the Bauhaus workshops. The books, like the contemporary journal *Bauhaus*, show Moholy-Nagy's influence in their bold design, modern typography and use of photography and photomontage.

Just as Gropius had fallen out with Itten and his followers in Weimar, so he, Moholy-Nagy and others began to feel alienated by the increasingly politicized atmosphere at the Dessau Bauhaus, especially when the committed communist Hannes Meyer succeeded Gropius as director

in 1928, prompting a number of resignations. Meyer himself was dismissed in 1930, but by then the city of Dessau, which had moved politically to the right, was looking for an excuse to be rid of the school. In 1932 a Nazi Party resolution to close the Bauhaus was passed by a large majority in the city council. The new director, Mies van der Rohe, moved the school briefly to Berlin but it closed for good in 1933.

Although efforts to resurrect the Bauhaus after 1945 met with less than complete success, both Weimar and Dessau are now proud of their Bauhaus heritage. They were never centres of avant-garde art in a wider sense, but both towns played host to an institution which was in itself central to the history of modern art and design.

Susan Reed

OPPOSITE:
Schlemmer, Moholy-Nagy
and Molnár,
Die Bühne im Bauhaus, 1925.

The fourth in the
'Bauhausbücher' series of
fourteen titles expounding
the theories behind the
Bauhaus workshops.

(BL X.900/8260)

Zurich

'Switzerland is a birdcage, surrounded by roaring lions', reflected Hugo Ball in his diary entry of 15 October 1915. During the First World War the 'birdcage' of neutral Switzerland had become a temporary home to an eclectic mixture of European artists and intellectuals. They were attracted by its reputation for tolerance, artistic freedom and multilingual culture, and the hope of a receptive public for their work. This international community of thinkers included such diverse individuals as James Joyce, Lenin, Tristan Tzara and Ball. While many French artists, such as Romain Rolland, based themselves in Geneva, the most significant avant-garde developments occurred in Zurich. Here the Dada movement blossomed out of a desire to use art as a means of protest against war and modern civilization.

The individual artists who formed Zurich Dada were initially brought together by Ball, who launched the Cabaret Voltaire in February 1916. Performing at the Holländische Meierei restaurant at Spiegelgasse 1 (Lenin lived at Spiegelgasse 12), the Cabaret Voltaire variety evenings soon aroused the curiosity and indignation of the highly conservative Zurich public. At first it lacked any specific artistic direction, but the arrival in late February of the radical German Expressionist Richard Huelsenbeck gave momentum to the desire to use new art forms to express opposition to the perceived spiritual bankruptcy of the age. Adopting an increasingly provocative and aggressive approach, the members of the Cabaret began to form into a more cohesive core unit comprising Ball, Huelsenbeck, Tzara, Janco, Arp and Hennings. Later they were joined by a variety of others, including Richter, Taeuber and Serner.

Though clearly influenced by Expressionism, Cubism and in particular by Futurism, these artists increasingly presented their own work. Tending toward the abstract, primitive and illogical, they insulted their audiences, emphasized spontaneity and refused to prescribe any concept of a utopian future. Wearing Janco's primitive and dramatic masks, they would play atonal music, perform abstract dance routines, use primitive rhythms and negro chants, and recite simultaneous poetry. Ball's 'sound poems' such as 'Karawane' and 'gadji beri bimba', which comprised newly invented words, were defining moments of these performances.

With the emergence of a distinctive identity, the Cabaret Voltaire group began to plan other projects. Tzara in particular wanted to produce a journal, and in June 1916 the first and only edition of *Cabaret Voltaire* was published. This anthology mainly contained poems and images by the Cabaret Voltaire artists, including the simultaneous nonsense poem for three voices 'L'amiral cherche une maison à louer' ('The admiral searches for a house to rent'). Also included were a drawing by Picasso and contributions by leading Futurists. For the first time Ball used the word 'Dada' in relation to the planned title of a future international arts journal.

A month after the publication of *Cabaret Voltaire*, the evening performances at the Spiegelgasse venue were brought to an end, due to complaints about the rowdy behaviour. However, on 14 July 1916 the first official public Dada soirée took place at the Waag Hall. There Ball read out the first Dada manifesto, and simultaneously signified his first break from both Zurich and the emerging Dada movement. These Dada soirées continued the trend of provocation which had characterized the Cabaret Voltaire, and followed a similar format. It was at the seventh Dada soirée at the Meise Hall on 23 July 1918 that Tzara read out his famous 'Manifeste Dada 1918' (Dada manifesto), and at the final soirée at the Kaufleuten Hall in April 1919 Walter Serner's reading of his 'Letzte Lockerung' (Final dissolution) manifesto caused him to be chased off the stage by an enraged audience.

During Ball's first temporary absence from Zurich, from July to November 1916, Tzara became the driving force behind the literary activities of the Dadaists. In July 1916 he began publishing a new series called Collection Dada. The series comprised

OPPOSITE:
Marcel Janco, Poster for the seventh Dada evening at the Zur Meise Hall, 23 July 1918

(reproduced in BL F.90/0354)

LEFT:
Cover of *Cabaret Voltaire*, June 1916, the first Dadaist publication.

Bibliothèque Historique de la Ville de Paris / Bridgeman Art Library

OPPOSITE:
The first page of the manuscript of Hugo Ball's Dada manifesto, which he read at the first public Dada soirée at the Waag Hall in July 1916. The text emphasises his concern with the corruption of language in modern society and acted as a means of introducing a recital of his 'sound poems', which dispensed with conventional language and comprised newly invented words.

Robert Walser-Stiftung, Zurich

a collection of Tzara's poetry called *La première aventure céleste de M. Antipyrine (The First Celestial Adventure of Mr Antipyrine)*, followed by two volumes of Huelsenbeck's poetry, *Phantastische Gebete (Fantastic Prayers)* and *Schalaben Schalomai Schalamezoma*, and finally Tzara's *Vingt-cinq poèmes (Twenty-five poems)* in 1918.

After Ball's return to Zurich in November, he became involved in a series of Dadaist public art exhibitions which were more educative in tone than the Cabaret Voltaire performances. Following the exhibition at the Galeria Corray in Bahnhofstrasse, in January 1917, the Dadaists rented the gallery until June 1917 and renamed it Galerie Dada. Here Expressionist works received on exchange from the Sturm Gallery in Berlin were displayed. Subsequently there were exhibitions including works by Wassily Kandinsky and Paul Klee, and the Italian painter Giorgio de Chirico. Together with these shows there were changing exhibitions of works by Janco, Arp and Richter, as well as educational lectures and tours. The exhibitions were accompanied by five Dada soirées at the Galeria Dada; by linking together visual art, literary

contributions, music and dance, the Dadaists were trying to embody the spirit of Kandinsky's *Gesamtkunstwerk* concept, or total work of art.

Despite these collaborations, both Ball and Huelsenbeck were opposed to the establishment of any kind of 'Dada Movement'. In January 1917 Huelsenbeck left Zurich for Berlin, and in July of the same year Ball and Emmy Hennings also left Zurich for good. Following Ball's departure Tzara proclaimed in a Zurich newspaper advertisement, 'Mysterious creation! Magic revolver! The Dada Movement is launched'.

Between July 1917 and May 1919 Tzara edited four volumes of the Zurich journal *Dada*, which succeeded *Cabaret Voltaire*. *Dada 1* and *Dada 2*, published in July and December 1917 respectively, followed a similar format to *Cabaret Voltaire*. These journals were a means of spreading the ideas of the Dadaists to an international audience, but it was *Dada 3* that made the biggest impact. Using a wide variety of typefaces and with lines of text sometimes appearing diagonally across the page, *Dada 3*, clearly influenced by the Futurists' typography, broke with stylistic conventions. With *Dada 3*

Zurich Dadaism really caught the attention of the European avant garde, including French painter Francis Picabia, who subsequently came to Zurich in the autumn of 1918 and published the eighth edition of his *391* journal while there.

Launched in May 1919, *Dada* 4–5 (also known as *Anthologie Dada*) contained Serner's 'Letzte Lockerung' manifesto, as well as contributions by Picabia, Jean Cocteau and André Breton, and was the last of the series to be published in Zurich. However, one last single-issue Zurich Dadaist journal, *Der Zeltweg*, edited by Otto Flake, Serner and Tzara, was published in November 1919, marking the end of the Zurich Dada Movement. Tzara joined Breton and Picabia in Paris at the end of 1919, and continued to publish Dadaist journals there. Janco departed for Paris and then Romania, Richter left for Berlin, Serner settled in Geneva, and Hans Arp and Sophie Taeuber went to Cologne, establishing another Dada group there.

Annemarie Goodridge

Timeline

Political, economic, social, cultural and technological events	Avant-garde activities
1900 Russia occupies Manchuria. Brownie camera marketed. Paper clip patented.	Gaudi begins construction of the Sagrada Familia. Isadora Duncan makes appearance as a dancer in Paris.
1901 Marconi radio message from Cornwall to Newfoundland. Sale of shellac phonograph disc begins. First electric typewriter, the Blickensderfer. Freud, *Über den Traum* (The Interpretation of Dreams), Vienna.	Picasso, first exhibition in Paris at Galerie Ambroise Vollard. Jarry, *Almanach illustré du Père Ubu*. Foundation of the Überbrettl, Berlin, cabaret with Schoenberg as musical director.
1902 Zeiss invents four-element Tessat camera lens. Etched zinc engravings begin to replace wood-blocks	Debussy, *Pelléas et Mélisande*.
1903 London, *Daily Mirror* uses only photographic illustrations.	*Camerawork*, New York.
1904 Russo–Japanese War. Offset lithography in wide use. Comic book published.	
1905 Trans-Siberian railway completed. First Russian revolution.	Apollinaire, 'Picasso', *La Plume*. Term 'les Fauves' coined. Photo-Secession Gallery at 291 5th Avenue, New York, founded by Alfred Stieglitz.
1906 First Russian Duma. Screen printing patented for use with photography in USA. Experimental sound on motion pictures.	Death of Cézanne. Kandinsky exhibition, Galerie Wertheim, Berlin. Archipenko and Bohomazov exhibition, Kyiv.
1907 Moldavian revolution. Martial law in Romania. Rutherford discovers atom nuclei.	Picasso, *Les Demoiselles d'Avignon*.
1908 Austria annexes Bosnia and Herzegovina. Revolt against Austrian rule in Bohemia. Emperor Wilhelm II dismisses Hugo von Tschudi, Director of the National Gallery, Berlin.	Picasso organizes banquet for Henri ('le Douanier') Rousseau in his Bateau Lavoir studio, Paris. Zveno group exhibition, Kyiv
1909 Revolution in Catalonia. Blériot flies across English Channel.	20 February: *Le Figaro* publishes first manifesto of Futurism by Marinetti. Diaghilev's Ballets Russes perform *Prince Igor* at the Théâtre du Châtelet, Paris. Salon organized by Izdebsky, Odessa.

1910	Revolution in Portugal. Neon lighting first displayed at the Paris Motor Show.	*Der Sturm* published by Herwarth Walden, Berlin, fortnightly. Henri Rousseau exhibition at Alfred Stieglitz Gallery, New York. *Impressionists' Studio*, edited by N.I. Kulbin. Diaghilev's Ballets Russes perform *Scheherezade* and Stravinsky's *Firebird*, with decorations by Bakst. Union of Youth, St Petersburg.
1911	Italy declares war on Ottoman Empire and occupies Tripoli; first use of aeroplanes in warfare. Rotogravure used in photographic reproduction.	Retrospective of Henri Rousseau at the Salons des Indépendants. Jarry, *Exploits and Opinions of Doctor Faustroll, Pataphysician*.
1912	Syndicalist strike in Portugal. First mail carried by aeroplane. First Balkan War. Fall of Adrianople.	Kandinsky and Marc, *Über das Geistige in der Kunst*. *Der Blaue Reiter*, Munich. Kruchenykh and Khlebnikov, *Worldbackwards*. Schoenberg, *Gurreleider* performed in Vienna. George Heym, *Umbra vitae*, published posthumously. Ballets Russes perform Stravinsky's *Firebird*, at Covent Garden, London.
1913	Second Balkan War. Treaty of Bucharest. Riots in Alsace-Lorraine. Stainless steel patented. Type-composition machines in production.	Marinetti visits Berlin. Cendrars and S. Delaunay, *La Prose du Transsibérien*, Paris. Apollinaire lectures at R. Delaunay's exhibition, Der Sturm, Berlin. Apollinaire, 'L'antitradition futuriste'. Stravinsky, *Le Sacre du printemps* performed, Paris. Kruchenykh, *Victory over the Sun*. Armory Show, New York. Arthur Craven, *Maintenant*. Roger Fry opens Omega Workshops, Bloomsbury, London.
1914	First World War begins after assassination of Archduke Franz Ferdinand at Sarajevo by Serbian nationalist. Battle of Mons. Russian second army defeated at Tannenberg.	Marinetti, *Zang tumb tuuum*. Marinetti's visit to Russia. *Blast*, London. Hasenclever, *Der Sohn*. *First Journal of Russian Futurists 1–2*. Posthumous publication of Mallarmé, *Un Coup de dés*. Semenko, *Derzannia*.
1915	Italy declares war on Austria. Germans capture Warsaw.	Balla and Depero, *Futurist Reconstruction of the Universe*. *291* (New York). Vorticist exhibition, Doré Gallery, London. Kassák publishes *A Tett*.

1916	Battle of the Somme.	Joyce, *Portrait of the Artist as a Young Man*.
	Battle of Verdun.	Dada founded.
		Kassák founds *Ma*, Budapest.
1917	February and October revolutions in Russia.	*Dada 1*, Zurich (July).
	Battle of Passchendale.	*Dada 2*, Zurich (December).
	Russian Civil War 1917–20.	T.S. Eliot, *Prufock and other Observations*.
	Implementation of Russian orthographic reforms.	*De Stijl* founded, Leiden.
		391 (Barcelona etc.).
		Apollinaire's *Les Mamelles de Tirésias*, Théâtre Renée-Maubel, Paris.
		Parade, staged by Diaghilev, with sets and costumes by Picasso, Théâtre du Châtelet, Paris.
		Malik Verlag founded by John Heartfield and Wieland Herzfelde.
1918	Treaty of Brest-Litovsk ends Russia–Germany conflict.	Tzara, 'Dada Manifesto', *Dada 3*.
	First World War ends.	Apollinaire dies in influenza pandemic.
	Weimar Republic proclaimed.	Mayakovsky, *Mystery-Bouffe*, with sets by Malevich.
	Bolsheviks take power in Estonia, Latvia and Lithuania.	
	Creation of Czechoslovakia.	
	Dissolution of Russian Orthodox Church.	
	Second Polish republic.	
	Influenza pandemic.	
1919	Murder of the Spartacists Rosa Luxembourg and Karl Liebknecht.	*Anthologie Dada* (*Dada 4–5*), Zurich.
	Suppression of the Bavarian Soviet Republic by Freikorps.	*Der Zeltweg*, Zurich.
	Hungary proclaimed a Soviet republic.	*Littérature*, Paris, no. 1
	Move of Russian capital from Petrograd to Moscow.	Marinetti, *Les Mots en liberté futuristes*, Milan.
	J.M. Keynes, *The Economic Consequences of Peace*, London.	Cendrars and Léger, *La Fin du monde*, Paris.
		Bauhaus manifesto.
		Jedermann sein eigner Fussball (Berlin).
		Kruchenykh and Zdanevich brothers form 41° group in Tibilisi.
1920	Right-wing Kapp revolt suppressed in Berlin.	Festival Dada, Paris.
	Russia–Poland War.	VKhUTEMAS (Higher Art and Technical Studios), Moscow, founded.
	League of Nations meets.	Gabo and Pevsner, 'The Realistic manifesto', Moscow.
	Miklós Horthy becomes Regent of Hungary.	*Cabinet of Dr Caligari* (film).
	Treaty of Trianon: Hungary cedes Transylvania to Romania.	Mondrian, *Le Neoplasticisme*.
		Pound, *Hugh Selwyn Mauberley*.
		Devětsil group founded in Prague.

1921	Peace of Riga ends Russia–Poland War.	*New York Dada.*
	Kronstadt mutiny.	*Jednodniuwka futurystuw*, Craców.
	New Economic Plan (NEP), Russia.	

1922	Economic Conference, Genoa.	Moholy-Nagy, *Telephone pictures.*
	Chanak crisis.	Erste Russische Kunstausstellung, Van Diemen Gallery, Berlin.
	Creation of Soviet Union.	
	Walter Rathenau, German foreign minister, assassinated.	Dada Congress, Weimar.
		T.S. Eliot, *The Waste Land.*
	Mussolini appointed Italian premier.	James Joyce, *Ulysses*, Paris.
	Two-colour Technicolor process for motion pictures.	First international congress for progressive artists, Düsseldorf.
	First cathode ray TV pictures.	

1923	Franco–Belgian contingent occupies Rhineland.	Mayakovsky and El Lissitsky, *Dlia golosa* (*For the Voice*), Berlin.
	Unsuccessful Nazi putsch in Munich.	
	Primo de Rivera becomes Spanish dictator.	Blue Four (Feininger, Jawlensky, Kandinsky, Klee) exhibition.
	Use of neon signs for advertising.	
		Moholy-Nagy joins Bauhaus.
		Zhovtnevyi zbirnyk panfuturystiv, Kyiv.
		Richter edits *G: Material zur elementaren Gestaltung* (Berlin).

1924	Stabilization of the German mark.	Breton, *Manifesto of Surrealism.*
	Death of Lenin.	*La Révolution surréaliste*, no. 1, Paris.
	Britain recognizes Soviet government.	Constructivistes Russes: Gabo et Pevsner, Galerie Percier, Paris.
	Dawes plan for German reparations agreed.	
	Communist coup in Estonia crushed.	Paul Leni, *Waxworks* (film).
		Schwitters exhibition, Kestner-Gesellschaft, Hanover.
		Clair, *Entr'acte* (film).
		Gebrauchsgraphik published, Berlin.

1925	Moroccan War.	Einstein joins Bauhaus board.
	Albania declared a republic.	Rodchenko works on Melnikov's Soviet pavilion for Exposition internationale des arts décoratifs et industriels modernes, Paris.
	Britain returns to gold standard.	
	French troops evacuate Ruhr.	
	Locarno Treaties.	Moholy-Nagy, *Malerei Foto Film.*
	Leica 35mm camera in production.	Ernst invents frottage technique.
	Nikolai Kondratiev, *The Major Economic Cycle.*	Berg's opera *Wozzeck*, using Schoenberg's 12-tone system and Sprechgesang.
		Posthumous publication of Kafka, *The Trial.*
		Eisenstein, *Battleship Potemkin* (film).
		Oesophage, Brussels.
		Josephine Baker makes first dance appearance in Paris.

1926	Military coup in Portugal.	Bauhaus opens in Dessau.
	Pilsudki coup in Poland.	Herbert Bayer designs single-case Universal
	Graphic formats standardized on A sizes, Germany.	alphabet.
		Aragon, *Le Paysan de Paris*.

1927	Black Friday, German economic panic.	Aragon, Breton, Eluard, Péret, Unik join
	Socialist riots in Vienna.	Communist Party.
	Movietone newsreels with sound.	Leningrad production of Berg's *Wozzeck*.
		Fritz Lang, *Metropolis* (film).
		Gance, *Napoleon* (film).
		Sander's People in the 20th Century exhibition, Cologne.
		Themerson's first photomontage films.
		A.E. Gallatin opens Gallery of Living Art, New York.

| 1928 | Leftist parties win French elections. | Brecht and Weill, *The Threepenny Opera*. |
| | Motion pictures in colour. | Tschichold, *Die neue Typografie*. |

1929	Stock market crash leads to worldwide recession.	Breton, 'Second Manifeste du surréalisme', *La Révolution surréaliste*.
	Yugoslavia created from Kingdom of Serbs, Croats and Slovenes.	Exhibition of Blossfeldt's photographs at Zwemmer's, London.
	Trotsky expelled from Russia.	Mayakovsky, *Bedbug*, performed at Meyerhold Theatre, Moscow.
		Film and Foto exhibition, Stuttgart.
		Dziga Vertov, *Man with a Movie Camera* (film).
		Buñuel, *Un Chien andalou* (film).
		Museum of Modern Art founded in New York.
		Stern, *Europa*.
		Dovzhenko, *Arsenal* (film).

| 1930 | Airship R101 crashes. | Buñuel, *L'Age d'or* (film). |
| | End of Primo de Rivera dictatorship in Spain. | Mayakovsky commits suicide. |

1931	Britain abandons gold standard.	Elsie Cohen opens Academy Cinema, Oxford Street, London, with Pabst film.
	Spanish republican constitution adopted after revolution.	Virginia Woolf, *The Waves*, London.
	Picard's record balloon ascent to 15,781 metres.	Abstraction-Création group founded by van Doesburg.

1932	USSR–Poland non-aggression pact.	Brassaï, *Paris de nuit*.
	Times Roman, designed by Stanley Morison, issued by Monotype Corporation.	Abstraction-Création group founded in Paris.
		Newer Super-realism (Chirico, Dalí, Ernst, Picasso), Julian Levy Gallery, New York.
		Themersons, *Europa* (film).
		Art groups dissolved in USSR in favour of Socialist Realist agenda.

1933	Polythene invented.	*Minotaure*, no. 1.
	Reichstag fire.	Bauhaus closes.
	Weimar Republic ends and Nazis seize control.	Gertrude Stein, *The Autobiography of Alice B. Toklas*.
	Purge of Communist Party in USSR.	
	Liberal Duca murdered by Iron Guard, Romania.	Brassaï's first one-man show at Batsford Gallery, London.
		Unit One formed in London by Paul Nash
1934	Ulmanis coup in Latvia.	Ernst, *Une Semaine de bonté*, Paris.
	Assassination of Sergei Kirov in Leningrad starts Big Terror	Dalí arrives in New York.
		Henry Miller, *Tropic of Cancer*, Paris.
1935	Eastman-Kodak produce Kodachrome colour film.	Dominguez invents decalcomania technique.
	Italy invades Abyssinia.	Christopher Isherwood, *Mr Norris Changes Trains*.
		Alfred Hitchcock, *The Thirty-nine Steps*.
		Mendelsohn and Chermayeff complete De La Warr Pavilion, Bexhill.
1936	Spanish rebellion begins.	Benjamin, 'The work of art in the age of mechanical production'.
	Show trials in USSR.	
	Berlin Olympics.	International Surrealist Exhibition, London.
	Edward VIII abdicates.	Cubism and Abstract Art, Fantastic Art, Dada and Surrealism, Museum of Modern Art, New York.
	Monotype Corporation floated on London Stock Exchange.	
1937	Attack on Guernica.	*Circle*, edited by Gabo, Martin and Nicholson, London.
	Sudeten crisis.	
	Photocopier invented by Carlson.	Paalen invents fumage technique.
		Moholy-Nagy retrospective exhibition at the London Gallery.
		Collège de Sociologie founded by Caillois, Bataille and Leiris, Paris.
		Degenerate Art exhibition, Munich.
		Solomon R. Guggenheim Foundation opens gallery based on collection of non-objective painting, with Hilla Rebay as curator.

Bibliography

INTRODUCTION
Walter Benjamin, *Illuminations*, London: Fontana, 1973.
Marshall Berman, *All that is Solid Melts into Air:*
 the Experience of Modernity, London: Verso, 1982.
David Cottington, 'What the papers say: politics and ideology
 in Picasso's collages of 1912', *Art Journal*, 47 (4), Winter
 1988, 350–35.
Peter Gay, *Weimar Culture: the Outsider as Insider*, New York
 and London: W.W. Norton, 2001.
Stephen Kern, *The Culture of Time and Space 1880–1918*,
 Cambridge, Mass., and London: Harvard University
 Press, 2003.
Rosalind E. Krauss, *The Picasso Papers*, London: Thames &
 Hudson, 1998.
Patricia Leighton, *Re-ordering the Universe: Picasso and Anarchism*
 1897–1914, Princeton, N.J.: Princeton University Press,
 1989.
Molly Nesbit, 'Ready-made originals: the Duchamp model',
 October, 37, Summer 1986, 53–64.
Christine Poggi, *In Defiance of Painting: Cubism, Futurism, and the*
 Invention of Collage, New Haven, Conn., and London:
 Yale University Press, 1992.
Robert Rosenbum, 'Picasso and the typography of Cubism',
 Picasso in Retrospect, edited by Roland Penrose and John
 Golding, London: Elek, 1973, 32–47.
William St Clair, *The Reading Nation in the Romantic Period*,
 Cambridge: Cambridge University Press, 2004.

THE MANIFESTO
Umberto Apollonio, *Futurist Manifestos*, Boston, Mass.: MFA
 Publications, 2001.
Timothy O. Benson and Eva Forgács (eds.), *Between Worlds:*
 a Sourcebook of Central European Avant-gardes, 1910–1930,
 Los Angeles: Los Angeles County Museum of Art, 2002.
Mary Ann Caws (ed.), *Manifesto: a Century of Isms*,
 Lincoln, Neb., and London: University of Nebraska Press,
 2001.
Jean-Pierre A. De Villers, *Le premier Manifeste du futurisme*,
 Ottawa: Éditions de l'Université d'Ottawa, 1986.
'The Injunctive text', special issue of *L'Esprit Créateur*, 23, 4 (1983).
Anna Lawton (ed.), *Russian Futurism through its*
 Manifestoes, 1912–1928, Ithaca, N.Y., and London:
 Cornell University Press, 1988.
Janet Lyon, *Manifestoes: Provocations of the Modern*, Ithaca, N.Y.
 and London: Cornell University Press, 1999.
F.T. Marinetti, *Marinetti: Selected Writings*, London:
 Secker & Warburg, 1972.
Vladimir Markov, *Russian Futurism: a History*,
 Washington, D.C.: New Academia Publishing, 2006.
Marjorie Perloff, *The Futurist Moment: Avant-garde,*
 Avant-guerre, and the Language of Rupture, with a new
 preface, Chicago and London: University of Chicago
 Press, 2003.
Martin Puchner, *Poetry of the Revolution: Marx, Manifestos and the*
 Avant-gardes, Princeton, N.J.: Princeton University Press,
 2006.

Jan Tschichold, *The New Typography: a Handbook for Modern*
 Designers, translated by Ruari McLean,
 Berkeley, Calif., and London: University of California
 Press, 1995.

THE AVANT GARDE AND THE LITTLE MAGAZINE
Dawn Ades, *Dada and Surrealism Reviewed*, London:
 Arts Council of Great Britain, 1978.
Dawn Ades (ed.), *The Dada Reader: a Critical Anthology*, London:
 Tate Gallery, 2006.
Dada, Paris: Centre Pompidou, 2005.
Focus on Minotaure, Geneva: Musée d'art et d'histoire, 1987
Les Soirées de Paris, Paris: Galerie Knoedler, 1958.
Undercover Surrealism: Georges Batailee and DOCUMENTS, London:
 South Bank Centre, 2006

THE LIVRE D'ARTISTE AND THE ARTIST'S BOOK
Stephen Bury, *Artists' Books: the Book as a Work of Art, 1963–1965*,
 Aldershot: Ashgate, 1995.
Susan P. Compton, *The World Backwards: Russian Futurist Books*
 1912–16, London: British Library, 1978.
Gerald Janecek, *The Look of Russian Literature: Avant-garde Visual*
 Experiments, 1900–1930, Princeton, N.J.: Princeton
 University Press, 1984.
Daniel-Henry Kahnweiler and Francis Crémieux, *My Galleries*
 and Painters, London: Thames & Hudson, 1971.
Vladimir Markov, *Russian Futurism: a History*, Washington, D.C.:
 New Academia Publishing, 2006.
Marjorie Perloff, *The Futurist Moment: Avant-garde, Avant-guerre,*
 and the Language of Rupture, with a new preface, Chicago
 and London: University of Chicago Press, 2003.
Margit Rowell and Deborah Wye, *The Russian Avant-garde Book*
 1910–1934, New York: Museum of Modern Art, 2002.
Donna Stein (ed.), *Cubist Prints, Cubist Books*, New York: Franklin
 Furnace, 1983.

THE AVANT-GARDE PHOTO-BOOK
Mark Haworth-Booth and David Mellor, *Bill Brandt: Behind the*
 Camera, Oxford: Phaidon Press, 1985.
Martin Parr and Gerry Badger, *The Photobook: a History, volume 1*,
 London: Phaidon, 2004.
Neue Sachlichkeit and German Realism of the Twenties, London: Arts
 Council of Great Britain, 1978.
Alan Sayag and Annick Lionel-Marie, *Brassaï: no Ordinary Eyes*,
 London: Thames & Hudson, 2000.
Ian Walker, *City Gorged with Dreams: Surrealism and Documentary*
 Photography in Interwar Paris, Manchester: Manchester
 University Press, 2002.

AVANT-GARDE CITIES
Dada, Paris: Centre Pompidou, 2005.
Raimund Meyer...[et al.], *Dada Global*, Zurich: Limmat Verlag,
 1994.

Index